RENAISSANCE

PRAGUE

Eliška Fučíková

Translated by Derek and Marzia Paton

Karolinum Press

Originally published in Czech as *Praha renesanční*, Prague: Karolinum, 2017
KAROLINUM PRESS, Ovocný trh 560/5, 116 36 Prague 1, Czech Republic
Karolinum Press is a publishing department of Charles University
www.karolinum.cz

ISBN 978-80-246-3857-7

The manuscript was reviewed by Beket Bukovinská, PhDr (Institute of Art History, the Czech Academy of Sciences),
and Professor Lubomír Konečný (Institute of Art History, Faculty of Arts, Charles University).

The Prague series is edited by Milada Motlová

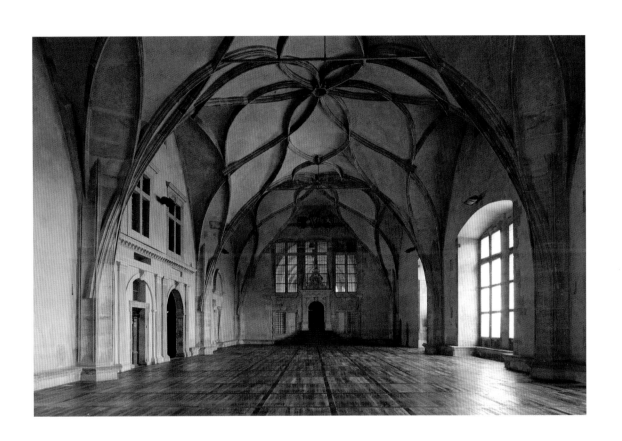

WILIM.WRZESOWICZ.ZWA
RZESOWICZ.NEG W I SLMINCZ
MISTR.KRALOWSTWI.CZESKEHO

CONTENTS

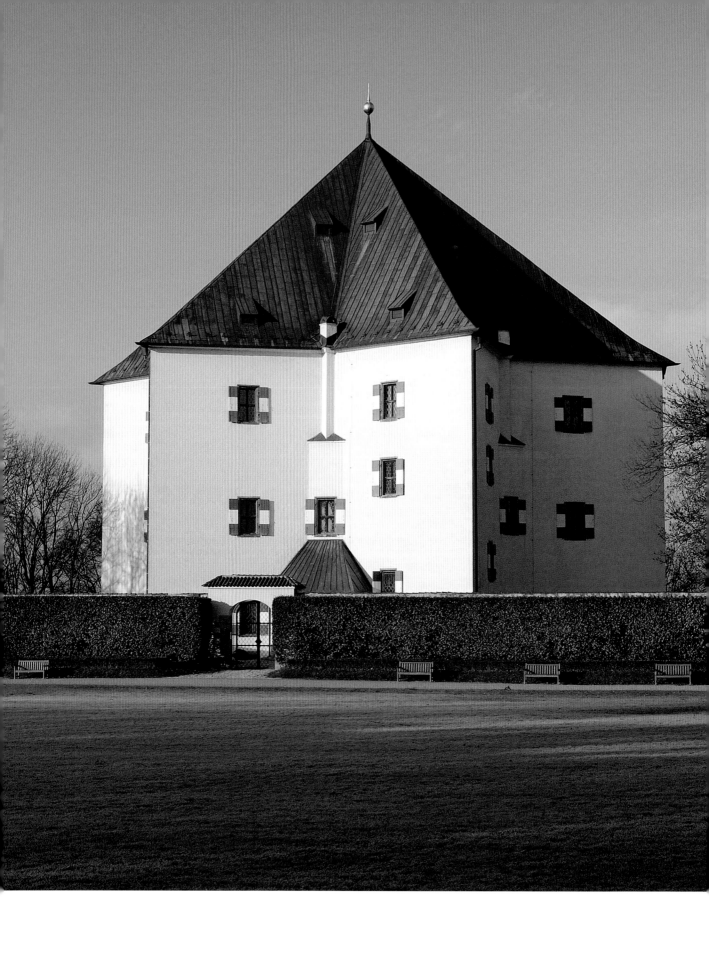

A CONCISE HISTORY
OF RENAISSANCE PRAGUE

: Myl. Skute czu
nor nik a
to kra:

'In the times of the great concerns that King Ferdinand was beset with because of the onset of the new Turkish War, his chief residence in Prague was struck by the unexpected catastrophe of a fire in which both the town and the king and country suffered great damage, some of which was beyond repair.' Thus begins the account of 'The Great Prague Fire of 1541' in Václav Vladivoj Tomek's *Dějepis města Prahy* (A History of the City of Prague, 1897).

It is generally believed that although this disaster had tragic consequences, it nevertheless contributed to the renewal of the city, fundamentally changing its appearance. That, however, is true only in part. Medieval Prague, which was made the capital of the Holy Roman Empire in the reign of Emperor Charles IV (1355–78), experienced turbulent times in the Hussite wars with the power struggles between the Calixtines (or Utraquists) and the Roman Catholics in the following century. These troubles were manifested not only in the Bohemian Lands' decreasing political importance in central Europe, but also in the loss of their influence in the areas of learning and the arts. The appearance of the Bohemian capital also suffered as a result of these violent conflicts. Though the architecture of the Old and the New Town of Prague, which were under Calixtine control, was not so adversely affected, the abundant sculptural and painted decoration of Prague churches was destroyed by the Hussite soldiers. The other two towns of the four that made up Prague – the Lesser Town and the Castle District (Hradčany, particularly the Castle itself) – suffered irreparable damage.

After the death of George of Poděbrady (*reg.* 1420–71), the Bohemian Diet elected as their king Vladislav II Jagiellon (*reg.* 1471–1516), but his position was far from secure. In the same period, the Roman Catholic nobles wanted Matthias Corvinus, King of Hungary, on the Bohemian throne. War broke out between the two rival monarchs, which lasted until 1478. They did not sign a treaty until the following year, whereby Vladislav II remained King of Bohemia and Matthias Corvinus became King of Moravia, Silesia, and the two Lusatias. The awkward situation was not resolved until 1490, when Matthias died without heir and Vladislav thus also gained the crown of Hungary. A condition of his election was that he move to Hungary. The king's building projects in the Bohemian Lands did not, however, suffer from this; his most important contributions to Prague architecture were, paradoxically, made right after that date.

When, following his election, Vladislav II moved to Prague, he first lived at the Royal Court (now long vanished) in the Old Town. The reasons were surely practical: unlike Prague Castle, this royal seat had not suffered damage during the Hussite Wars. The king later moved to the Castle, in 1483, when troubles erupted in the Old Town. Considering the desolate state of this royal seat, he had to begin the overall rebuilding of the Castle immediately. First, a wing, in the Late Gothic

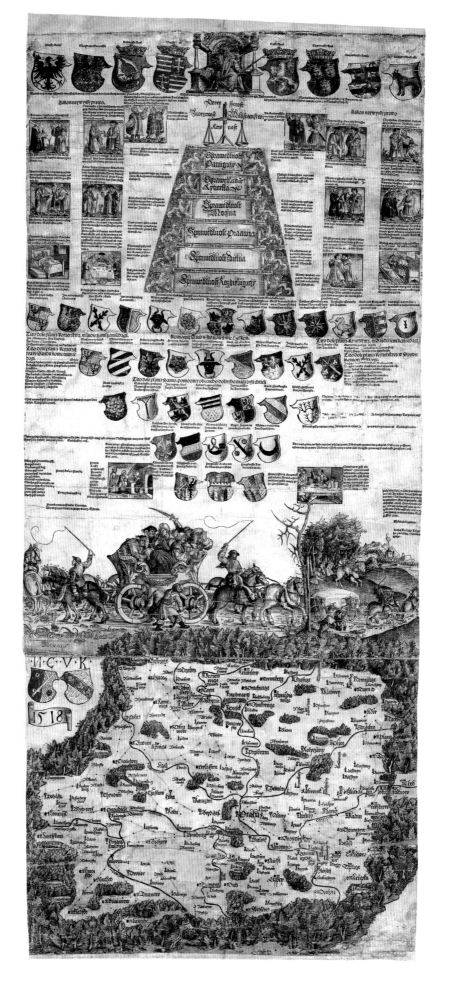

(14)

style, was added to the west side of the royal palace. Its master builder is believed to have been Hans Spiess. The rooms on the ground floor – the Green Chamber, which was rebuilt later, and what is known as Vladislav's Bedchamber – originally served as a court of justice and small throne room. At the end of the 1480s Benedikt Ried, an outstanding master builder, came to Prague.

The city and indeed the whole country are indebted to him for the exceptional architectural jewel of the Vladislav Hall, built from 1490 to 1500 (one can still see the year 1493 carved above the window on the outer north wall and the year 1500 inscribed on the east inside wall of the hall, below the vault). The aesthetically striking and technically demanding vault still suggests the continuation of the Late Gothic style. By contrast, the huge windows of the hall on the south and the north sides are among the first evidence of the early acceptance of the principles of Italian Renaissance architecture in the Bohemian Lands. It is therefore thanks to Vladislav II that the first Renaissance buildings were erected in Prague, or at least at the Castle, already at the end of the fifteenth century. Vladislav's projects at Prague Castle are easily recognized by the letter W (for Wladislaw) on the coat of arms above the window on the east end of the hall. From 1503 to 1510, Vladislav had another building erected in the same style: a new wing, linked perpendicularly, in a southerly direction, to the Vladislav Hall. Today called the Louis Wing, it was intended for the apartments of the king and queen.

In a letter to Lord Burgrave Jindřich z Hradce, Vladislav II comments on 'so many people having access to the castle, even to places we use as rooms, built at extraordinary costs, for our honour and that of the crown and for the pleasure and joy of future kings of Bohemia and the honour of this kingdom'. He also ordered the completion of the decoration of the most sacred space in the Bohemian Lands, the Wenceslas Chapel in St Vitus' Cathedral. He had thus found a dignified way to carry on the work of his distant predecessor, Emperor Charles IV, who had ordered the artist, known today only as the Master of the Litoměřice Altarpiece, and his workshop to paint scenes from the life of St Wenceslas above the lower band

The Klaudyán (Claudianus) Map of Bohemia

Mikuláš Klaudyán (Nicolaus Claudianus, born Kulha) was a physician from the town of Mladá Boleslav, c.50 km north-east of Prague. He was a member of the Bohemian Brethren (Unitas Fratrum) and was a great proponent of book printing. In Mladá Boleslav he was in charge of the Bohemian Brethern's printing house, and in 1517 went to Nuremberg to print Jan Černý's herbal entitled *Knieha lekarska kteraz slowe herbarz: aneb zelinarz*. At the same time, he had woodblocks made in the workshop of Hieronymus Höltzel for the earliest map of Bohemia with accompanying illustrations. The map, which is now known by his name, was intended for pilgrims on their way to Rome, and is therefore oriented with south at the top, as was the custom at the time. The upper part of the map has portraits of the reigning king, Louis of Jagiellon, and the coats of arms of his crown lands. Below them are allegories of Justice surrounded by fourteen moralizing scenes from the Scriptures. Another part shows the coats of arms of leading noble families, senior officials of the kingdom, and the most important towns. The map distinguishes between Catholic and Calixtine towns, and shows the roads for pilgrims and the distances between places, and also schematically indicates the lay of the land. Apart from its importance as a piece of period cartography, the map is also a useful historical document about the state of society in Bohemia at the end of the 1510s. The carriage with two teams of horses, each pulling in the opposite direction, is probably a symbolic expression of domestic political conflicts or perhaps the rivalry between the two main Christian confessions.

of outstanding medieval wall paintings. These paintings are in what was then the new, Renaissance style. These monumental portraits on the altar wall commemorate the builder, Vladislav II, and his wife Anne. In the paintings of the St Wenceslas legend on the south wall, the attentive observer will, however, also find a portrait of the master builder Benedikt Ried and on the north and the west walls two views of Prague Castle in its new form designed by Ried. The large altar painting in the cathedral, showing the Glorification of the Virgin, was commissioned by the king from one of the most important German Renaissance painters of the time, Lucas Cranach the Elder. It was damaged in an act of Calvinist iconoclasm, which took place in the cathedral in late 1619; one of its preserved fragments is today exhibited in the Prague Castle Gallery.

Vladislav's son, Louis, was crowned King of Bohemia in 1509. He cried when the large and heavy crown was put on his head; he was only three and half years old. When, in 1522, at the age of the sixteen, he arrived in Prague with his wife, Mary of Austria, the lintel of the door to the chambers in which he lived was already decorated in his honour with the letter L (hence, the name of this part of the Castle, the Louis Wing). This new part of the palace, which was meant to provide sufficient space and comfort for the apartments of the royal couple, ultimately turned out to be too small, because the regular sojourns of the monarch in Prague required accommodating not only him and his wife but also their retinue. A new building site was sought on a hitherto vacant area of the Castle precinct. The most suitable seemed to be the western edge of the southern slope at the end of the road from the Lesser Town to the Castle, a place easily accessible from the Castle side as well. The existence of the new building, which had long remained hidden in the later remodellings and was undoubtedly erected at the impetus of Vladislav II, has been confirmed by recent construction work at the western part of the New Palace. A fragment of a Late Gothic window, probably from the masonic lodge of Hans Spiess, had been discovered earlier. The discovery of part of the south façade decorated with Renaissance sgraffito and pierced by rectangular windows is evidence of where the 'Queen's Palace' once stood. Evidence of this palace and its use during the sojourns of royal couples, particularly Ferdinand I and his wife, Anne of Bohemia and Hungary, is provided by many archive documents from the period. The appearance of the palace is preserved in a coloured drawing from what is known as the Würzburg Sketchbook (or Album): a *veduta* (cityscape) of Prague from 1536–38.

The new, Renaissance style was adopted cautiously and rarely in the towns of Prague. 'Modern' Renaissance façades were given to the most important municipal buildings. The town hall of the Old Town was decorated on the south wall by a monumental tripartite window inspired by court architecture. The Old Royal Palace had portals designed by Benedikt Ried. The original appearance of the Renaissance changes made to the Town Hall of the New Town can today no longer be fully appreciated because of the remodelling of the building carried out in 1905. Only rich burghers in the sixteenth century could afford grand remodelling of their originally Gothic houses. A preserved example, similar to the portals of the Old Royal Palace, is the monumentally designed jambs of the portal of the Stone Lamb (U Kamenného beránka, no. 551) on Old Town Square.

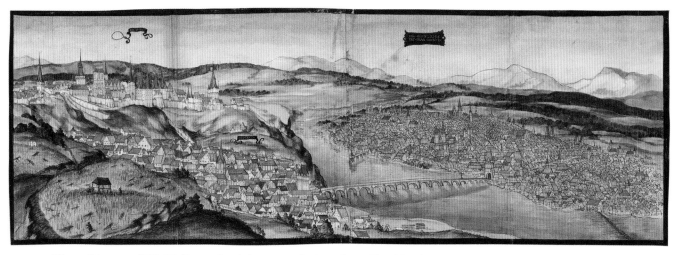

View of Prague, 1536–38 (from what is known as the Würzburg Sketchbook or Würzburg Album)

In the reign of the Jagiellons a great deal of construction work was undertaken, and it transformed the skyline of Prague, particularly the Castle. This is recorded in the monumental drawing, a *veduta*, which Otto Henry, the Elector Palatine (1556–59), brought back from his travels in central Europe. In addition to the newly built Vladislav Hall in the Old Royal Palace, the drawing shows the new building on the west salient of the south side of the Castle, which is labelled the Queen's Palace.

The existence of the Queen's Palace has been confirmed also by the recent renovation work in this part of the New Palace. Many decades before this, a fragment of a window was discovered. Its mason's marks suggest that the masons who worked here were probably members of the lodge of Hans Spiess. The south wall, covered with sgraffito decoration, became an inner wall during the remodelling of the palace in the reign of Maria Theresa in the eighteenth century, when a new wall was built in front of the original façade of the New Palace, several metres closer to the town. This is the wall we see today.

Emperor Ferdinand I successfully carried on the building activity of his father-in-law. In the period when this *veduta* was made, he was continuing the expansion of the Castle northwards towards the Deer Park Moat and the vineyards on its far side.

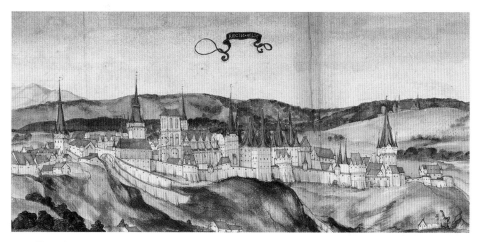

Detail of the Queen's Palace

In this drawing of the Prague panorama from 1536–38 one can clearly see a building that importantly enriched the apartments of the royal seat at Prague Castle. The work was carried out in the reign of Vladislav II Jagiellon, when the Gothic royal palace was being remodelled in the new style. Considering the richly built-up part of the Castle precinct, the most accessible area was partly vacant and partly covered with smallish houses on the promontory to the west. It was most likely chosen not only for its accessibility from what is today Hradčanské náměstí (Hradčany Square), but also with the prospect of expanding the Castle beyond the Deer Park Moat (Jelení příkop). The remains of this building are today hidden in the inner walls of the wings of the New Palace, which were built by Nikolaus Pacassi in the eighteenth century.

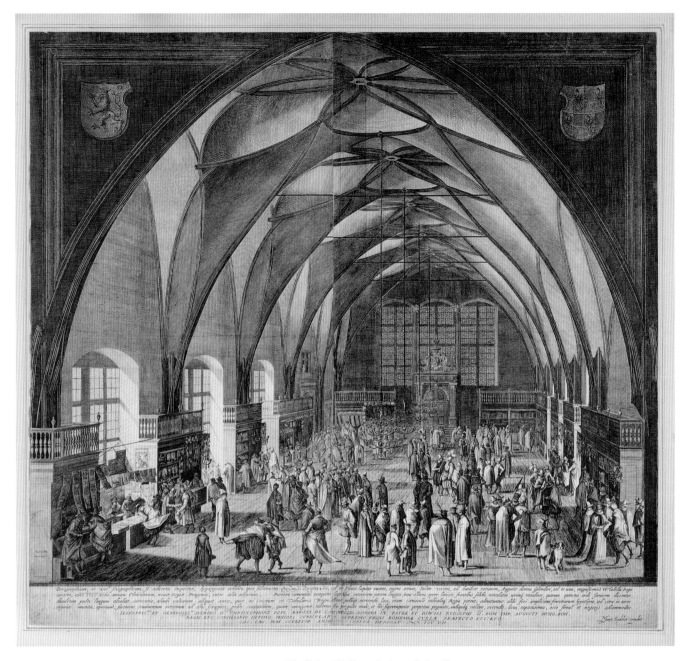

AEGIDIUS SADELER: **Vladislav Hall** – whole and detail

The hall was primarily intended as a place for the estates to pay tribute to the monarch and to hold court ceremonies. The equestrian stairs from the second courtyard enabled knights to enter directly on horseback for tournaments. A large feast was held here probably only to mark the coronation of Ferdinand I as King of Bohemia in 1527. In 1543 stallholders were ordered to clear out of the hall, which had previously been freely accessible to the public. The same order was issued again in 1561, when the hall in which the diet held its sessions was still being reconstructed. But not even the order of Emperor Maximilian II in 1565, stipulating that the stalls could remain only in the adjacent rooms and on the stairs, was observed. And so, in the following decade, the stallholders continued to occupy the hall, giving their stalls a respectable uniform appearance, and creating a kind of 'luxury market', freely accessible to visitors from the town. This appearance has been captured by Aegidius Sadeler in his copper engraving of 1606.

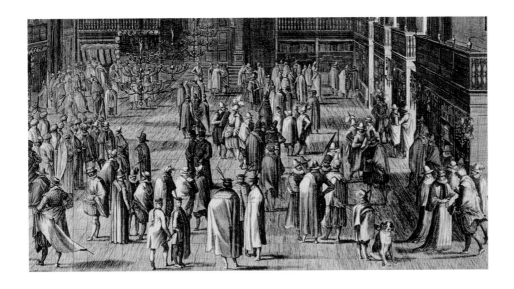

In 1506 Vladislav II and Emperor Maximilian I signed an agreement on the basis of which Vladislav's daughter Anne was to be given in marriage to one of Maximilian's grandchildren, Ferdinand, the son of Philip I of Castile, called the Fair, and Johanna, called the Mad. In 1521, therefore, Ferdinand married Anne. The untimely death of her brother, the young king Louis, at the Battle of Mohács in 1526, opened the way for a new dynasty, the Habsburgs. The Bohemian and the Hungarian thrones were then assumed by Ferdinand that year.

Though their wedding was the result of a diplomatic agreement, Ferdinand and Anne actually did love each other. Their exemplary marriage resulted in fifteen children, of whom thirteen survived. Their parents looked after them adoringly and ensured that they were given good educations. Even before marrying, Archduke Ferdinand ruled several Austrian lands. His Spanish upbringing ensured that he would oppose the Reformation, and that is why he was not welcomed in Austria and why he was anxiously received in the Bohemian Lands. He was crowned King of Bohemia on 24 March 1527, and though he promised the Estates of Bohemia that he would remain at Prague Castle if possible, that was not to be. Nevertheless, he devoted extraordinary attention to making Prague Castle grand, and he kept a very close eye on how work was proceeding, not only from Vienna but also during his frequent visits to Prague. With a profound knowledge of architecture, this learned monarch was able to comment competently on the works as they progressed. In 1527 he ordered that the houses purchased during the reign of Louis Jagiellon, right beside the queen's bedchambers, be finally paid for. In the following decades, then, this part of the Castle became the site of intensive remodelling, following on from what was known as the Queen's Palace, which had already been erected here in the reign of Vladislav.

The densely built-up precinct of the Castle, whose total area had not changed in size since the tenth century, still lacked something that was required at all grand European royal and aristocratic seats in this period – a garden. Ferdinand had known splendid gardens from his youth at the royal seats in Spain and the Netherlands. If Prague Castle was to become his royal seat, it would have to have gardens. A suitable place seemed to be beyond the Deer Park Moat, where the neglected vineyards of the Chapter of St Vitus' Cathedral and St George's Convent

of the Benedictine nuns lay. This area was highly suitable simply because of its southern exposure, protected from strong winds by the huge castle buildings. In order to make the garden accessible directly from the Castle, a bridge had to be built over the deep Deer Park Moat. When, in 1534, Ferdinand I sent the castellan a contract concluded with Italian master builders and masons to make the Royal Garden, he also demanded a report on the progress of erecting the piers of the bridge, which was already under construction.

It was also necessary to make everything ready for the construction of a wooden access gallery, below the queen's bedchambers, which further on was to lead above the stables below the ramparts all the way to the bridge, and to link up, once completed, with the entrance to the Royal Garden.

In November of the year, Benedikt Ried died. The Castle therefore needed a new master builder. Ried's foreman, Bonifaz Wohlmut, applied for the job, and Ferdinand was willing to give him a chance. The Bohemian court council, however, did not consent, and proposed instead that the builders who were already working at the Castle continue there. The king, in April 1535, therefore sent to Prague the Italian master builder Giovanni Spazio and his assistants, with whom he had concluded a contract from the year before. The castellan was to see to the completion of the bridge by the next year, so that Ferdinand, when he again visited Prague, could ride across it and check on how work on the garden was proceeding.

Ferdinand I continued the expansion and building of his Prague seat with remarkable speed. But there was one limiting factor that prolonged the execution of his ambitious plans: money. The difficulties that stemmed from this hindered all the construction work at Prague Castle even in subsequent decades. Moreover, the great fire at the Castle, Hradčany, and the Lesser Town, in June 1541, destroyed much of what had been so laboriously built, including the wooden road on the piers of the Powder Bridge (Prašný most) linking the royal seat with the Royal Garden, which was under construction. Contemporary reports provide a gloomy picture of the fire and its aftermath. It seems, however, that the Castle buildings were not in fact as badly damaged as is described. Already on 12 November 1541, the monarch announced that he had no intention of calling a session of the Bohemian Diet in Kutná Hora (Kuttenberg) on 4 December, as had been proposed, but insisted that it be held in the usual place, Prague Castle. He gave precise instructions about what needed to be done to ensure that it would indeed take place. He would stay in the Old Royal Palace in a room he had once stayed in, above the Green Chamber. The latter could serve as a throne room. The rooms he thus made available in the new building, the Queen's Palace, could be used also to accommodate his councillors, so that he would have them as close to hand as possible. It would, he noted, be necessary to carry out only the most pressing repairs to the floors, and to hang something in the manner of tapestries on the walls, so that it would not be necessary to paint everywhere. This quick and cheap repair work to prepare the palace for a short-term sojourn of the royal or the imperial court at Prague Castle would also be the typical approach in the future. And, moreover, no truly important event could take place here in future without providing accommodations to guests both at the palaces of noblemen at Prague Castle and in the houses of inhabitants of the Lesser Town and Hradčany.

The Royal Garden and the Summer Palace in the seventeenth century

An illustration in *Historia coelestis* (1666) by Lucius Barrettus (pseud. of Albert Curtz) shows the Royal Garden with the Summer Palace and the Singing Fountain, the Fig House, the Orangery, the tennis courts and the Lion's Yard. In its day, the illustration served as a reminder that the Royal Summer Palace was a place suitable for astronomers to make their observations (and it was indeed used by them). The upper storey of the summer palace was given suitable decoration already in the reign of Emperor Ferdinand I – the court astronomer was supposed to design a starry firmament for its vaulted ceiling.

The tempo of the rebuilding of Prague Castle into a modern Renaissance seat was, then, not slowed even by the great fire. The establishment of a large garden was amongst the priorities. As early as in the summer of 1538, grape vine, peach, cherry (so popular at the time), apricot (grafted on to plum trees), almond, and fig trees were planted. There were also orange and lemon trees. In January 1541, the brothers Nicholas and Claudeius Reinhart came from Lorraine at the invitation of Ferdinand I, in order to create an ornamental garden here. They ordered rare young plants from France, and the assortment was enriched by seeds and plants ordered from all across Europe and the Orient. In 1554 the Italian botanist and physician Pietro Andrea Mattioli arrived in Prague to be the personal physician to Ferdinand I and Ferdinand II, Archduke of Austria. He compiled his own herbal, which, though written in Latin, was published earlier in Czech (as the *Herbář anebo Bylinář*). The translation was by the renowned botanist, astronomer, and physician to three emperors, Tadeáš Hájek z Hájku, who lived on Betlémské náměstí in the Old Town.

Herbarz:ginak

Bylinář/welmi vžitečný/ a Figůrami pie-
knymi y zřetedlnymi/podlé praweho a ya-
ko žiwého zrostu Bylin/ozdobeny/ y také mnohymi a zkussenymi
Lékarzstwými rozhognieny/ gessto takowy nikdá w žiadnem
Nazyku prwé wydán nebyl: od Doktora Petra Ondře-
ge Matthiola Senenského/Nayjasniegssiho Arcy-
knjžete Ferdynanda 2c/přednjho žiwotnjho Lékaře/nayprw w La-
tinské Ržeči sepsaný/a giž pro Obecné dobré Obywateluow
Královstwij Cžeského / na Cžeskau Ržeč/od Do-
ktora Thadeásse Hágka z Hágku/přelo-
ženy/a wůbec wssechněm
wydaný.

Bibliothece *Ara hovi nae*

*

Při koncy přidáno kratke naučenij a
zpráwa/o rozličném Diftyllowánij a pálenij Wod/
s několika Pýckami k takowému pálenij náležitými / kteréž
netoliko Apatekářuom / ale y giným kteřijž se
w tom kochagij/dobře se treffiti
budau mocy.

🐦

Gest také trogij Index: Geden podlé gmén Latinských/
Druhý podlé Cžeských / a třetij obzwlásstnij / podlé Nemocý
a neduhuow sebrany.

Wytisstieno w Starém Miestie Pražském b Giržij-
ka Melantrycha z Awentynu.

Létha Pánie/

M. D. LXII.

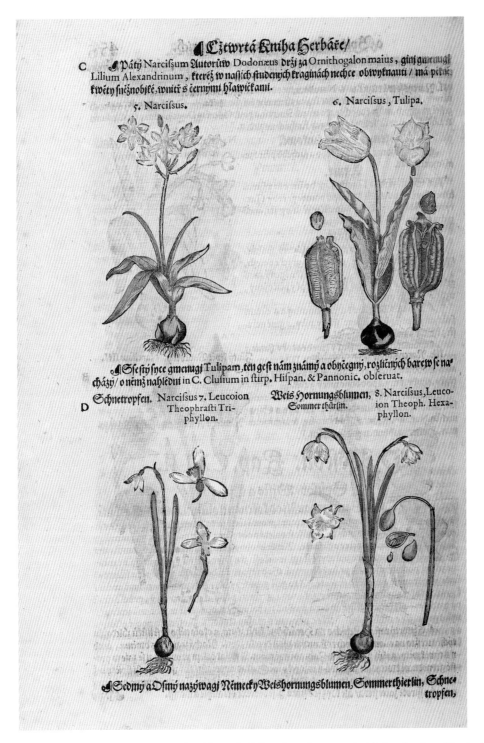

A Herbal; or, a highly useful book of botanical drawings decorated with lovely, clear illustrations of real plants that seem to be growing [...] by Dr Pietro Andrea Mattioli [...]

In 1555, at the recommendation of Archduke Ferdinand II (the governor of the Bohemian Lands), Emperor Ferdinand I, his father, made the famous botanist Pietro Andrea Mattioli his personal physician. He had already been in the archduke's service for a year, and, thus remained in Prague for another eleven years. Mattioli's *Discorsi* (Commentaries) on Dioscorides' famous *De Materia Medica* (between AD 50 and 70), which forms the basis of the *Discorsi* (and became as well known as *De Materia*), was published in Italian in 1544, and then in Latin in 1554. Tadeáš Hájek z Hájku, entrusted with the Czech edition, made a selection of the original version, to which he added local plants. In between a French (1561) and a German edition (1563), the Czech edition was published, as *Herbář* (A herbal), in 1562 by Jiří Melantrich z Aventina. Rich in detailed illustration, it was made possible thanks to funding from the Bohemian Diet, Emperor Ferdinand I, and Bohemian nobles and burghers. The popularity of Mattioli's *Discorsi* is testified to by the numerous translations, including another Czech edition, with a richly decorated title page, from 1596. It was actually the German edition of Mattioli's herbal, by Joachim Camerario the Younger, which was translated into Czech by Adam Huber with the assistance of Daniel Adam z Veleslavína.

In 1538 work on a Lusthaus, or summer palace, began in the Royal Garden. It is undoubtedly one of the loveliest Renaissance buildings in central Europe. Its execution was entrusted to Italian builders: a model was made by Paolo della Stella, who was then in charge of all the construction work until the end of his life in 1552. Italian masons created the bas-reliefs in advance, which were not put in place until the summer palace was given an additional storey and a distinctive roof in the shape of a ship's hull. By that time, Stella's successor, the builder Bonifaz Wohlmut, was in charge of the construction work; he did not finish it until 1563. The summer palace was primarily intended for court entertainment: Archduke Ferdinand II recommended to his father not to use marble for the floor of the upper storey since it would be dangerously slippery during dances. The monumental building, clearly visible from the town and attracting visitors' attention to its extraordinary architecture, was also a dignified way for the new emperor to make his presence felt. In 1556 the title of Emperor went to the central European branch of the Habsburgs. Two years later, in Frankfurt am Main, Ferdinand I was crowned Holy Roman Emperor.

Written communication between Emperor Ferdinand I, his Master of the Royal Household (Bohemian Hofkammer), and his senior officials provides interesting testimony to the building works at Prague Castle and the operation of the royal court. From 1547 onwards, another extremely interesting source of information appears: correspondence between Ferdinand I and his son, Archduke Ferdinand II. The year 1547 was full of dramatic events. In January, Ferdinand's beloved wife, Anne of Bohemia and Hungary, died in childbirth. At the battle of Mühlberg, on 24 April, Emperor Charles V, with the support of his allies, was victorious over the Protestant forces of the Schmalkaldic League. He also received help from reinforcements sent by his brother, King Ferdinand I. In the previous two years, he had faced a similar revolt in the Bohemian Lands, when the Calixtines, who were particularly strong both in Prague and in rural towns, demanded their rights with increasing vehemence. The king rejected their terms and conditions, which they had formulated in many articles on questions of religion and the administration of the Bohemian Lands. After their defeat at Mühlberg, members of the rebelling Bohemian Estates entered into talks with the monarch, though without success. Ferdinand I strikingly curtailed the power and rights of the royal boroughs, and at Prague Castle he established an appellate court, to which the free courts of the towns were subordinated. To deter the defiant Estates, two rebel burghers and two members of the gentry were put to death in 1547.

Because of the king's frequent absences and also because of his greater powers, his second-born son, Ferdinand II, Archduke of Austria, was made governor of the Bohemian Lands in 1547. As early as in 1543, Ferdinand II sojourned in Prague, to keep his mother, Anne Jagiellon, company. Sharing his love of architecture and art in general, Ferdinand II enjoyed his father's favour to a high degree. And he felt at home in Prague. He was provided with an abundant allowance for his new office, and he did everything he could to ensure that he represented his father in a dignified manner. His twenty years in Prague were, from the social and cultural standpoint, a real blessing for the Bohemian Lands.

VÁCLAV HÁJEK Z LIBOČAN: *Kronika česká* (**Bohemian Chronicle**), published by Jan Severin in 1541.

Despite a life of hardship, caused by conflicts with the nobility, which resulted in his being transferred from parish to parish, this Catholic priest, who lacked a true education as a historian, compiled a remarkable work. His *Kronika česká* relates the history of the country from the arrival of the Czechs (according to him, in 644) to the present, that is, to 1526. Hájek assiduously gathered together a great number of sources, which he was actually unable to judge critically. Consequently, his chronicle contains a lot of information, mainly about the earliest history of the country, which does not correspond to reality. Nevertheless, it is a gripping narrative, which later well-known chroniclers turned to as a source, for example, Paprocký and Beckovský. It is also interesting that foreigners visiting Prague must have encountered Hájek's account in one form or another. In their travel writings, they noted the remarkable history of early Bohemia, concerning, for example, the life of Princess Libuše (Libussa). Another work of Václav Hájek's, which describes the great fire of the Lesser Town and Hradčany in 1541, also contains certain invention. Here, the author, as he admits, records his personal experience, which, in the parts relating to Prague Castle, does not quite correspond to the facts.

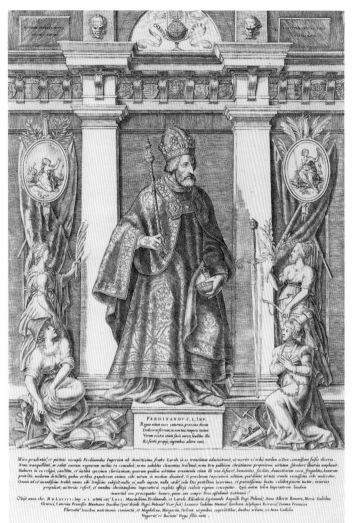

Portrait of Emperor Ferdinand I
Engraved by Gaspare Uccello, after a drawing
by Francesco Terzio.

As the official court painter, Francesco Terzio had
plenty of opportunity to have Habsburgs sit for their
portraits. A number of these paintings are still mainly
in public collections in Austria, for example, in Vienna
and at Ambras. Terzio's drawings gave the large
genealogical series of prints a unified form. Portraits
of Habsburgs in the *Avstriacæ gentis imaginvm* were
intended to emphasize the importance, venerable age,
and historical continuity of the House of Habsburg
through several centuries.

Archduke Ferdinand II was eighteen years old when he assumed power in Bo-
hemia. Thanks to his superb education, his range of interests was exceptionally
broad. From his father, he inherited such a profound interest in architecture that in
this field he even made his mark as a well-informed amateur. His correspondence
with his father, Ferdinand I, provides evidence that together they discussed the
building works that were under way at Prague Castle, right down to the last detail,
including the shapes and sizes of the drain pipes at the Royal Summer Palace.
He also advised the Emperor in buildings that were designed and being built by
Bonifaz Wohlmut: the organ loft in St Vitus' Cathedral and the vault of the Diet
in the Old Royal Palace, in which, probably on purpose – considering the great
age of these spaces and their significance for Bohemian statehood –, gothicizing
forms are used together with the new forms of the Renaissance.

That's why the scrivner's gallery in the Old Diet, with its pure Palladian Renais-
sance forms, looks like a building from another world, which has been transferred
to a space inspired by the vaulted ceiling of the Vladislav Hall.

Ferdinand II's advice to his father was particularly useful in the decoration
of the façade of the building containing the New Land Rolls, the registers of the
hereditary estates of the Bohemian Lands. The series of monarchs' portraits, which

Portrait of Archduke Ferdinand II
Engraved by Gaspare Uccello, after a drawing
by Francesco Terzio.

As governor, Ferdinand II, Archduke of Austria, car-
ried out important political tasks during his twenty
years in power, not only in Bohemia, but also in other
lands of the Empire. In Bohemia, however, he was
also the driving force behind court festivities, hunts,
and other entertainments. It was at that time that he
began as a collector, but he was also intensely inter-
ested in architecture.

In the park known as the New Game Reserve
(Nová obora) he had the Star Hunting Lodge
(Hvězda) built for his pleasure. It was erected in
keeping with his ideas about a building of this type.
Together with his father, who also loved architecture,
he would discuss all the building works at Prague
Castle and in the crown domains. Archduke Ferdi-
nand II took Francesco Terzio into his services, and
thus enabled him to obtain an extraordinary com-
mission – a genealogy of the House of Habsburg.
Incorporating the figure of the archduke into such a
rich framework provided, among other things, space
for recalling his pastimes: not only organizing spec-
tacular tournaments and combats, but also actively
participating in them, and his passion for hunting,
which he pursued both in his domains and in those of
important noble families.

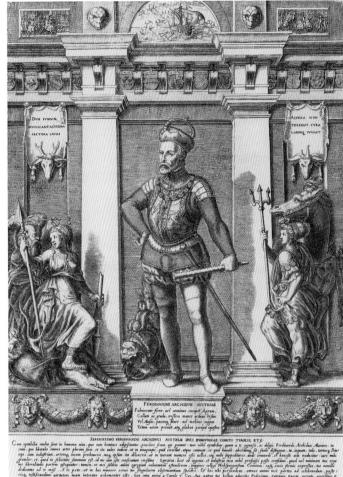

was intended to substitute for the vanished paintings in the Old Royal Palace, and
was originally planned for the Vladislav Hall, began on the façade of that building.
The portraits were made by an Italian painter, probably Domenico Pozzo, directly
on dry plaster. The archduke stopped the work not only because of the cost of the
paints used, but also, indeed mainly, because, in his opinion, the paintings would
be immediately damaged by the first big rain. Fragments of the paintings have
fortunately been preserved because a new wing was built in front of them a few
years later. They were discovered in the twentieth century during renovations of
the room of the Land Rolls, and they bear witness to the great skill of the painter,
who had been summoned to the imperial court from Milan and was employed
more often at the court of Archduke Ferdinand II at Ambras Castle in Innsbruck
than at Prague Castle.

The ruler's court always employed good painters to make, among other things,
formal portraits of the royal family for its gallery of members of the ruling house and
as presents for other high-born families. The Austrian Jakob Seisenegger entered
the service of Ferdinand I in 1531, and first met his employer in Prague. For a centu-
ry his static, unchanging compositional scheme became something like a model for
portraits of the nobility throughout central Europe, including those of Bohemia.

(27)

In 1554, the painter Francesco Terzio, a native of Bergamo, who had been in the service of Archduke Ferdinand II three years before, came to Prague. His largest work at Prague Castle was the painted decoration of the new organ in St Vitus' Cathedral, but that has unfortunately not been preserved. Another work is probably the design for the decoration of the Chapel of St Sigismund in the cathedral, which was presented to the emperor by the builder Hans Tyrol in 1559. Many portraits of members of the royal family and of the Bohemian nobility can reasonably be ascribed to Terzio. He made drawings for paintings for the portrait gallery of the Habsburgs, which were engraved by Gaspare Uccello (also known as Osello and de Avibus). They were printed from 1558 to 1571.

Terzio also came up with a design for the Singing Fountain in the Royal Garden. It was then modelled by the sculptor Antonio Brocco and its wooden mould was made by the carver Hans Peysser. It was cast in bronze by Tomáš Jaroš, a gunsmith and metal founder at the imperial court. This extraordinary work, the result of a joint effort from 1562 to 1568, adorns the Royal Garden at Prague Castle to this day. Before 1570, Terzio retired from court service, to spend more time painting. Though he was engaged mostly at the court in Vienna, he also found employment elsewhere, including the Spanish Court, his native Bergamo, Milan, Venice, and, lastly, Rome, where he died in 1591.

The close relationship between Ferdinand I and his son came under strain when, in 1557, Archduke Ferdinand II secretly married Philippine Welser, the daughter of a rich Augsburg banker and merchant. The marriage with a low-born girl had to be kept a secret, so Philippine spent most of her life in Bohemia at Křivoklát Castle (about 60 km due west of Prague), which became her residence. And that is where Ferdinand II began to build his collections. His vast collection of armour once belonging to important men of Europe and elsewhere became his pride and joy. He later called it his 'ehrliche Gesellschaft', honourable society. When, twenty years later, he moved from Prague to his new Tyrolean residence at Ambras, he took with him, among other things, his armour collection, which alone weighed 347 *Zentner* (more than 21 metric tons). Another area of his collecting passion comprised portraits of renowned and interesting figures of the past and present. He amassed about a thousand of them, mostly small in size. This collection inspired members of the Bohemian nobility who, emulating him, began to decorate their great houses with similar sets of works. When the French ambassador, for example, was visiting the home of the president of the Aulic Council (Reichshofrat), Paul Sixtus von Trautson, on Hradčanské náměstí, it was said that the walls in the room where the ladies were dining were hung with about 400 portraits of the most important people of all time.

It was thanks to Archduke Ferdinand II that the New Palace was expanded on the western promontory of the southern part of the Castle. Known as the Ferdinand Building, it has three gables, making it clearly indentifiable in the *veduta* of Prague from 1562. And it was the comfortable home of the new governor here. In addition to discharging his official duties, he still had time for a rich social life. He often initiated social events himself on a variety of occasions with the participation of entertainers and artists. Here too he inspired the Bohemian noblemen, who willingly followed his example. This 'maximus comoediarum amator', greatest lover of

plays, was invited to the courts of prominent nobles in order to participate in a wide variety of entertainments, including hunting for game, but also tournaments and other pastimes that followed. It was he who set the tone for such entertainments. Indeed, he participated with such verve that he even suffered serious injuries.

When Ferdinand I arrived in Prague in 1558 for the first time since his coronation in Frankfurt as Holy Roman Emperor, Prague welcomed him with great pomp, including a pageant in which about five hundred people participated. Dressed up as Hussites, they put on a show for the emperor of an attack by the forces of the Czech general Jan Žižka. School boys of Prague, dressed as the Muses, welcomed him with song, and Jesuits, the first of whom had arrived in Prague only two years before, erected a triumphal arch on Charles Bridge. Fisherman on the River Vltava together with the people from the nearby riverside community of Podskalí simulated the taking of a moated castle. The next day, the festivities moved to the garden of Prague Castle, where a grand spectacle was organized. The guests, seated in golden armchairs, watched as Jupiter, enthroned on massive stage scenery depicting the cliffs of Vesuvius, shot bolts of lightning at giants, who carried huge rocks and sought to dethrone the supreme ruler of Olympus. The scene was full of wondrous stage effects, including devils, from whose eyes, ears, and noses flames shot, and who suddenly changed into monkeys that leapt about. This was followed by a procession of costumed figures, as well as other entertainments – creating in all an unforgettable experience.

From reports sent by ambassadors of foreign lands accredited to the imperial court we know of many of the entertainments that were held here. In one report, sent to the Duke of Mantua, we read about a tournament that Archduke Ferdinand II held in 1562, where, together with forty men, he fought against his brother, who had the same number of men on his side. After this splendid show, the emperor ordered a magnificent banquet that ended with a procession and merrymaking with the lovely ladies of Prague.

A few months after that, on 20 September, Maximilian II's coronation as King of Bohemia took place in Prague, followed a day later by the coronation of Mary as his queen. Simply their arrival in Prague was for the people of the city a great event. Maximilian was accompanied by his two sons – the princes Rudolph and Ernest –, and, according to a young contemporary chronicler, Marek Bydžovský, Maximilian was 'ceremoniously welcomed by all three Estates, who had been summoned to the Diet by Emperor Ferdinand, and was especially welcomed by the people of Prague. He arrived with 500 mounted Hungarian, who were gloriously and handsomely equipped, and had with them six camels, and pitched their tents in the fields between the summer game reserve and the schloss'. The vast retinue required extraordinary organization. Since the number of guests far exceeded the capacity of the royal palace to accommodate them, the emperor's family and special guests had to be lodged in the great houses of the Rožmberks, Pernštejns, and Švamberks at Prague Castle. The subsequent festivities in the town had to be cancelled because of the threat of plague.

Archduke Ferdinand's love of architecture, perhaps also his desire to build a royal seat of his own design, resulted in one of the most remarkable works of Renaissance architecture in the Bohemian Lands, the summer palace (or hunting

A fragment of terracota decoration from the façade of the former Pernštejn House, now Lobkowicz House, at Prague Castle

On land bought in 1554 from Wolf Krajíř z Krajku, Jaroslav z Pernštejna began building an extraordinarily impressive palazzo of four wings. Its façades were lavishly decorated in figurative and ornamental terracotta reliefs, something unique at Prague Castle. The house was probably finished by 1562, when it was offered to the royal family as accommodations during the coronation of Maximilian II as King of Bohemia. Severely in debt, Jaroslav fled to Italy, and his Prague house became the property of his brother, Vratislav II, who then owned it from 1560 to 1577. Vratislav II z Pernštejna, who was Lord Chancellor of the Kingdom of Bohemia, decided to expand and modernize the just-finished building. This resulted in the removal of its terracotta decoration, part of which was then recycled as building material. After remodelling the house in the nineteenth and twentieth centuries some of the discovered pieces were removed and exhibited.

With the marriage of Polyxena z Pernštejna and Rožmberku to Zdeněk Popel z Lobkowicz, the house became Lobkowicz property, and today bears their name.

lodge) in the royal game reserve, which at that time was still outside the city gates. Work on the building, on the plan of a hexagram, started in 1555. Since the building was not limited by any older structures, work progressed quickly, and it was soon called the Star (Schloß Stern, in German, letohrádek Hvězda in Czech). It was built by the master builders Giovanni Maria Aostalli and Giovanni Lucchese, based on the design of the archduke, under the supervision of Bonifaz Wohlmut. A year and half later, when the schloss was roughly built, plasterers covered the walls of the lowest storey with bas-relief sculptures of exceptionally high quality, comparable with the decoration of the great Italian palazzi and villas of the time. According to a recent comprehensive work about the Star hunting lodge, the bas-reliefs were designed and executed by Antonio Brocco, a native of Campione, who, with his colleagues, had come to Prague from Dresden. After finishing work at Hvězda, and also at Nelahozeves (north of Prague) and Telč (in south Bohemia), Brocco followed his employer, Archduke Ferdinand II, to Innsbruck and Ambras.

With its unusual plan and internal layout, the Star hunting lodge was at that time an exceptional work of architecture by any standards. In the game reserve, with walls and avenues, of which the middle one, the longest, led directly to it, the schloss was the jewel of the whole sophisticatedly composed complex. The grounds included a kitchen, an aviary, the house of the gamekeeper, and, on the hilly terrain, a Ballhaus, that is, a court for real tennis. The superbly equipped area had no residential function, serving instead only to represent the court and to provide a place for amusement. High-born visitors, local and foreign, were invited to hunt in the park richly stocked with game (including a large herd of European bison), and when the hunt was over, the guests partook of a lavish banquet and enjoyed entertainments including dancing. The top storey of the lodge had a hall for social events, and its floor still contains some of the original coloured glazed tiles.

Ferdinand I and his son's building activity and patronage of the arts were well received amongst the nobles and burghers of Bohemia. Thanks to the inspiration of these two great builders, the appearance of other works of architecture at Prague Castle began to change. After the fire of 1541, the house of the lord burgrave was remodelled in the Renaissance style: the façade of the two-storey building with a tower is decorated with sgraffito in the geometric pattern reminiscent of the back of an envelope, so popular in the Bohemian Lands. Across the street, in the early 1550s, two opulent houses were erected. Nearer to the east entrance to the Castle stood the Pernštejn house, whose façade was decorated in the 1550s with figurative and ornamental terracotta relief sculpture. This decoration, exceptionally beautiful in the precinct of Prague Castle, was removed during remodelling in the 1560s, and regrettably few fragments have been preserved (now in the collections of Lobkowicz House, Prague Castle, and the National Museum). The same fate was also met by the neighbouring Rožmberk (Rosenberg) House, whose architecture and costly furnishings made it one of the most impressive houses at the Castle. Its builder was an aristocrat second only to the king in rank, Vilém z Rožmberka. In the first phase, the building with an arcaded courtyard and articulated gables was built. The gables remained a striking feature of the Hradčany silhouette as seen from the town well into the middle of the eighteenth century. During the coronation of Maximilian II as King of Bohemia, Rožmberk House provided lodgings for the

royal family and, because of the ease of access to it, a wooden corridor was built at the height of the first storey during the ceremony, enabling dry passage directly to the Vladislav Hall. In the mid-eighteenth century, Empress Maria Theresa ordered the complete remodelling of the large area into the Institute for Distressed Noblewomen (Ústav šlechtičen, Theresianische Adelige Damenstift), an endowment for girls and unmarried ladies. Although at least the original large ground-floor hall and several adjacent rooms could be restored during recent renovations, they hardly evoke the grandeur of this once splendid residence, which, with its costly furnishings, in many respects surpassed even the royal palace.

The continuous presence of the king's representative, Archduke Ferdinand II, and the duty to participate in the annual sessions of the Bohemian Diet, led members of important noble families to build similarly grand houses in Prague. Because there was no longer space at the precinct of Prague Castle, the sites nearest the royal seat were on Hradčanské náměstí. That is where, perhaps already by the second half of the 1540s, Jan z Lobkowicz the Younger began to build his urban residence. With a large hall and rooms decorated with painted ceilings, the house was not finished until 1567. Today, with its splendid view of the town and its distinctive place in the silhouette of Hradčany, the house is now known by the name of its last owners, the Schwarzenbergs. Since its recent comprehensive reconstruction, it has been open to the public who wish to see the collections of Bohemian Renaissance and Baroque art, exhibited here by the National Gallery in Prague. The Lord Chancellor of the Kingdom of Bohemia, Jáchym z Hradce, also needed to live near the Castle. In the early 1560s, he began to remodel the house that he had bought on the left side of the steep road leading from the Lesser Town up to the Castle. He invited to Prague Antonio Ericer, his favourite master builder, whose skills had been tried and proved at the family seat in Jindřichův Hradec (Neuhaus), south Bohemia. The house of the Lords of Hradec, furnished with all the comforts, including stables, kitchens, and cellars, had on the south side, where Nerudova ulice runs today, a hanging garden and, at its highest point, a pavilion with a magnificent view of the town. Construction work continued in the following two decades under Jáchym's son Adam II, supervised by a master builder at the emperor's court, Ulrico Aostalli. Today, all that remains of this building is its Renaissance north façade facing the Zámecké schody (Castle Steps).

Whereas the inhabitants of the Lesser Town tended to be people who needed to be close to the royal court – noblemen, court officials, artists, artisans, and of course also merchants –, the Old and the New Town had a much more varied population. As is suggested by the street names that exist to this day, people of individual occupations tended, already from the Middle Ages onwards, to concentrate in certain places: in Celetná street, for example, they were the producers of *calta* – baked goods like pretzels and pies, whereas in the street V Jirchářích, the inhabitants were people who made fine leather. In the sixteenth century, this custom was no longer so strictly observed. Some parts of town were chosen by rich burghers because of their suitable location and impressiveness, others were settled by artisans; the poor lived on the outskirts.

Old Town Square was the centre of the Old Town. Its town hall, the most important community building, has a splendid Renaissance window from the 1530s

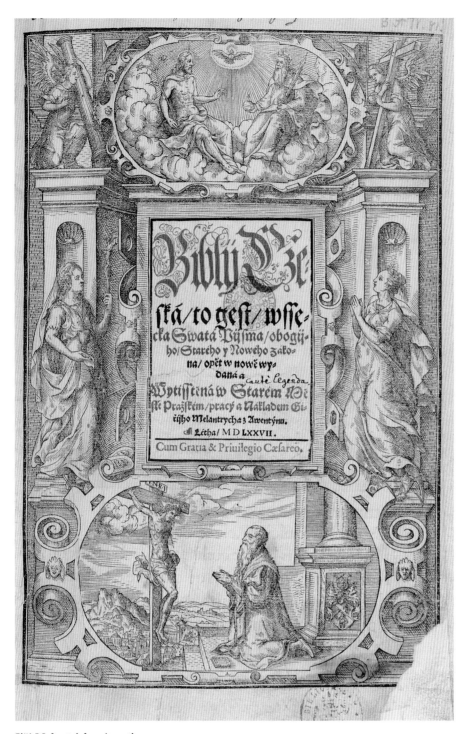

Jiří Melantrich z Aventina

At the printer Bartoloměj Netolický's, in the house U Flavínů on Lesser Town Square (no. 36), Melantrich was more than just an employee. He is already mentioned as a partner in Netolický's first edition of the Czech Bible (1549). In 1551 when he bought a house there, he became a citizen of the Old Town. A year later, he acquired Netolický's press and thus also the privilege of publishing other editions of the Bible. Such a demanding task could only be carried on with financial assistance from others, including the royal court, in particular, Archduke Ferdinand II. In 1556, Melantrich published the Bible for a second time, with a new title page and in many copies; he was subsequently raised to the nobility. He added more than two hundred excellent titles to the number of Czech books, including translations of Mattioli's *Discorsi* (published in Czech as *Herbář*), *Práva a zřízení zemská Království Českého* (The laws and constitution of the Kingdom of Bohemia), a translation of Johann Gessler's *Praestantiora, ac dudum modo experta contra pestem aliqua remedia, ex antiquissimis medicis* (as *Lékařství přednější a zkušenější proti morovému nakažení* [Ancient physicians' remedies against the plague], and a selection of sermons by Savonarola, *Sedmero krásné a potěšitelné kázání* (Seven lovely and uplifting sermons). In 1570 he prepared another edition of the Bible, whose title page bears an engraving of the only known portrait of Melantrich, as he kneels before the Cross. Its many illustrations are by Francesco Terzio, a court painter of Archduke Ferdinand II.

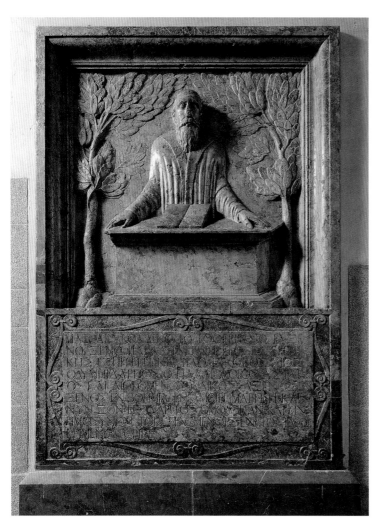

Matouš Collinus z Chotěřiny

A teacher and writer, he was born Kalina and was called, in Latin, Mattheus Collinus a Choterina. After studies in Prague, he left for Wittenberg, where he became a pupil of the outstanding local humanist Philipp Melanchton. When he returned to Prague, Collinus was made, in 1541, a professor of Greek and Latin at the university, and was a highly knowledgable interpreter of classical literature. Most of his literary works were never published, and have been preserved only in fragments. When, in 1548, Count Hardegg gave him a house, called the Angel's Garden, in today's Jindřišská ulice, he began to operate a private school there, which he devoted his time to above all, after he had to leave the university in 1560. In the group of poets gathered around Jan Hodějovský z Hodějova (Johann Hodiegowsky von Hodiegow) the Elder, a humanist and a deputy of the Lord Chief Justice of the Bohemian Kingdom, he was among the most talented.

The Greek inscription on the commemorative plaque translates as: 'This plaque has been erected for you, Collinus, by Jacob Palaeologus, known for having been in exile. May you, the guardian of a wandering foreigner in hard times, accept our eternal thanks for your friendship.'

on its south façade. The Thein Church College (Týnská škola) on the opposite side of the square was also given a new Renaissance façade. The area in and round the Thein (Týn), called the Ungelt, was for centuries a place where merchants used to stop to have the goods they brought to Prague cleared through customs. It had by this time, however, long ceased to serve only its original purpose. Beginning in 1548, the man in charge of the Ungelt was Jakub Granovský z Granova. Once he had paid off all his debts tied to the old Ungelt house, he requested Emperor Ferdinand I to make the property hereditary. Granovský remodelled the whole house in the form that it has essentially kept to this day. The façade on the courtyard side was pierced on the first storey by high arcades and was decorated with biblical and profane themes using chiaroscuro. The Granovský house is among the most important works of burgher architecture of Renaissance Prague. It may very well have been decorated by some court artists, including Francesco Terzio.

Unfortunately, many of the imposing Renaissance houses near and around the Old Town Square were considerably remodelled in later centuries. On the corner of Celetná and Železná streets, in house no. 553, lived Sixtus von Ottersdorf, a well-known humanist, politician, and spokesman of the Estates rebellion against Ferdinand I. The house bears his name to this day. Thanks to him, for example, the Bible was revised and in part newly translated. It was published by Jiří Melantrich

z Aventina, a printer and publisher, who for his work in spreading education was elevated to the nobility by Ferdinand I. Melantrich's house with the printing press used to be in Kožná ulice, but it was torn down in the late nineteenth century. Its imposing Renaissance appearance has been preserved only in old photographs. For his work in publishing Czech literature and translations, Melantrich earned himself a place amongst the most respected figures of sixteenth-century Bohemia.

In 1556, Jesuits settled in a former Dominican monastery in the Old Town of Prague, and immediately began pastoral work and repairs to the monastery, which had been badly damaged by the Hussites. They also began to build the large area called the Clementinum. The way it looked before the Baroque remodelling by the master builders Lurago and Orsi is recorded in a drawing from the archive of the Jesuit Curia in Rome. The changes carried out by Bonifaz Wohlmut in 1560–61 appear to be visible in the drawing.

Striking changes to the architecture of the Jewish quarter did not begin until after the fire of 1567. Among the earlier buildings, only the Pinkas Synagogue partly survived the conflagration. Its decoration dates back to 1535. With a ceiling vaulted with intersecting ribs, the space is still Late Gothic, but the ornately decorated portal and some of the decorative details of the architecture are already Renaissance. A record from 1541 mentions the Jewish town hall, which was not, however, completed until the 1570s.

Nor did the Church buildings of the town undergo any considerable remodelling or modernization. They too had to wait until the great building boom that began in the reign of Maximilian II and, mainly, after Rudolph II came to the throne as the new king of Bohemia and emperor.

* * *

In 1562, Maximilian II became King of Bohemia. The first-born son of Emperor Ferdinand I, he had from childhood been raised for his future duties as head of state. He spoke German, Latin, French, Italian, Spanish, even Hungarian and Czech. Amongst his teachers at Innsbruck was Wolfgang August Schiefer, who inspired his sympathy for Lutheranism. That was strongly manifested in his lukewarm attitude to the Catholic faith, and it led to tensions in his relations with his father and, later, his wife, Mary of Austria. His election as King of Bohemia awakened great hopes amongst the non-Catholic estates of Bohemia, but they were not fulfilled, for Maximilian II, perhaps because of the continuous tensions between the two sides of the religious conflict, did not like spending time in Bohemia.

He could, however, appreciate the Renaissance transformation of the royal residence in Bohemia, perhaps even be inspired by it, when he stayed in Prague in order to be crowned King of Bohemia on 20 September 1562. The Castle precinct, separated from the town by steep slopes and a deep moat, looking out over the city from high above it, creating an imposing backdrop, and emphasizing the distance between the royal seat and the common people of the town. This was in stark contrast with the castle at Vienna, which, surrounded by fortifications, was in the middle of the flat city. Archduke Ferdinand II, Maximilian's brother, who enjoyed considerable popularity amongst the people of Bohemia, still resided in Prague.

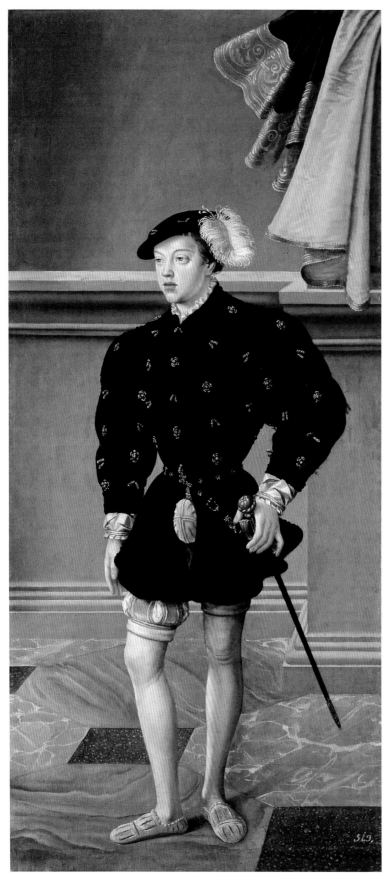

JAKOB SEISENEGGER: **Portrait of Maximilian II in his youth**

As the court portraitist of Emperor Ferdinand I, Jakob Seisenegger created something like the model for the official portrait, which for decades influenced portrait painting in central Europe. The scheme of each remains the same: the figure, turned slightly to the left or the right, stands on a marble floor, one hand on the hilt of his rapier, against a backdrop of gathered drapery. Maximilian's portrait was probably painted before 1544, when the future monarch was put into the care of his aunt, Mary of Austria (also known as Mary of Hungary), in the Netherlands. A youth of about fifteen, dressed in the Spanish style, he keeps his distance from the viewer by gazing into the distance. This is how this official portrait differs from that of his brother, Archduke Ferdinand II, made by the same painter at roughly the same time (now in Ambras Castle). His boyish face is livelier, not only in the composition but also in the freer way it has been painted. The portrait of the young Maximilian II is the only example of this type of work by the prolific Seisenegger which is preserved in the Prague Castle Gallery.

FRANCESCO TERZIO: **Emperor Maximilian II in armour**

With this portrait of Maximilian II, Francesco Terzio concluded his series of drawings for a genealogy of the Habsburgs, which was made as engravings by Gaspare Uccello from 1558 to 1571. This drawing demonstrates that Terzio designed several variations for each figure. Whereas in the engraving, the emperor is walking, as if leaving the picture, in the drawing he has struck a majestic pose, with his gaze on the viewer. This print may also have been a draft of a painting for the family gallery.

At his court in Vienna, Maximilian II surrounded himself with a group of outstanding scholars who, like him, were interested in the natural sciences. Though he rarely appeared in Bohemia, the members of his court often travelled there, appreciating the good conditions in which to continue their learning. Pietro Andrea Mattioli remained his personal physician, and Maximilian continued to support Mattioli's botanical studies. The Czech edition of Mattioli's *Materia medica* is therefore dedicated to him. Ogier Ghiselin de Busbecq had already been in the diplomatic service of Ferdinand I, and when, in 1562, he returned from Turkey, he enjoyed Maximilian's favour thanks to his botanical interests. From the Orient he brought hitherto unknown plant species – lilacs, tulips, and hyacinths –, which enriched not only the emperor's garden in Vienna, but also the Royal Garden in Prague. Maximilian also appreciated Busbecq's linguistic, archaeological, and antiquarian interests. For a while, he entrusted him with the education of the young prince Rudolph, who later, as emperor, remained in touch with him, in writing and also while 'working' on various projects.

AVGERIVS GISLENVS BVSBEQVIVS.

Ogier Ghiselin de Busbecq

The bastard son of a Flemish aristocrat, Ogier Ghiselin de Busbecq received a superb education at top European schools, which largely ensured him a splendid career at the imperial court. Emperor Ferdinand I sent him in 1556 as his ambassador to the court of the sultan, Suleiman the Magnificent, in Constantinople. He later related his sojourn in the Ottoman Empire in the *Itinera Constantinopolitanum et Amasianum* (republished as *Turcicae epistolae*, Turkish letters), which he published upon returning from his diplomatic mission. In this work, he shares his observations of Ottoman society, art, architecture, medicine, religion, social classes, local customs, languages, flora and fauna, and much more. Thanks to Busbecq, unusual varieties were planted in the imperial gardens, including the first tulips, hyacinths, and lilacs. Maximilian II made him the official escort of his sixteen-year-old daughter, Princess Elizabeth, on her journey to wed Charles IX in Paris, where Busbecq remained in the employ of the imperial court. He carried out a variety of diplomatic tasks for Rudolph II as well, also buying things for him like hermetic literature and clocks.

Among the people employed at Ferdinand I's court and then at the court of his son Maximillian II, who succeeded him as emperor, was Johann Crato von Krafftheim, one of the most important physicians of his day. Apart from looking after Maximilian's health, he also, as he wrote, became his adviser on matters of politics and religion. He did not leave Prague until 1581. One of the people who served longest at court was Jacopo Strada, who was first hired in 1558. Though he was trained as a goldsmith, it would have been hard to find anyone else so active in a such a wide range of fields: he was, among other things, an antiquarian, master builder, numismatist, historian, linguist, inventor, and creator of court festivities. He first arrived in Prague in 1565 to acquaint himself with the burial place chosen for Ferdinand I at St Vitus' Cathedral. (The funeral was organized by Ferdinand II.) At the same time, he was probably also meant to draft a concept for the future royal mausoleum there. Strada was, by the way, also a consultant on the design of Maximilian I's tombstone at Innsbruck, which was commissioned from the Netherlandish sculptor Alexander Collin. The stone for Ferdinand I's tomb at St Vitus' in Prague was also commissioned from Collin. Strada spent part of his life in Prague. He bought a house in the Old Town, which he and his son Ottavio used. Ottavio successfully succeeded his father in all the areas he had been active in.

Though Maximilian II preferred Vienna to Prague, he did not neglect Prague Castle. He took pains to ensure that the buildings begun by his father and brother were completed. In 1567, Bonifaz Wohlmut began to build a wing linking the two houses of Count Thurn, which had been purchased two years before. This meant the further expansion of the residential palace in the western part of the Castle. Beginning in 1548 three tennis courts were gradually built in the garden, which is evidence of the great liking for ball games at the imperial court. With time, some

of the tennis courts ceased to exist when the land they were on was put to other use. In 1567 Wohlmut began building the Great Tennis Court (Velká míčovna) at the edge of the Deer Park Moat (Jelení příkop). The fourth such building, it is the largest and remains standing to this day. The façade of this exceptional piece of architecture in the Palladian style is lavishly decorated in sgraffito, with allegories of the Elements, the Virtues, and the Liberal Arts. The Royal Garden could by this time already provide court society with a wide range of amusements: a hall for social events (including dancing) in the Royal Summer Palace, a real tennis court (*Ballhaus* or *míčovna*), a shooting range, an orangery, a menagerie and an aviary with rare birds, decorative gardens to stroll in, and a pergola providing shade.

In this period, Giuseppe Arcimboldo was in the service of the emperor. Though employed as the official portrait painter since 1562, he was mainly admired for his seemingly endless skill and invention. He too saw the Royal Garden as an abundant source of inspiration and models for his work. Maximilian II admired his paintings, especially the composite heads Arcimboldo made for him, consisting of a great variety of things, organic and inorganic. For these works, Arcimboldo carefully made preparatory studies from nature and from the works of other artists. On the themes, for example, of the four seasons and the four elements, he left nothing to chance in their intricate compositions. Presented to Emperor Maximilian II on New Year's Day 1569, the paintings were accompanied by poems by Giovanni Battista Fonteo. The poems interpreted the messages of the paintings for the emperor: allegories of empire, based on a complicated system of the relationships

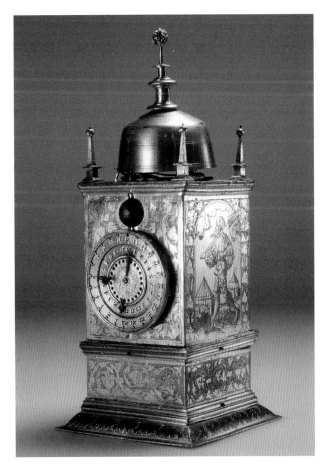

HANS STEINMEISSEL: **Tabernacle clock**

Hans Steinmeissel trained in the workshop of the clockmaker Jakub Čech in Platnéřská ulice (Platnergasse, Armourers' street), Prague. After the death of his master in 1540, he took over the business, and seven years later became a citizen of the Old Town. In 1548, he married Čech's daughter and in 1551 became the keeper of the Old Town astronomical clock, but, it appears, not for long. Zikmund Winter, a late-nineteenth writer and historian, recalls a curious story from a period source. It relates how Steinmeissel was given the keys to the clock but kept them only for one night before returning them with the explanation that the job would drive him mad.

This tabernacle clock has a face divided into 24 parts, twelve of which are provided with protuberances to help determine the time in the dark of night. Its case is engraved with ornaments and with figures of mercenary soldiers (landsknechts) on the sides. This is the earliest preserved clock of its type in central Europe.

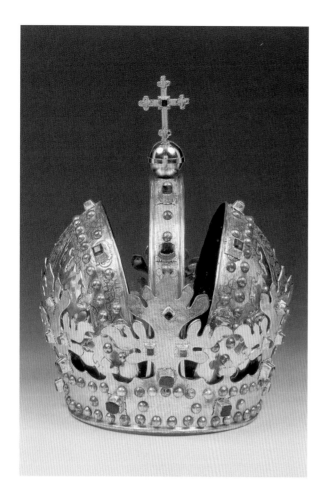

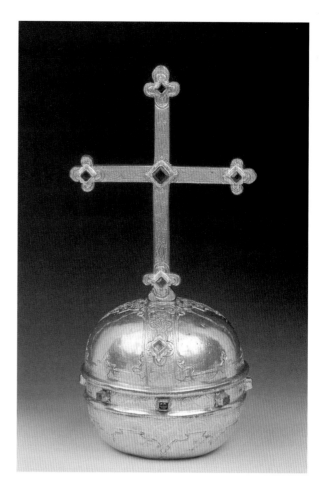

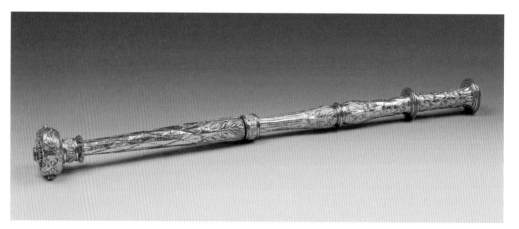

Funeral regalia of Emperor Ferdinand I

Crown, orb, and sceptre. These regalia, used for royal and imperial funerals at Prague Castle until the beginning of the twentieth century, first appear in the inventories of the St Vitus' Treasury in 1635. They were, however, undoubtedly made much earlier, in the second half of the sixteenth century. Considering the careful preparations for laying the body of Emperor Ferdinand I in his tomb at St Vitus' Cathedral, it is reasonable to assume that they were made specially for his funeral, which was held on 22 August 1565. The sceptre is similar in form to the regalia that Emperor Ferdinand I ordered from Hans Haller at Augsburg in 1533. Much later, in the seventeenth century, this golden sceptre became part of the Bohemian crown jewels. The funeral regalia were probably used when the body of the late monarch lay in state; the original jewels appeared in royal funerals only during the actual ceremony – namely, in the procession to the Cathedral and during the Requiem Mass.

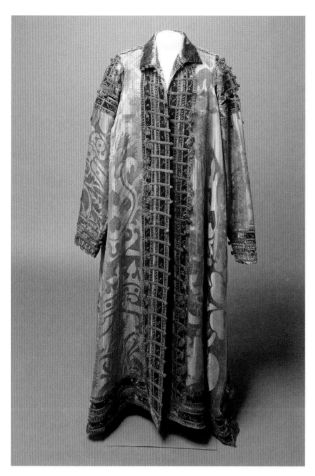

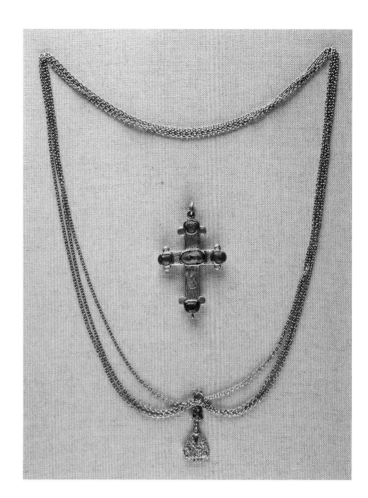

From the grave goods of Emperor Maximilian II

Coat. A long coat of this type (originally black) was listed in period inventories as Hungarian, according to the place where this fashion originated in the second half of the sixteenth century before spreading throughout Europe. It was popular with the elderly and with scholars, and thus suited the emperor, whose chief interest was in the natural sciences, which he supported.

A miniature of the Order of the Golden Fleece and a pendant cross. Emperor Charles V decorated Maximilian II with the Order of the Golden Fleece in 1546. The original decoration, a heavy large collar, was non-transferable: after the death of its bearer, the collar had to be returned. Consequently, its bearers were given miniature copies to take with them to the grave. A similar, smaller version, was also found in the coffin of William of Rosenberg (Vilém z Rožmberka) in a church in Vyšší Brod, south Bohemia. Together with a copy of the Order of the Golden Fleece, a tooled pendant cross of silver gilt with malachites was placed on his chest. On the recto, below the inscription INRI, is a relief of the crucified Christ, and on the verso, decorated with malachite, are the engraved initials M. A. R (Maximilianus Augustus Rex).

between the micro- and macrocosms, and the institutions of government, praising the House of Habsburg, and wishing it eternal glory. Arcimboldo's self-portrait, today in the National Gallery in Prague, enables the viewer to look in the face of this remarkable man, who was also employed to design court festivities. In 1570, on Old Town Square, Maximilian II held grand Shrovetide revels. The public space in which it took place enabled a large number of people to watch this unprecedented spectacle. Its extraordinariness and the admiration it aroused are attested to by the verse eulogy written by Adam Cholossius and published in the *Historický kalendář Daniela Adama z Veleslavína* (Historical almanac of Daniel Adam z Veleslavína), as well as a description of the festival in the annals of Marek Bydžovský z Florentina

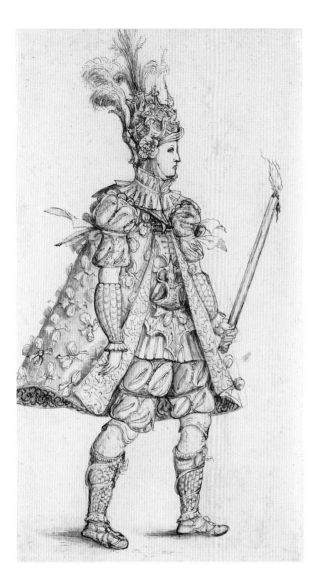

WORKSHOP OF GIUSEPPE ARCIMBOLDO:
Figure study with burning torch

The less Giuseppe Arcimboldo painted the portraits for which he had been hired at the imperial court, the more he worked in Vienna and Prague as an ingenious organizer of court festivities. His workshop must have employed several artists who knew the master's signature style of drawing, in order to execute his designs for the numerous 'extras', that is, the less important figures in the spectacles. Apart from these amusements, Arcimboldo and his assistants also designed the court balls. One of them, in 1571, included performances by torch-bearers – perhaps like the very ones represented in this drawing.

(*Svět za tří českých králů*, The world during the reign of three kings of Bohemia) and even in a contemporary print published in Augsburg. A large backdrop representing the volcano Mount Etna, which spit fire, smoke, and boulders, was erected on the square. Ravens and strange birds flew out of it, while chamois and squirrels scrambled over its rocks. A hero of antiquity, Perseus, rode Pegasus across the sky, clutching Medusa's head in his hand. King Porus of India arrived on an elephant, which he made kneel before the emperor and empress. The Furies, Argus, Medea and her husband Jason rode black horses. Medea's chariot was driven by a green devil, and was drawn by horses covered in dragon scales. Classical mythology was further represented by Theseus, Bohemian mythology by Vlasta with her retinue of girls, and Celtic mythology was represented by King Arthur and his knights. Fama (the personification of fame), a winged maiden, rode on a cage containing a live lion. The magician Zirfeo rode a six-legged dragon, letting the emperor know that by striking a blow to the volcano he would liberate the people trapped inside. In a procession, King Arthur, lovely ladies, Moors, and Cupid with a fool on a rope emerged from the volcano. Then came a peasant wedding (reminiscent of the paintings of Hieronymus Bosch) and other amusing groups. The procession

GIUSEPPE ARCIMBOLDO: **Self-portrait**

A bewitching gaze and emotionless face – these are
perhaps the best words to describe the drawing in
which Arcimboldo has captured his own likeness.
It was probably made in the 1570s, at a time when
the painter had already begun to work for the new
monarch. The apparent lack of expression says
much about his character and complicated soul.
His paintings of composite heads, often probably
representing real people, recall the masks of Jap-
anese and Chinese theatre. It was not by chance
that Arcimboldo, in the large Shrovetide festivities
on Old Town Square in 1570, appeared in the cos-
tume of a magician. Though his highly traditional
official portraits of the imperial family do not really
provide evidence of why he was employed at the
court as a portrait painter, this drawing reveals him
to be a master portraitist, an outstanding draughts-
man capable of capturing much of the inner life of
the sitter.

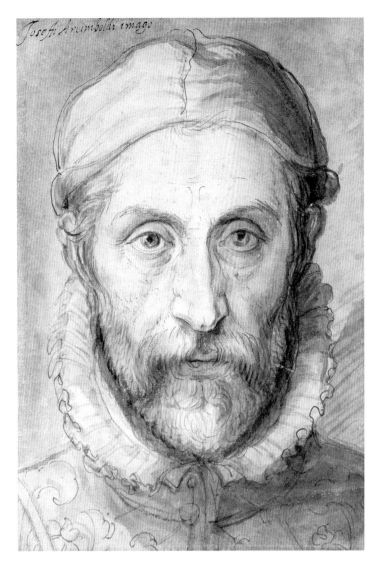

concluded with a man dressed in black and with a black beard – the creator of the
spectacle, Giuseppe Arcimboldo.

Another person in the service of Maximilian II, beginning in 1566, was the
Italian sculptor Antonio Abondio. An outstanding medallist, he made medals
with portraits of important figures of the period. In a round medallion, he extols
Maximilian II as a Roman emperor and military commander, and, on the verso, he
recalls Maximilian's triumphs, albeit temporary, in the wars against the Turks. He
was also well known for his portraits modelled in coloured wax, and particularly as
the maker of superb moulds for coins struck in the imperial mints. Many important
goldsmiths, clockmakers, and gem-cutters worked for Maximilian II. They lived
mostly in Vienna or sent their creations from the places they were permanently
employed, usually Nuremberg and Augsburg.

Nikolaus Müller was a goldsmith with a court title who was employed in Prague.
Thanks to his superb work, he was able to acquire considerable property, including
two houses in the Lesser Town. Although none of his works is now known to us,
we can look him in the face in a family portrait – actually an epitaph painting by
his distinguished son-in-law, Bartholomeus Spranger.

The rebuilding work at Prague Castle inspired the nobles there to enlarge their great houses. William of Rosenberg, in 1571, bought the houses of the lords of Rosenthal (Rožmitál) and Schwanberg (Švamberk), and then had them mostly demolished. In their place, he enlarged his house westward with the addition of a new wing that had a colonnade and a charming garden surrounded by an arcade. Similarly, Vratislav z Pernštejna rebuilt his grand house soon after it had been given a remarkable terracotta façade. He also added a new wing with a loggia and substituted sgraffito for the three-dimensional decoration.

In 1538, Florian Griespek von Griespach, a member of the Hofkammer, bought a partly built house on Hradčanské náměstí right next to the Castle. A senior official and confidant of Ferdinand I, Griespek was also a passionate builder and he over-saw construction work at Prague Castle. At Nelahozeves and Kacéřov, he built ex-traordinarily imposing Renaissance castles. His great house on Hradčanské náměstí was undoubtedly also splendid, but when it became necessary to provide the new archbishop of Prague with a dignified seat, Griespek sold the just-finished house to Emperor Ferdinand I, who then, in 1562, gave it to Antonín Brus z Mohelnice 'to occupy and live in as his and future archbishops' hereditary property'. Gries-pek then built a new house in Újezd (in the Lesser Town), whose appearance we know only from a charming early seventeenth-century drawing by Pieter Stevens.

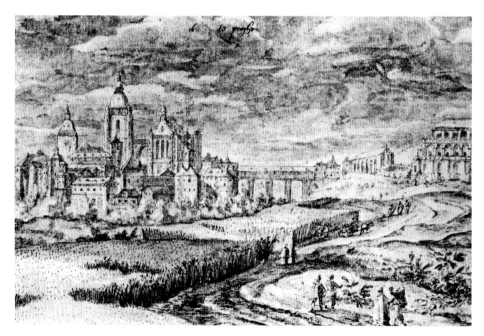

PIETER STEVENS: **Prague Castle with the Powder Bridge (Prašný most), the Great Tennis Court, and the Royal Summer Palace**

An outstanding court painter of Rudolph II, Pieter Stevens chose in this work to record Prague Castle from an unusual point somewhere on Letná Plain. He has thus provided us with a remarkable panorama of part of the Castle precinct which Emperor Ferdinand I had ordered built. The bridge, called Prašný most, linked the Castle to recently acquired land, including the Royal Garden, on the other side of the Deer Park Moat (Jelení příkop). The drawing shows not only the bridge but also the Tennis Court, the Orangery, the Fig House, and, in particular, the Royal Summer Palace – all built for the pleasure of the royal court. Despite later remodelling, these parts of the Castle have largely preserved their appearance to this day. The only major change is that the moat under the bridge was filled in during the reign of Empress Maria Theresa. Only recently was the rampart pierced to link the two parts of the moat by a short tunnel, making the whole moat accessible to the public.

The House of Florian Griespek von Griespach – *October*, from the *Month*s series
(Hollstein 139) engraved by Aegidius Sadeler after a drawing by Pieter Stevens

In 1568, six years after he had sold Emperor Ferdinand I his great house on Hradčanské
náměstí for the future seat of the archbishop, Griespek von Griespach bought a house at the
foot of Petřín hill. He had it rebuilt into a grand three-storey residence with a garden. He was
clearly an enthusiastic and experienced builder, having erected, for example, the outstanding
Renaissance castles in Nelahozeves and Kacéřov. That's why, even in this new project, he made
no compromises when it came to the architectural appearance of the house. Located next to
what is now the Church of Our Lady of Victory and its adjacent monastery, it resembled a
suburban villa, a style popular at that time. Today, only fragments of its perimeter walls have
survived in the area of the monastery. The appearance of the house was, however, fortunately
recorded in about 1605 by Pieter Stevens in a drawing (Paris, Fondation Custodia), which
Aegidius Sadeler engraved in a mirror-image as a print in the *Months* series (1615).

The archbishop, despite having acquired the new building, entrusted Bonifaz
Wohlmut with drawing up plans for its extensive remodelling. The instructions
for this work, preserved in the archives, were probably compiled by Wohlmut.
They provide fascinating evidence of contemporary taste and ideas of how the
archbishopric should be represented by architecture and also the expectations of
comfort. The wooden panelling of the rooms is described as 'healthier and warmer
in winter time'. The main hall should be given a lovely wooden ceiling, 'which
would be merrier and more princely' than a vaulted one.

After thorough rebuilding in later centuries, only the chapel of the earliest
Archbishop's Palace has survived, though the preserved decoration dates only from
the late sixteenth and the early seventeenth century, together with a fragment of
the charming sgraffito decoration of the façade on the courtyard side of the west
wing of the palace.

The builder Bonifaz Wohlmut also settled in the Lesser Town. In 1556, he
bought three houses on the corner of what are now Karmelitská and Harantova
streets. The exquisite house that he made from them at great cost is, however,

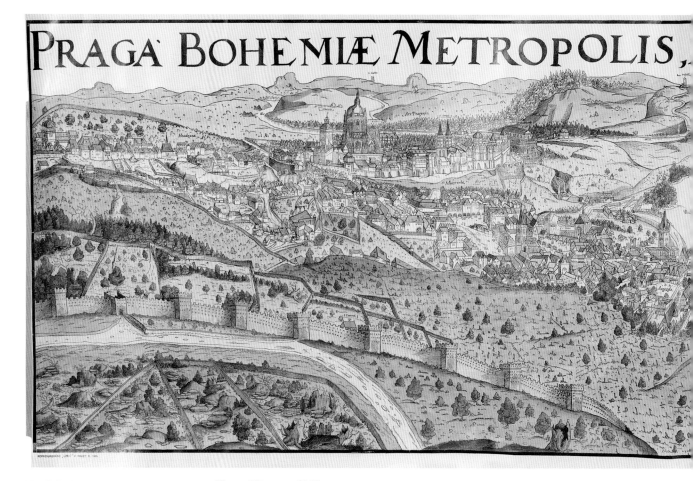

JAN KOZEL AND MICHAEL PETRLE: **View of Prague, 1562**

This rare woodblock print, known only from two examples in collections in Wrocław and Stockholm, is a reliable and eloquent depiction of Prague from the end of the reign of Ferdinand I. The view was engraved by Michael Petrle, a painter of ornamental decoration and lettering, who came from Annaberg, Saxony. In 1565 he was made a member of the painters' guild in Prague, and lived in this city until the end of his life, in 1588. In about 1570, he set up a printing press in the New Town, and, probably because he was doing well, he soon bought a house at the foot of the Castle Steps, where he ran his business. He thus became a neighbour of the painter Bartholomeus Spranger, from whom, shortly before his death, he commissioned an epitaph painting, the lower part of which has portraits of his whole big family (today, at the Archbishop's Palace, Prague). The *veduta* of Prague comprises prints from ten different woodblocks on five sheets. Considering the date, Petrle must have made it before he became a member of the painters' guild. The *veduta*, also called the 'Breslauer Prospekt', was drawn from high above what is today the Prague district of Smíchov. Though for the overall impression this was a less attractive standpoint than those used in later panoramic *vedute* of Prague, it is all the more faithful to the proportions of the individual areas of the city. The lower part of the print includes a long text about the origin of the city, a description of it, a poem by Matouš Collinus z Chotěřiny, and the printer Jan Kozel's dedication to Emperor Ferdinand I.

recorded only in old *vedute* of Prague. Thanks to a panoramic drawing of the city from 1606, known as the 'Saedeler Veduta', we also know the appearance of the house of Jiří Mehl ze Střelic, an imperial councillor, humanist, and bibliophile. With its three gables, pavilion that rises above them, and high slender tower, it makes its presence felt on the south slope of the Castle where the Thun House stands today. A similarly imposing building was owned from the 1560s onward by the Trčka family on what is now Valdštejnské náměstí (Waldstein Square). Fragments of its once lavish decoration have been preserved to this day in the attic rooms of Waldstein House, which was built on the site of the former Trčka House, using some of its perimeter wall.

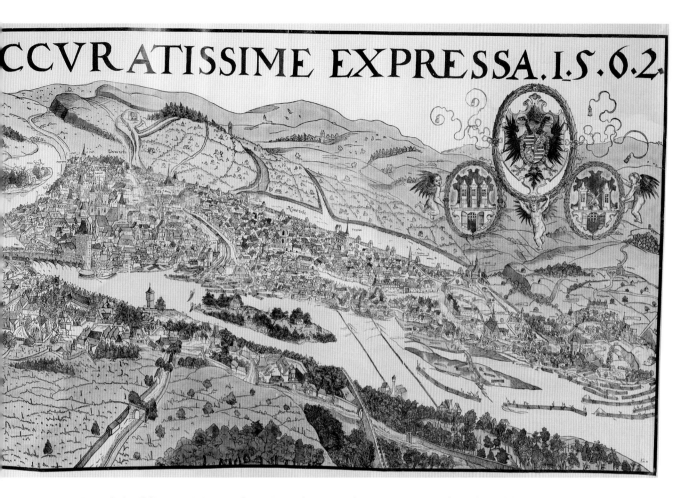

Though building activity in the reign of Maximilian II continued in the Old Town as well, little of the architecture has remained. After 1560, for example, two striking arched gables decorated a house in today's Husova ulice, which was called U Zlaté slámy (The Golden Straw) or, alternatively, U Černého hada (The Black Serpent). At that time, painted wooden ceilings with exposed beams became popular. These have been preserved in their original state from the 1560s, for example, even on two storeys of house no. 479/I, called U Bindrů (Binder House). Most of the houses both in the Old Town and in the New Town were not, however, completed until the last decades of the sixteenth century and at the beginning of the seventeenth, when the building boom peaked with the arrival of the new monarch, Emperor Rudolph II, and in connection with his moving the imperial seat to Prague.

Kozel and Petrle's *veduta* of Prague, published in 1562, provides a panorama of all three parts of the city – the Old Town, the New Town, the Lesser Town – as well as Hradčany and the Castle. It provides evidence of how quickly and strikingly the individual quarters lost their medieval character in favour of the new style that had come to the Bohemian Lands in the reign of the Jagiellons and, mainly, Ferdinand I, the first Habsburg on the Bohemian throne. Little, as we can see from the *veduta*, has changed in the New Town, where – with the exception of the grand town hall – artisans' multi-storeyed homes only slowly came to reflect the new style. There, the Renaissance made a vigorous entrance only in subsequent decades, when Prague became the capital of the Holy Roman Empire of the German Nation.

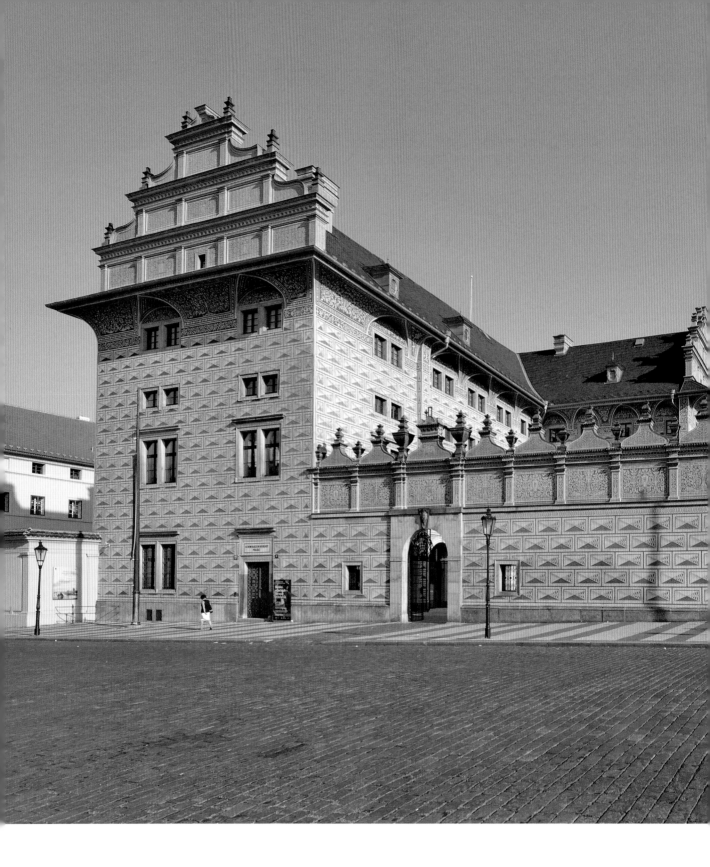

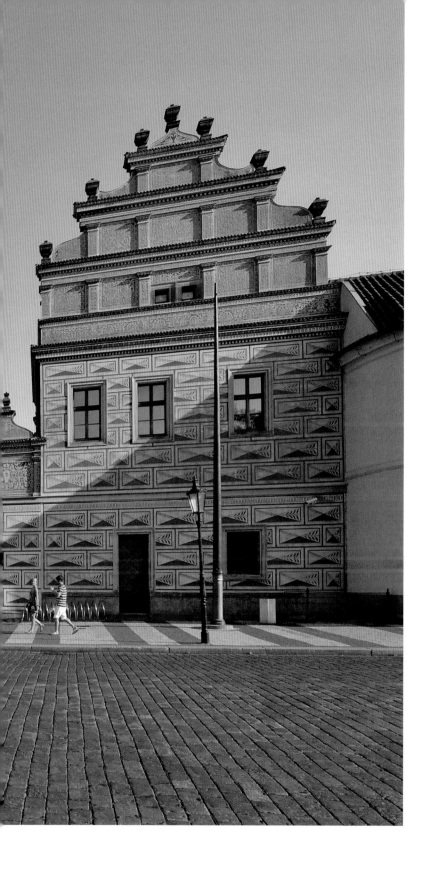

RENAISSANCE PRAGUE:
A GUIDE TO THE CITY

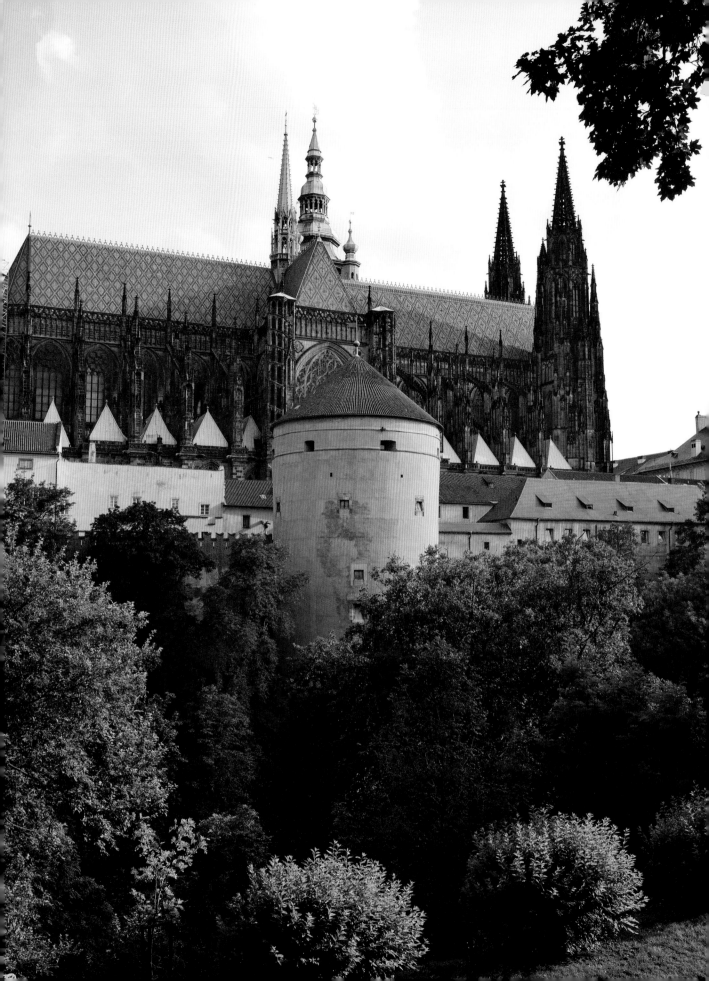

1/ THE POWDER TOWER (PRAŠNÁ VĚŽ), ALSO CALLED MIHULKA

In the Jagiellon period, the fortifications of the Castle, particularly on the north side, began to be repaired after 1490, probably under the direction of Benedikt Ried. The most massive of the artillery towers, Mihulka, is cylindrical; today it serves as a place for exhibitions. In the reign of Rudolph II, the upper storey, probably half-timbered, was substituted for by a low wall, as at the White Tower and the Mathematics Tower. The original roofs were at that time removed and terraces were built instead, affording a panoramic view into the distance.

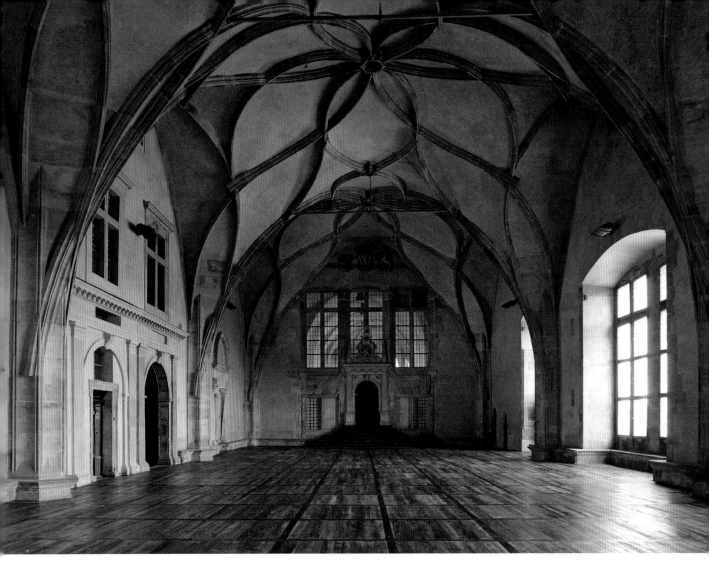

2A–G/ THE VLADISLAV HALL

One of the most beautiful spaces of the transition from the Late Gothic to the Renaissance is a work by the ingenious master builder Benedikt Ried, whom King Vladislav II had summoned from Saxony. We have a written record of his being in Prague from 1489 onwards. The Vladislav Hall was doubtless his largest and technically most demanding building at Prague Castle. It was made on the site of several demolished rooms in the palace of Charles IV (*reg.* 1346–78) and used of some of the earlier walls. The building itself bears inscriptions from several years related to its construction. Though we do not know when the work began, the year 1493, inscribed below the windows on an outside wall, suggests that construction was already well advanced by this point. The front wall inside the hall bears the inscription 1500.

The elegant ceiling vault of the hall, with its interlacing ribs, is the result of an ingenuous design and the superb craftmanship of the stonemasons, bricklayers, and plasters. On the north side, the hall was no longer supported by flying buttresses outside, as had been the custom in the Gothic period. Instead, it uses only massive piers, deeply anchored. The south façade, because of its height, had to make do without them.

Direct access to the gallery of the Vladislav Hall afforded visitors a magnificent panoramic view of the city. In a way that has remained popular to this day, visitors immortalized their visit by inscribing their initials, coats of arms, or names into the wall or stone door jambs. Sometimes, they even added a bit of verse. It is no coincidence that most of the earliest instances of this graffiti date from the 1560s. An unknown visitor – probably someone working on the building – drew a small 'veduta' by the entrance to the gallery in the Vladislav Hall, a view of the middle part of the Castle. Though really just a diagram, it is the earliest illustration of this architecture.

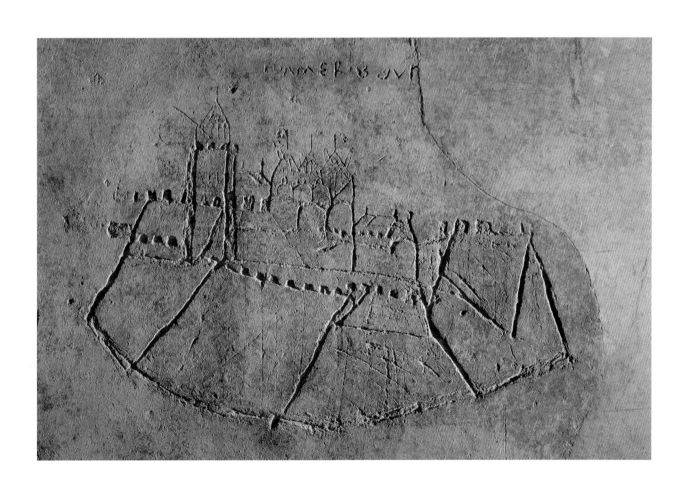

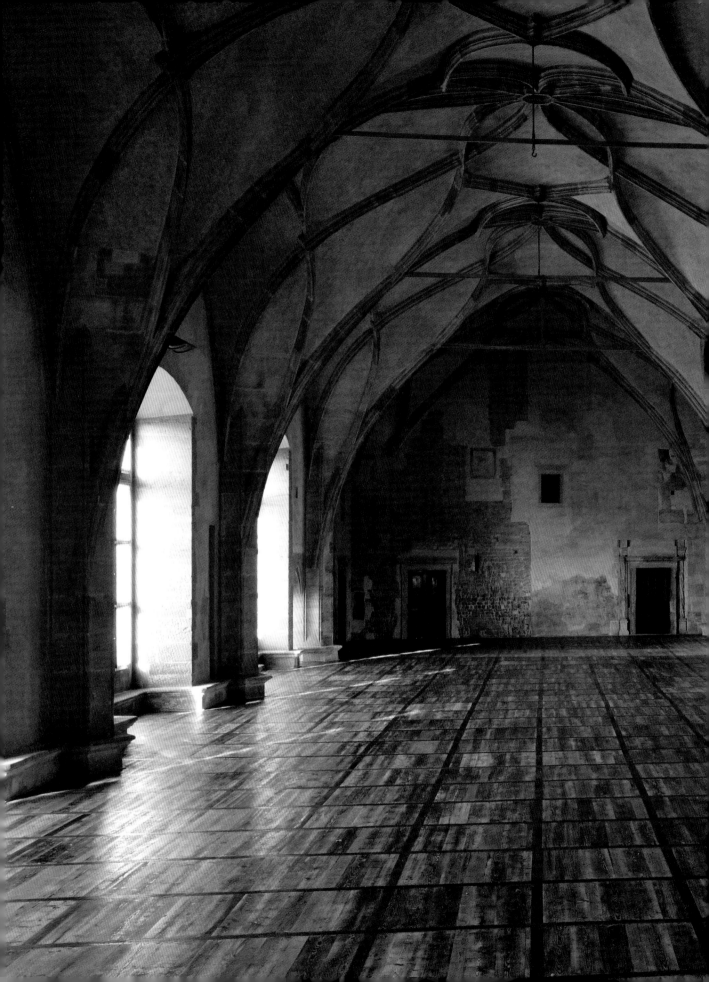

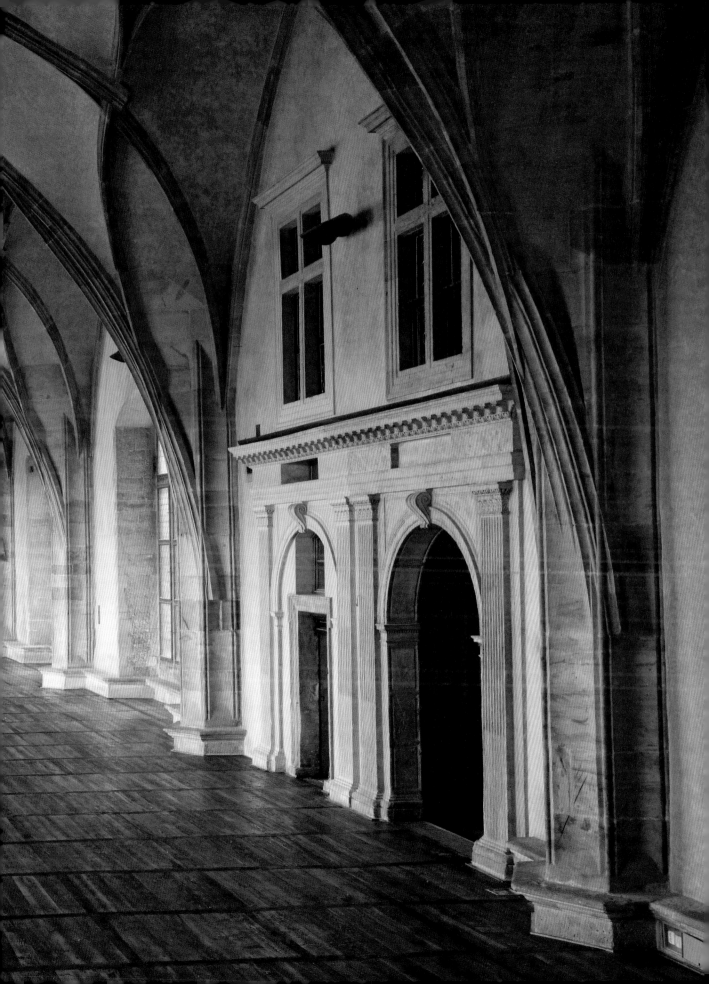

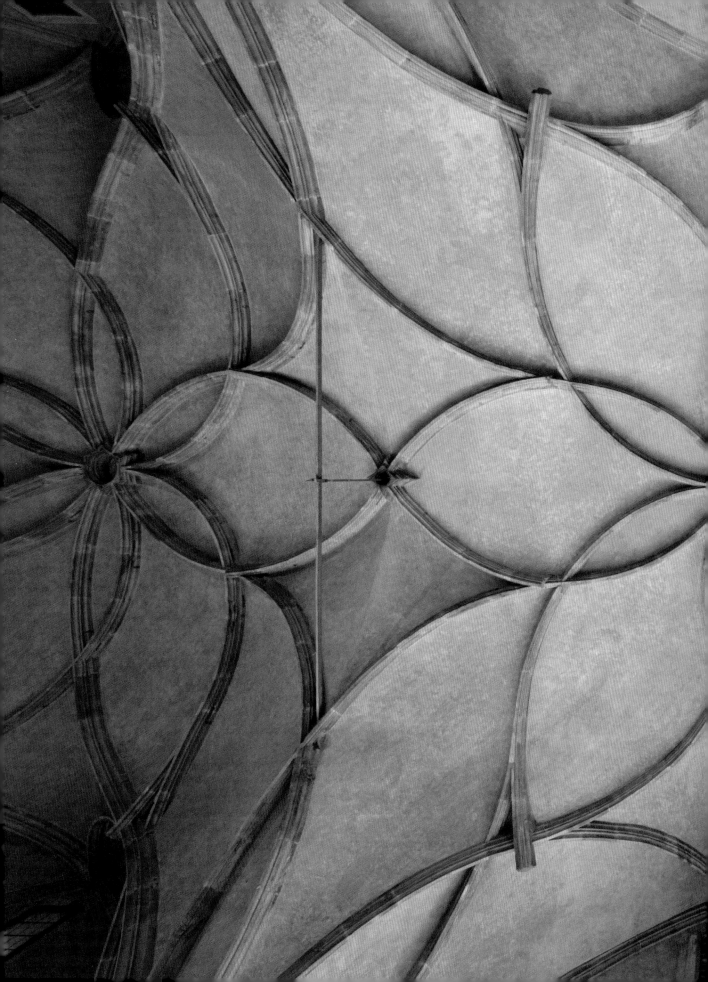

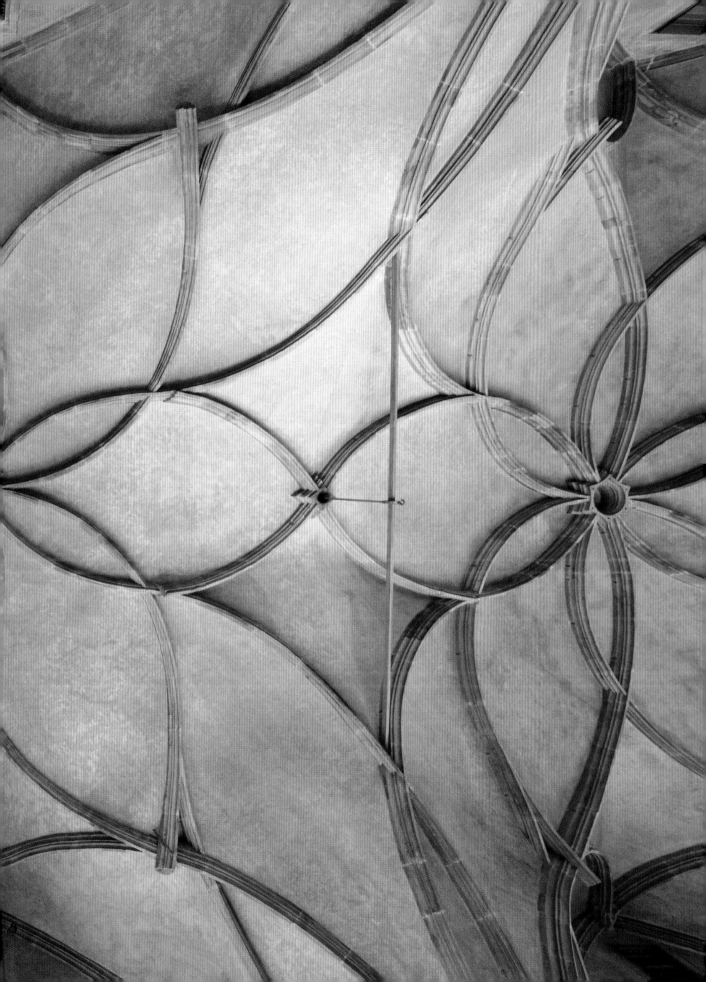

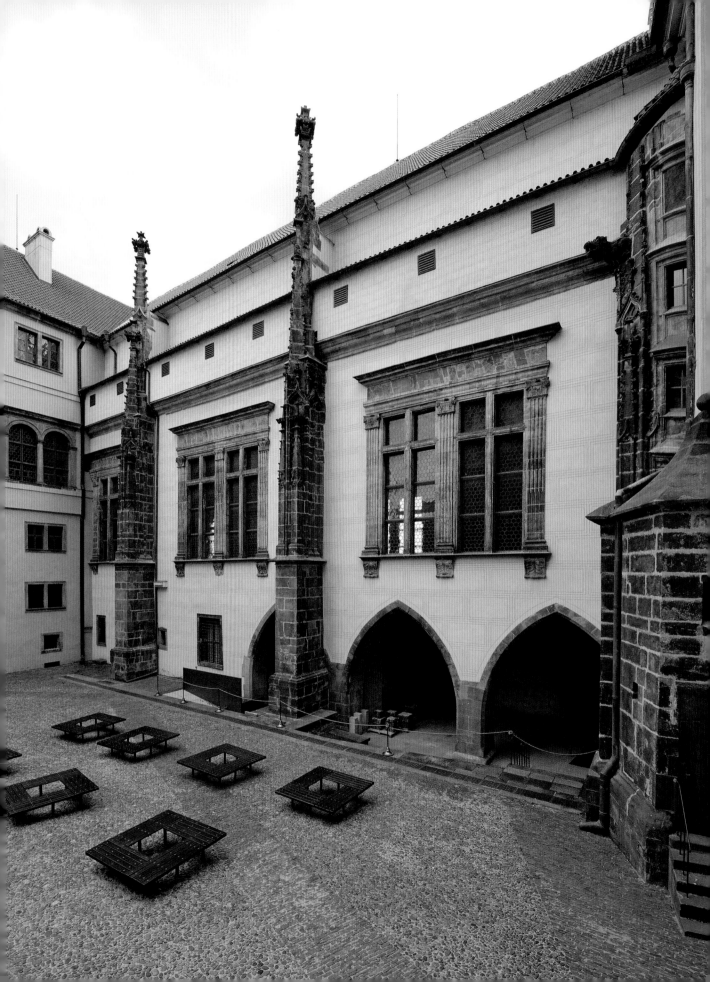

The windows of the Vladislav Hall are among the earliest
examples of Renaissance architectural forms in the Bohemian
Lands, as is testified to by the inscription and year 1493 on
the frieze. The Italian model, perhaps from Urbino, may
have been introduced by the stonemasons summoned from
Italy or by the masons who worked for the king at Buda
Castle in Hungary.

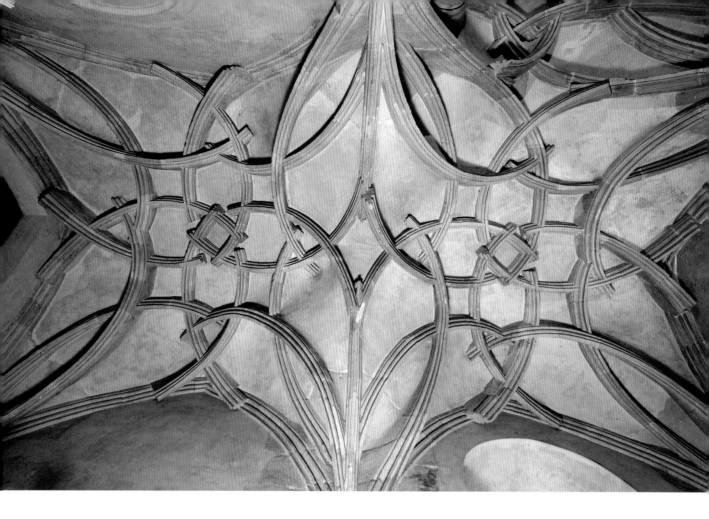

3A–B/ THE EQUESTRIAN STAIRS

This part of the Old Royal Palace is also the work of the master builder Benedikt Ried. It testifies to his remarkable ability to combine elements of the waning Gothic style with the new elements of the Renaissance. This too is how the entrance from the Vladislav Hall to the Equestrian Stairs is designed – the archaicizing form of the ogee arch has been set into the classic Renaissance portal recalling an aedicule. The vault with interlaced ribs is something of a 'mannerist' variant of the vaulting of the Vladislav Hall, later inspiring Bonifaz Wohlmut when building the hall of the Diet.

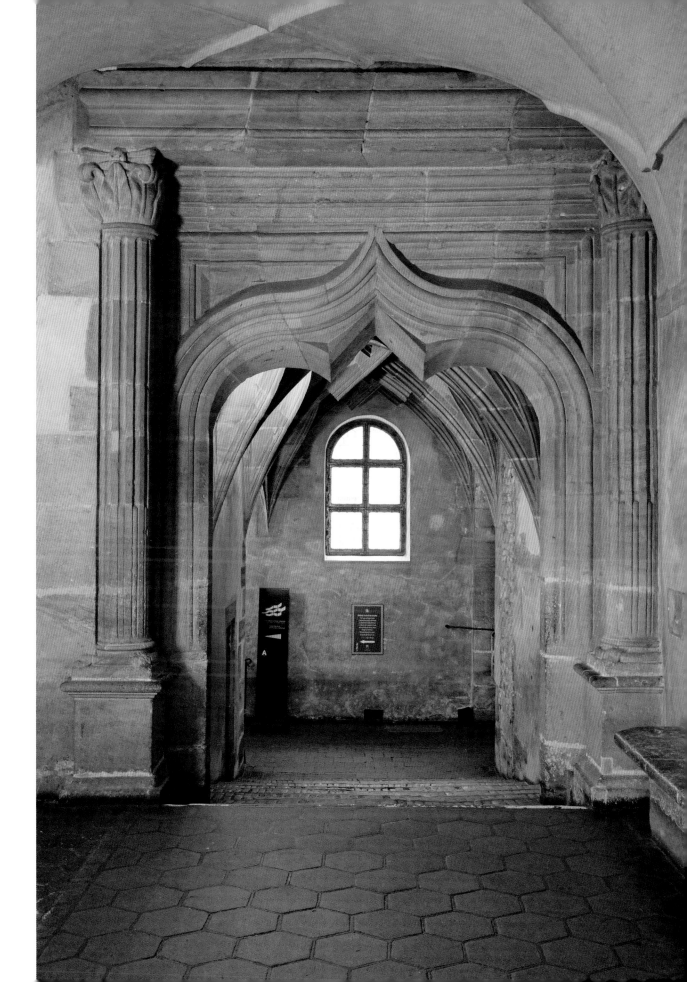

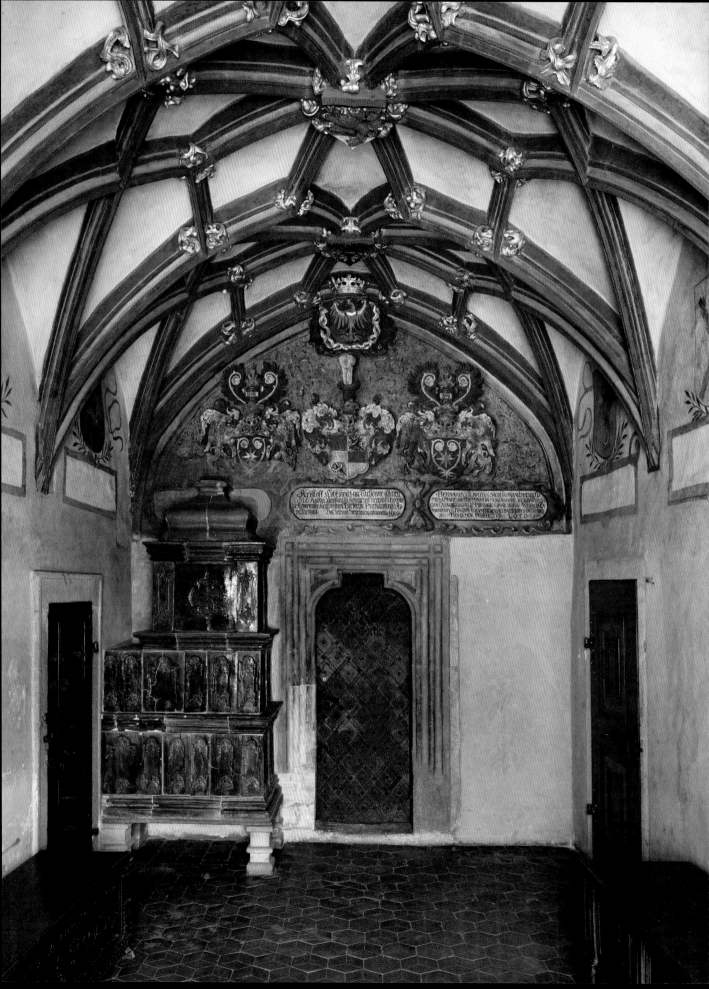

4/ VLADISLAV'S BEDCHAMBER

The Old Royal Palace, west wing.

The designer of this wing, which was built on to the Royal Palace before 1490, is generally believed to have been Hans Spiess of Frankfurt. This royal mason first appeared at Prague Castle in 1486. He settled in Hradčany (the Castle district), where he had a house and vineyard, and even sat on the town council.

The ground-floor rooms of this wing were used by officials of the monarch's court. The 'Green Room' (before being remodelled in the eighteenth century) was used for sessions of the law courts. Two smaller rooms, the first of which served as a small throne room, still preserve their Late Gothic appearance today. They are marked with a W, the initial of the builder, King Vladislav (then written as Wladyslaw). The larger of the two rooms came to be known as 'Vladislav's Bedchamber' only much later. The upper storey of the wing contained rooms for members of the royal court. They were still being used for this purpose in the reign of the first Habsburgs in Bohemia. Emperor Rudolph and his mother Mary of Austria (also, of Spain) lived there briefly.

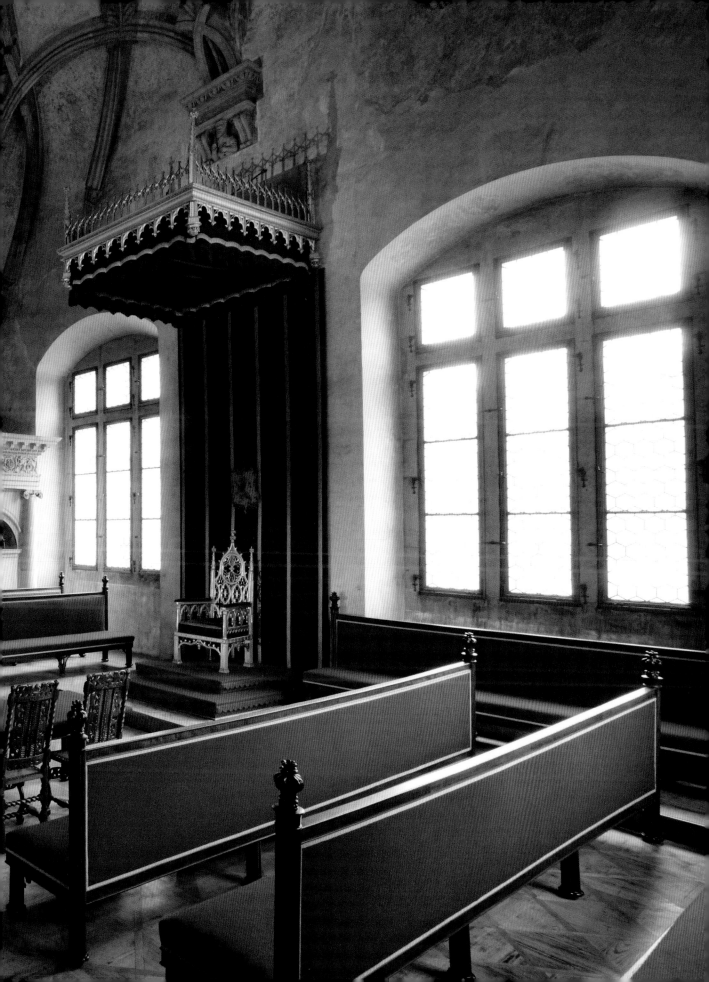

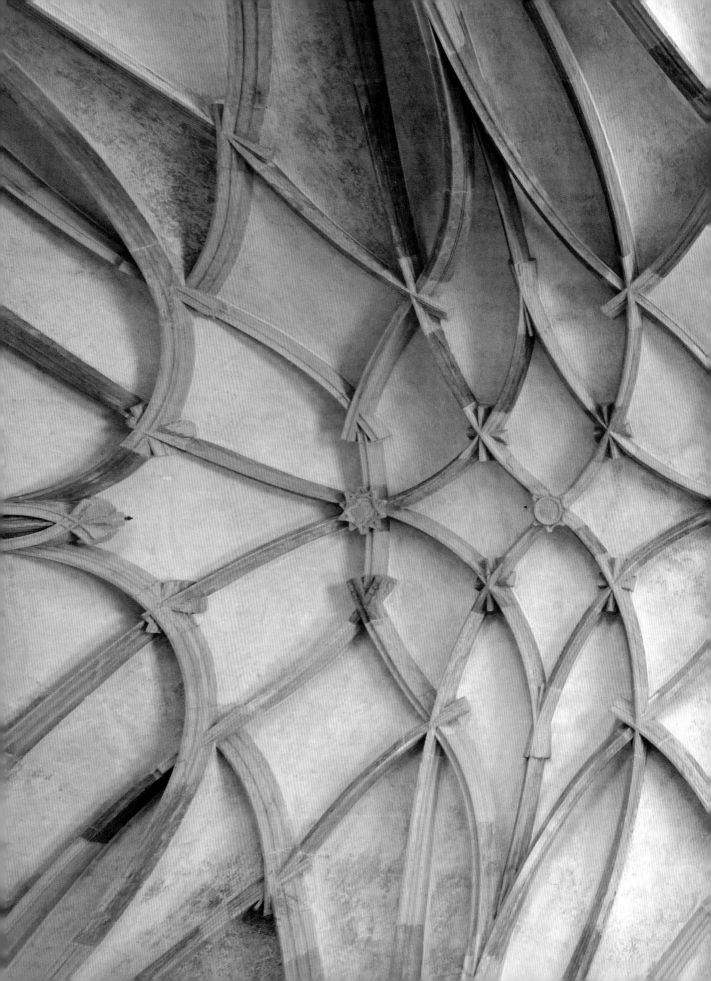

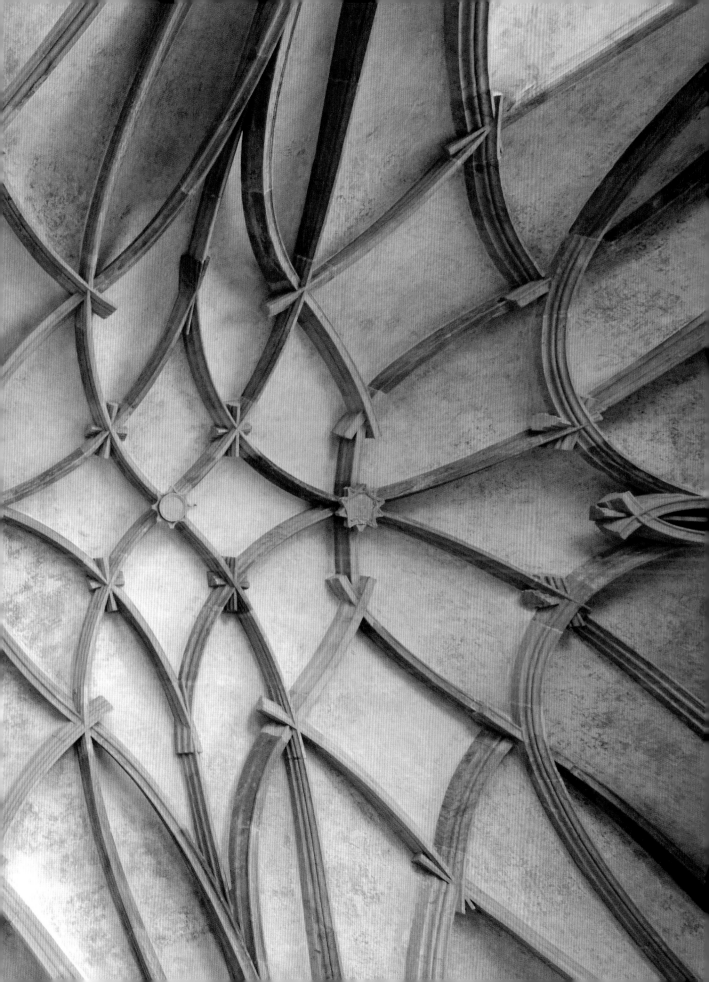

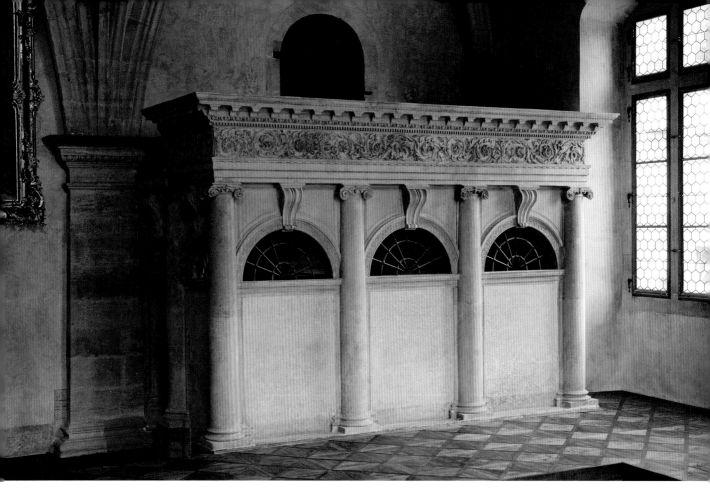

5A–F/ THE OLD DIET

The hall at Prague Castle in which the Bohemian Diet used to hold its sessions was badly damanged in the great fire of 1541. Its reconstruction was entrusted to the master builder Bonifaz Wohlmut. As is shown by the preserved architectural drawings in the archives of Prague Castle, this important room, which served as a hall of the diet and a court room, was meant to be built in a Renaissance style. It seems that Emperor Ferdinand I decided in favour of a historicizing design by Wohlmut, inspired by the vaulted ceiling Ried had used over the Equestrian Stairs. The construction work took place from 1559 to 1563. Below the springers between the corbels above the throne and, opposite, above the entrance are two half-figure busts, one of Ferdinand I, the other of Wohlmut.

The scrivener's gallery

The gothicizing hall of the Diet included a gallery for the scribe who kept the minutes of the Diet sessions. But the gallery is in a style completely different from that of the rest of the hall. Though it was built in the same period and was also designed by Wohlmut, it is an outstanding example of classic Renaissance, that is, Palladian, architecture in Bohemia of that time. The gallery was originally accessible by a spiral staircase directly from the hall, and was vaulted underneath, but lost its original delicate appearance when the original arcades of the ground floor were walled in. The planned decoration of the Diet, which had been entrusted to the painter Domenico Pozzo, was ultimately never carried out, because the work would have taken several months, thus preventing the immediate use of the hall for the Diet.

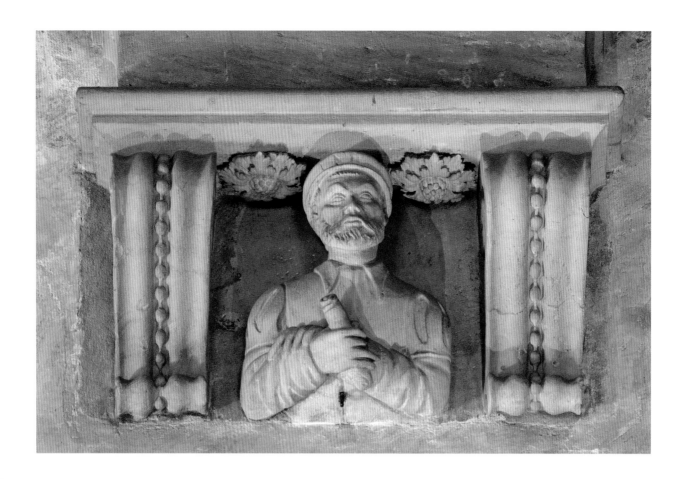

A corbel with a portrait of a master builder

The man holding a rolled-up paper in his hand is undoubtedly a master builder. In connection with the just-finished hall of the Diet, it is very likely that this a portrait of Wohlmut. On the other side of the hall is a console similarly decorated with a portrait of Emperor Ferdinand I. Linking together portraits of a builder and his client is unusual. If the portraits on these consoles are in fact who we think they are, then the Wohlmut portrait in this location and in this company suggests he had a considerably high opinion of himself.

The portal to the Diet

During Wohlmut's remodelling work, the portal leading from the Vladislav Hall to the Diet was in its original Jagiellon style from about 1500. The double-framed portal comprises a pair of torqued columns with Renaissance capitals, a motif that frequently recurs in Ried's work. The recessed inner frame of the portal consists of engaged columns with decorated twisted fluting, which he was also fond of.

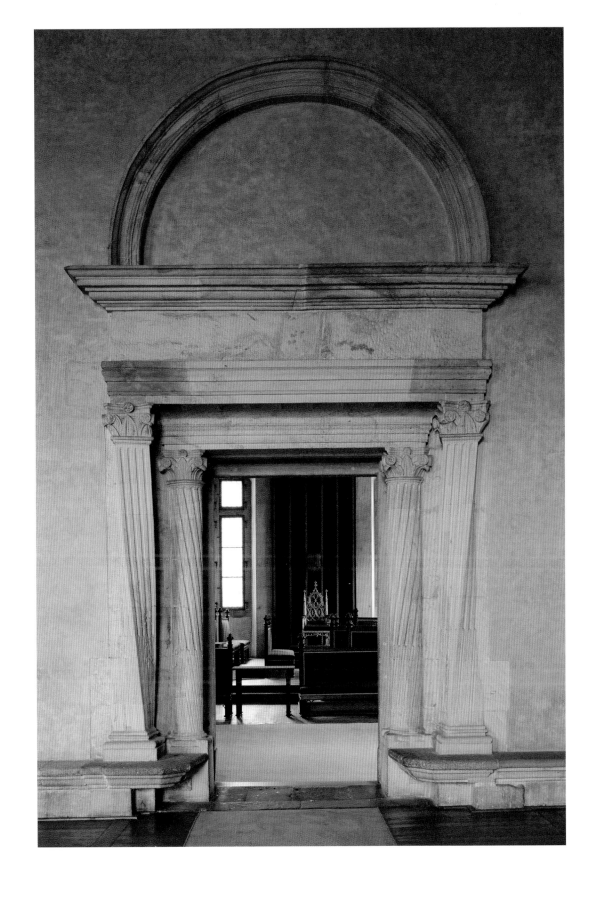

(71)

6A–D/ THE ROOMS OF THE NEW LAND ROLLS

The rooms in which the Land Rolls were kept also suffered greatly in the great fire of 1541. The worst damage was done to the extremely important historical documents deposited there, including records of the ownership of lands and buildings, official books of the Bohemian law court (*Landesgericht*), and decisions of the sessions of the Bohemian Diet. In 1561, Archduke Ferdinand II, in order to unify the exteriors of the buildings of the New Land Rolls and the façade of the Vladislav Hall, ordered the decoration of their plaster only in sgraffito with a repeating geometric pattern reminiscent of the back of an envelope. The Renaissance rooms of the offices were gradually painted with the coats of arms of the officials of the law courts who worked there. The furnishing of the offices was also completed with furniture, including shelves for the books, each of whose spines was distinctively painted in bright colours to make it easy to tell one from the other.

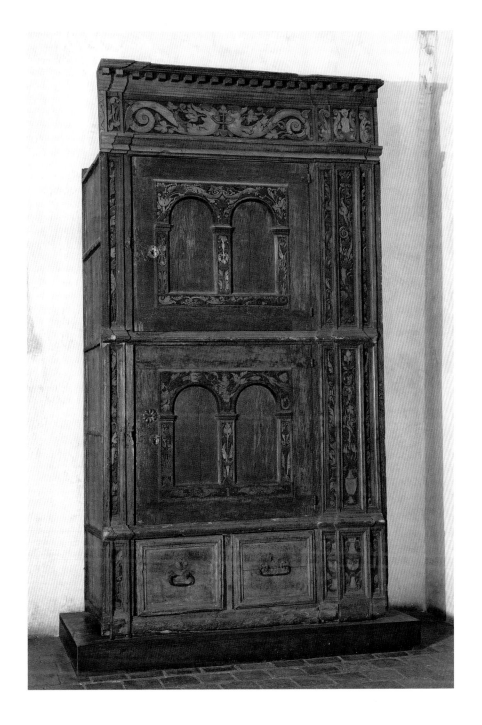

A cabinet in the rooms of the New Land Rolls

From a bill sent by the metalworker Mates Handschuh, dated May 1563, it is clear that the just-built rooms of the New Land Rolls were furnished that year. The earliest preserved piece of furniture at Prague Castle is a cabinet from 1562, probably acquired specifically for these office spaces. Its decoration, wood inlay, testifies to the fact that the furnishing of the rooms of the Land Rolls was also carried out with great attention to detail.

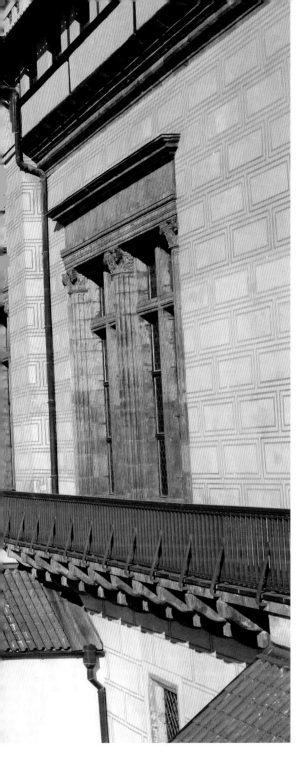

7A–C/ THE LOUIS WING (LUDVÍKOVO KŘÍDLO)

After some of the rooms of the medieval royal palace were demolished in order to build the Vladislav Hall, stately rooms had to be built not only for the offices and law courts of the Bohemian Lands, but also for the king and his court to live in. Construction work began right beside the Old Palace: above the entrance passage, the master builder Hans Spiess erected a short northern wing with a throne room and a court room; upstairs he built chambers for the king and his retinue. They, obviously, could not suffice, and so on the opposite side, in the direction of the town, another wing was built, from 1508 to 1510, which is now known as the Louis Wing. Seen from the Garden on the Ramparts, its great height is reminiscent of an early skyscraper, while its ever-widening lower part recalls a fortress. Though the exterior is plain, articulated only by large windows, the interior was designed for comfortable living. The ceilings of the imposing chambers were given vaults with intricately intersecting ribs; the service rooms simpler. The first time Vladislav's son Louis was in these just-finished chambers was for his coronation in the Cathedral as King of Bohemia, in 1509, at the age of three and half. Years later, in 1522, when he arrived with his wife Anne, they lived in the new wing – consequently, its portals are inscribed with an L (instead of Wladislaw's W).

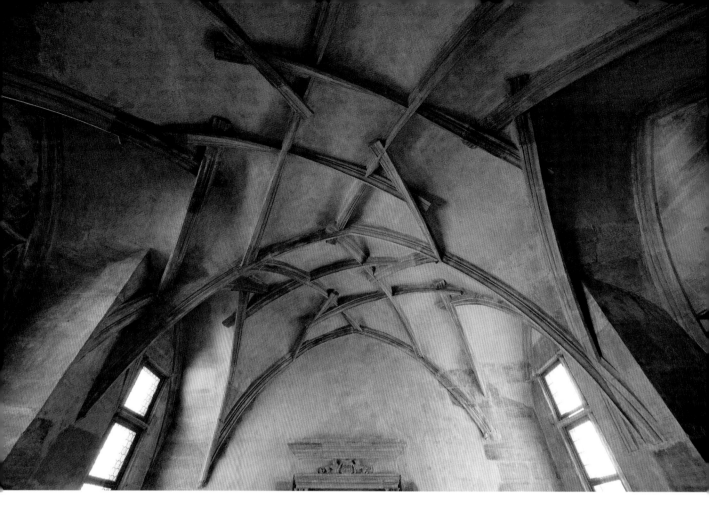

The coat of arms, monogram, and year 1508 on the small spiral staircase leading from the first floor of the Louis Wing attest to the fact that during the diet held that year the New Palace by Benedikt Ried must have already served to accommodate the royal court. The chambers with the large rectangular windows facing east and south were large and bright, comporting with ideas of comfortable housing in the then new Renaissance style. Only their vaults still had Gothic decoration – intersecting ribs like those used by Ried on the vaulted ceiling above the Equestrian Stairs.

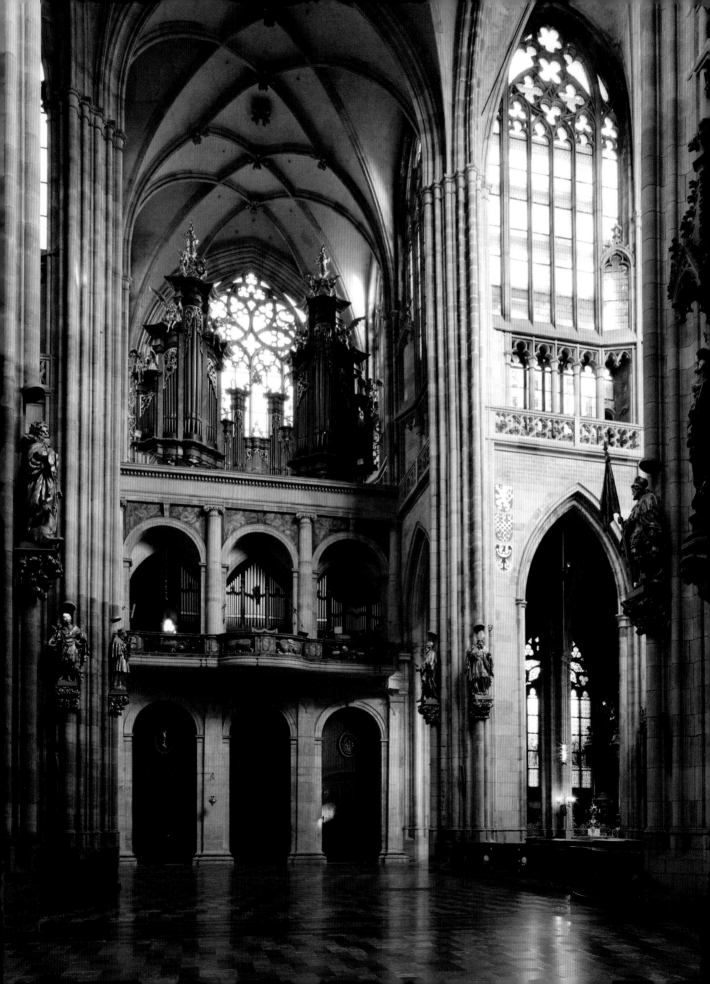

8A–B/ THE CHOIR LOFT OF ST VITUS' CATHEDRAL
From 1557 to 1560, a loft was built in front of the Cathedral
choir, which resulted in the choir being closed for several
centuries. Bonifaz Wohlmut was chosen as the master builder
for this job. As was often true of Emperor Ferdinand I's
decisions, it was a compromise between a Renaissance and
a Gothic style, something suitable, the monarch felt, for the
interior of a church. Nevertheless, the inner walls were given
a classicizing Renaissance appearance. Their decoration was
entrusted to the workshop of Francesco Terzio, a court painter
of Archduke Ferdinand II. The choir loft formed a dignified
background to the Royal Mausoleum. Between 1924 and
1926, however, the loft was moved to the north transept
of the church, where it has remained to this day.

Wall paintings in the St Wenceslas Chapel
of St Vitus' Cathedral

The impetus to paint the walls of the Chapel of St Wenceslas, the most holy space of the cathedral, probably came from the senior figures of the Roman Catholic estates in the Bohemian Lands, who may have also proposed the painter. Though he was an artist of outstanding skill, trained by Italian and Augsburg painters of the period of Maximilian I, the actual name of the Master of the Litoměřice Altar remains unknown. Most of the work is his, but the painting of the upper parts was carried out together with several assistants. Work on the decoration – the figures of angels and Bohemian saints beside the statue of St Wenceslas – began in the 1480s; it was executed by another painter, with a different personal style. The scenes from the life of St Wenceslas are in the new, Renaissance style.

The man holding the square and compass (the usual symbols of a master mason or master builder) who is portrayed on the south wall of the Wenceslas Chapel is generally believed to be the royal master builder, Benedikt Ried, who was responsible for the important Renaissance remodelling of Prague Castle.

Monumental portraits of Vladislav II Jagiellon and his wife Anne de Foix
on the east wall of the chapel.

In the central band of paintings on the west wall with
a scene of St Wenceslas arriving at the Imperial Diet, the
viewer's eye is drawn to the many figures with striking
portrait-like features. The scene undoubtedly commemorates
the initiators of the new decoration of the St Wenceslas
Chapel. Among other representatives of the Estates of the
Bohemian Lands, Lord Chancellor Albrecht of Kolowrat
and Jan z Vartemberka (Johann von Wartenberg), Provost
of Prague and Litoměřice are portrayed here, the latter of
whom probably composed the iconographic programme
of this series of paintings.

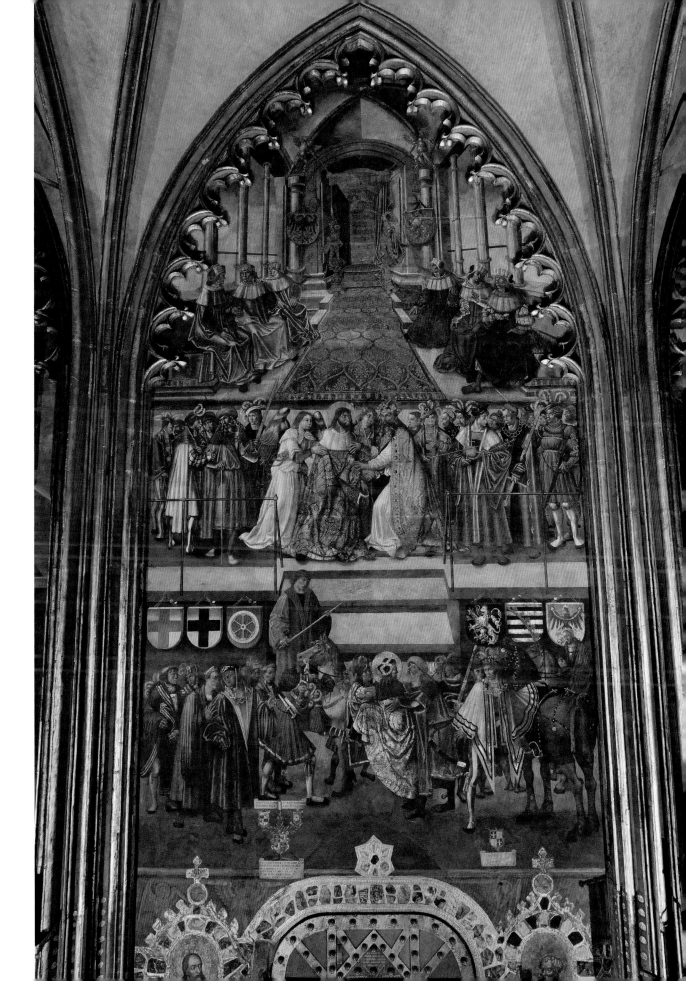

The paintings of the Master of the Litoměřice Altarpiece are renowned for their superb perspective, the setting of the scene in the landscape, genre details, and portraiture. The paintings were probably not finished until the coronation of the young heir to the throne, Louis Jagiellon, in 1509. Apart from portraits of King Vladislav II, his wife Anne de Foix, and the master builder Benedikt Ried, the attentive viewer will find on the north wall a view of the silhouette of Prague Castle. The programme for the decoration of the St Wenceslas Chapel was an expression of Bohemian patriotism and was intended to remind the monarch in this sacred space over the tomb of St Wenceslas of the important position he had assumed in the Empire as King of Bohemia.

In the upper band on the west wall, with the subject matter of St Wenceslas toiling in the vineyard, the artist has depicted, in a stylized form, the most important and best known of Ried's works, the Vladislav Hall, still with the original five tented roofs. After the fire of 1541, they were replaced with the design we see today.

10/ LUCAS CRANACH THE ELDER:
St Catherine and St Barbara with fragments of the figures of St Dorothy and St Margaret, *c*.1520, 105 × 173.5 cm, mixed media on a lime panel, Collection of Prague Castle

The altarpiece on the theme of the Glorification of the Virgin, from 1520–22, formerly adorned one of the chapels in St Vitus' Cathedral. It may have been commissioned by King Louis himself or the provost of the chapter, Arnošt ze Šlejnic, who was in close touch with the Elector of Saxony. The altarpiece suffered a sad fate: after a hundred years

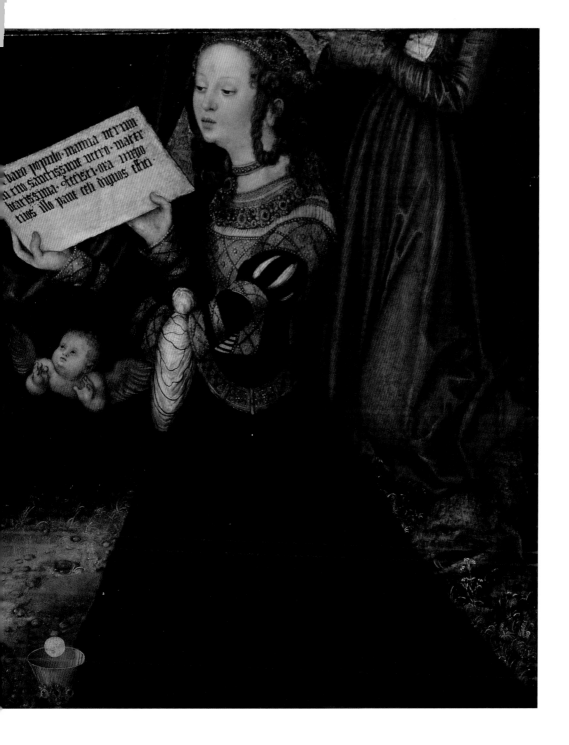

in the cathedral it fell victim to the iconoclasm of the Calvinists, who, led by the preacher Abraham Scultetus, destroyed the decoration inside the cathedral. The altarpiece was broken into several pieces, which were then deposited in the Castle gallery. In this state, it was of little interest even to the Swedish soldiers who had occupied the Castle in 1648, in order to bring the famous collections of Emperor Rudolph II to their queen, Christina. The greatest part of the central panel has remained in the Castle Gallery to this day; the smaller pieces were sold at auction in 1782 and ended up in various collections in Europe.

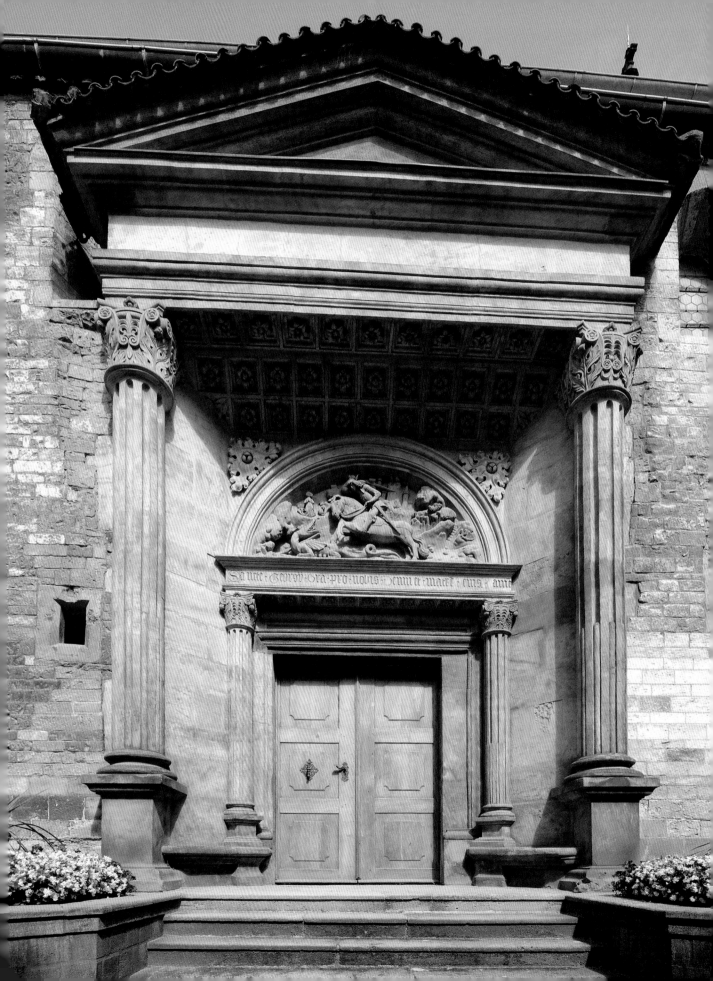

11A–B/ THE SOUTH PORTAL OF THE BASILICA OF ST GEORGE

The Romanesque south wall of the basilica of St George at Prague Castle is made of finely dressed ashlar masonry. It is interrupted by the grand Renaissance portal, which was probably designed by Benedikt Ried. This outstanding piece of architecture is surmounted by a marlstone tympanum, a high-relief sculpture representing St George slaying the dragon (this is a copy; the original is on display in *The Story of Prague Castle* permanent exhibition). The valiant knight bears a striking resemblance to the very young Louis of Jagiellon, who, in 1522, stayed at Prague with his wife Mary. The chambers in which they lived provided all the amenities of Renaissance housing. The early phase of the Renaissance style is evident in the relief sculpture in which the dragon-slayer saint represents the Christian world and the dragon the enemy of Christianity – the Turk. The war with the Turks turned out to be fatal for Louis. He drowned in a stream at the Battle of Mohács, in southern Hungary, in 1526.

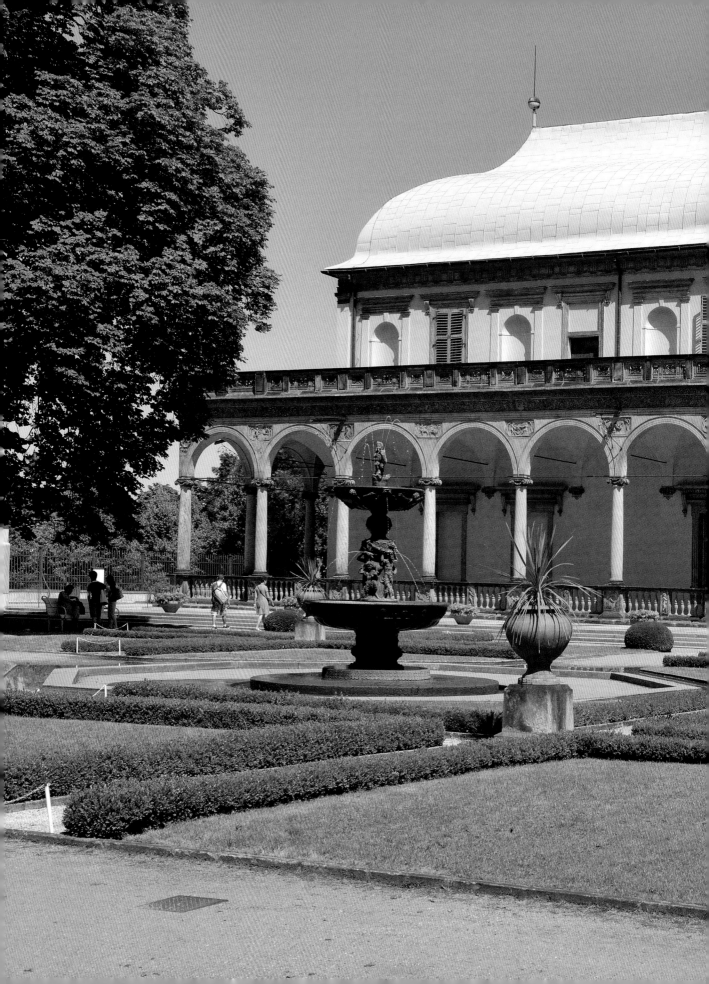

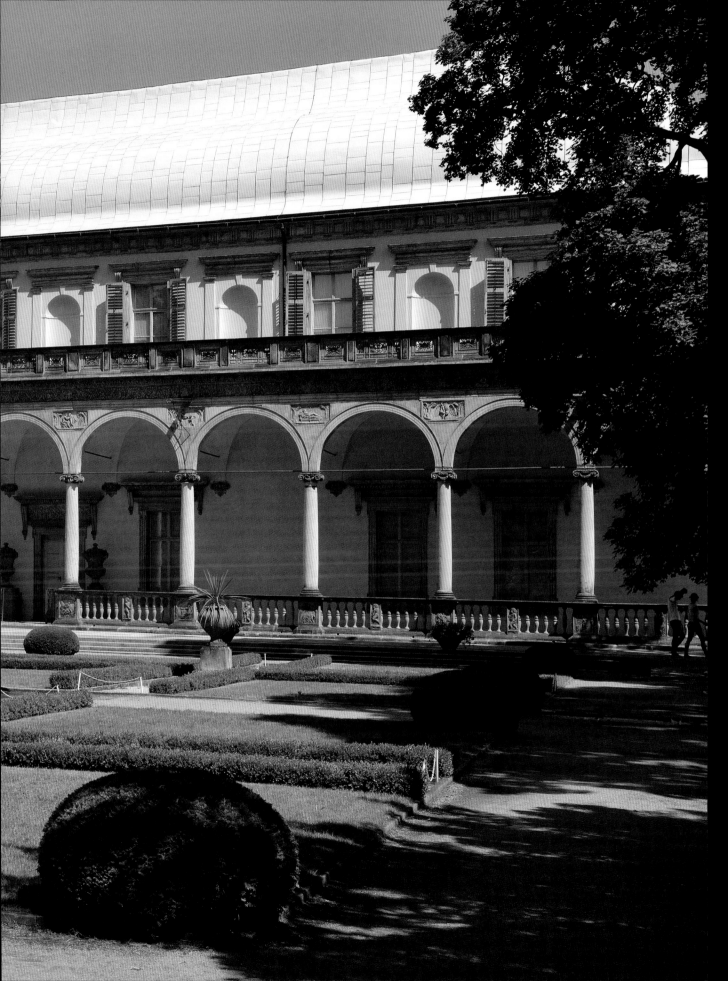

Emperor Ferdinand I ordered a royal garden to be built on a vineyard that he had recently purchased above the Deer Park Moat. At the far end of this piece of land on a promontory with a view of the city, he planned to build a summer palace (a *Lusthaus*), which at that time was becoming a requisite part of luxurious Renaissance residences. After the perimeter wall was erected, the master builder Paolo della Stella, together with thirteen superb masons, came to Prague from northern Italy in late 1537 and they set to work on the actual building. But things did not go as quickly as the emperor would have liked. The Italian masons threatened to quit unless they got paid. But they themselves caused offence by stealing the fruit harvest and also damaging the vines in the course of their work. By the time Paola della Stella died, the ground floor of the summer palace with its arcaded gallery, windows, and portals was finished, as were the relief sculptures for the column pedestals and the spandrels of the arcades. Nevertheless, the reliefs were not put in place until the first floor of the building and its unusual roof (in the form of the hull of a capsized boat) were finished. The first storey and the roof were designed by Bonifaz Wohlmut and built from 1556 to 1564. The result is widely considered one of the loveliest Renaissance buildings of its kind north of the Alps.

The summer palace was undoubtedly first and foremost a place of court entertainments and festivities, which is why there was also dance hall on the first floor.

The abundant outstanding relief decoration suggests that its scenes were chosen to commemorate both the happy marriage of Ferdinand I and Anna Jagiellon and to celebrate the monarch as the head of the Holy Roman Empire.

Rudolph II, who was not fond of noisy court entertainments, had items related to astronomy, which he collected, moved to the Summer Palace; its gallery then served his court astronomers in their observations of the heavens.

The Royal Summer Palace is also often called the Summer Palace of Queen Anne or simply the Belvedere.

The vaulted ceiling on the ground floor of the Royal Summer Palace

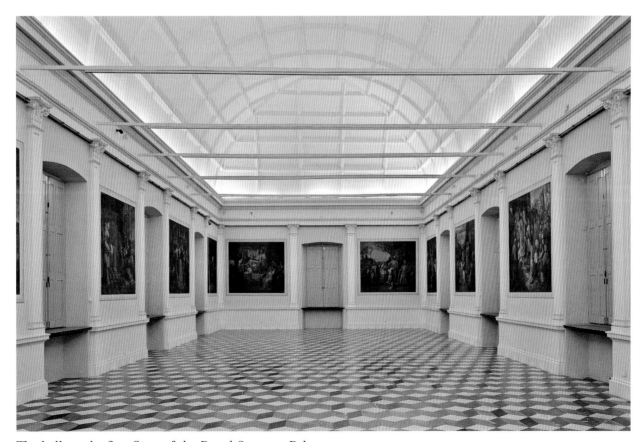

The hall on the first floor of the Royal Summer Palace

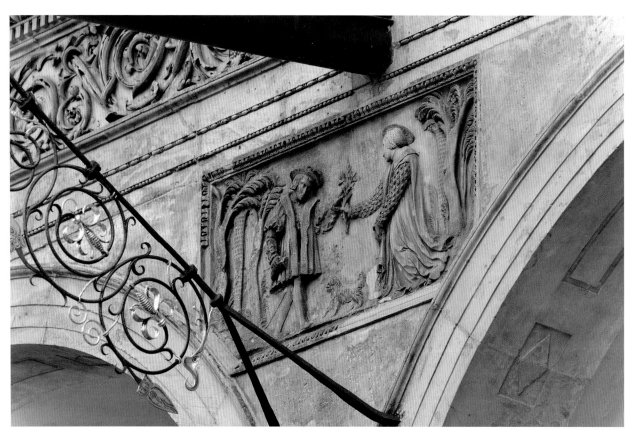

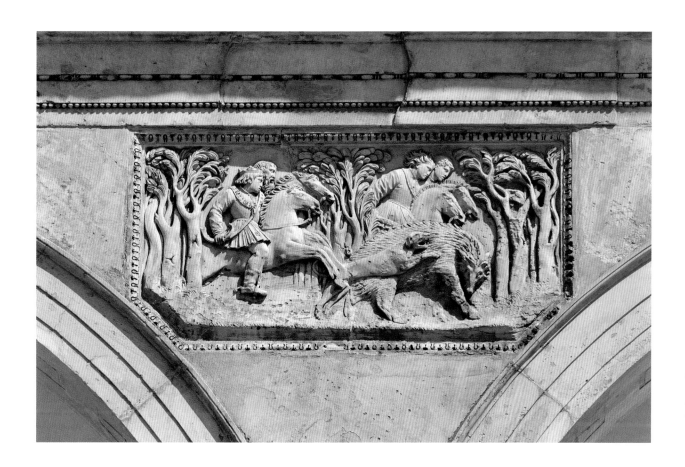

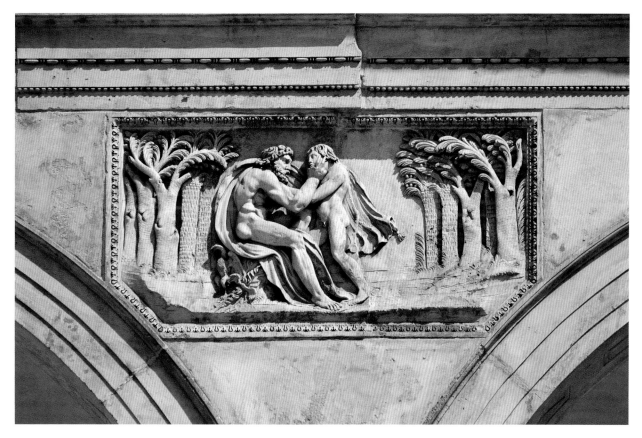

(97)

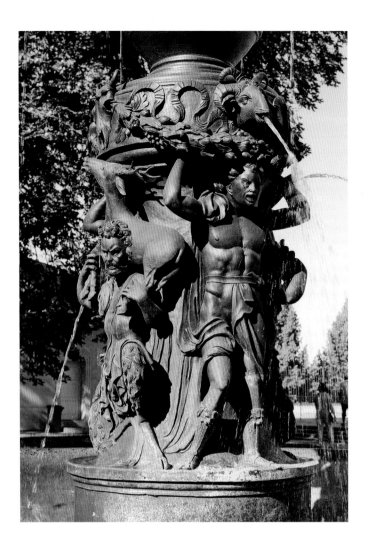

13A–B/ THE SINGING FOUNTAIN

In 1562, Francesco Terzio, a court painter of Archduke
Ferdinand II's, drew a design for a fountain that Emperor
Ferdinand I had ordered for the Royal Garden in Prague.
From the drawing, a model was made by the sculptor and
stucco artist Antonio Brocco. The wooden mould was made
by Hans Peysser, a Nuremberg woodcarver in the service
of the archduke. The casting of the fountain in bronze
was entrusted, in 1563, to Tomáš Jaroš, a metal founder,
gunsmith, and bell founder from Brno, Moravia, who was
working in Prague. The casting dragged on, however, until
1568, when the fountain was finished and could be chased.
After it was put into operation three years later, the fountain
attracted extraordinary attention from visitors to Prague.
When, in 1603, Pierre Bergeron, a French visitor, saw it, he
noted in his diary that the Royal Garden had 'a fountain that
plays like bagpipes; the water gushing from its top falls into
the basin so gracefully that it emits a harmonious sound like
the voice of that instrument'.

(98)

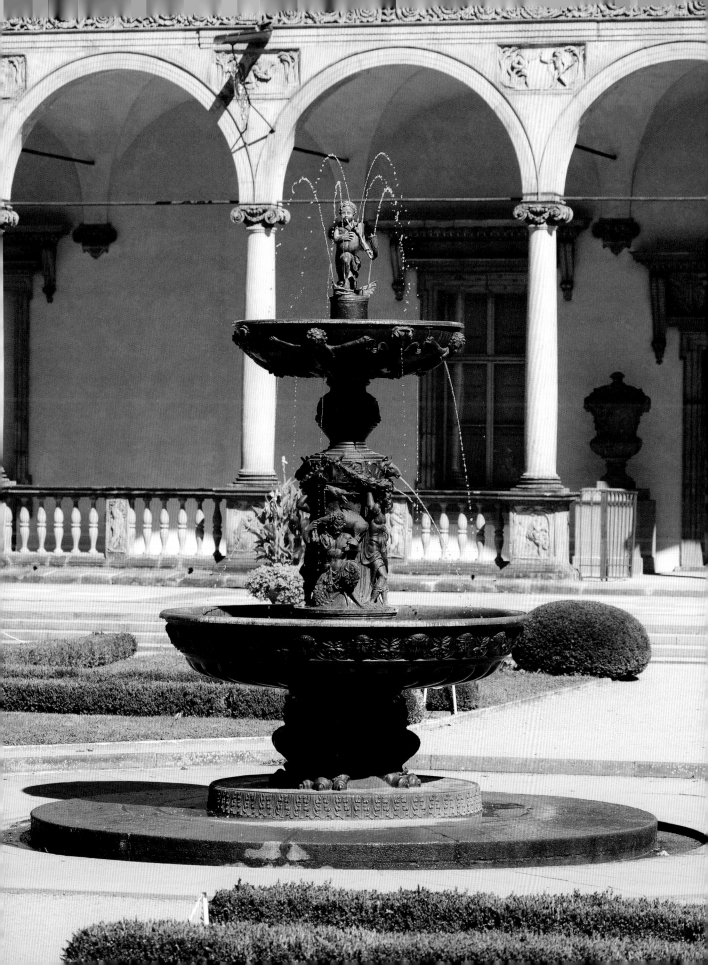

14/ THE FIG HOUSE

In 1560, Bonifaz Wohlmut drew up landscaping plans for terraces below the Royal Summer Palace. Some of the terraces in the upper part were meant to be planted with orange, pomegranate, and fig trees. In about 1570, the lower terrace was walled in and became the Fig House. The structure, which was roofless in the summer months, was given a temporary covering in the winter and was heated with a stove. The walls of the Fig House have been preserved to this day. After its renovation in the late twentieth century, fig trees were again planted here, and are still growing well.

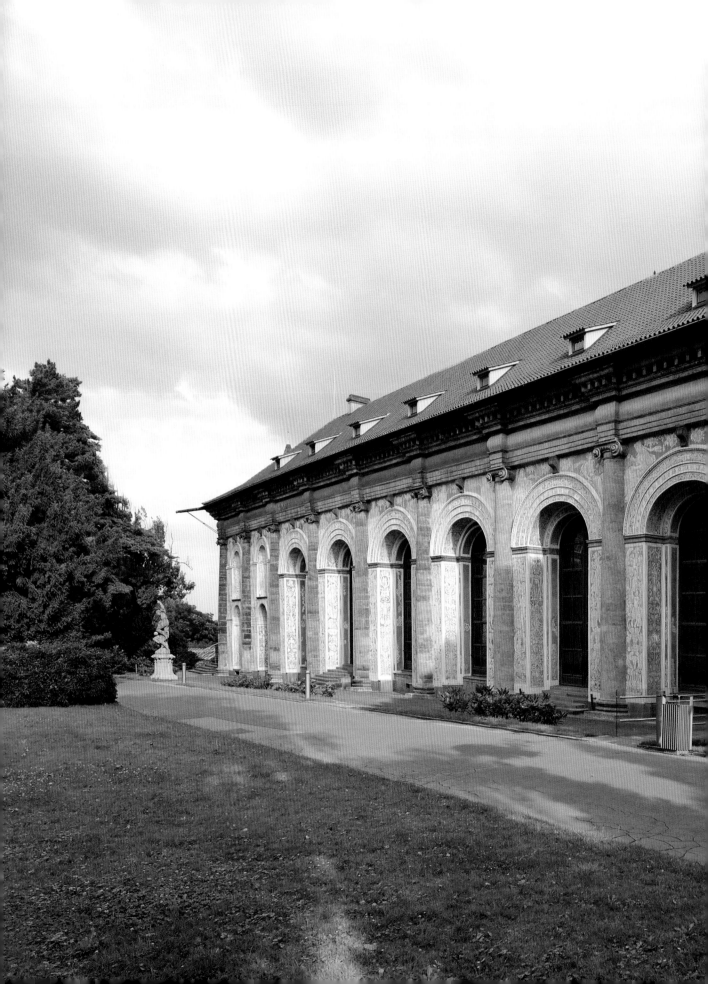

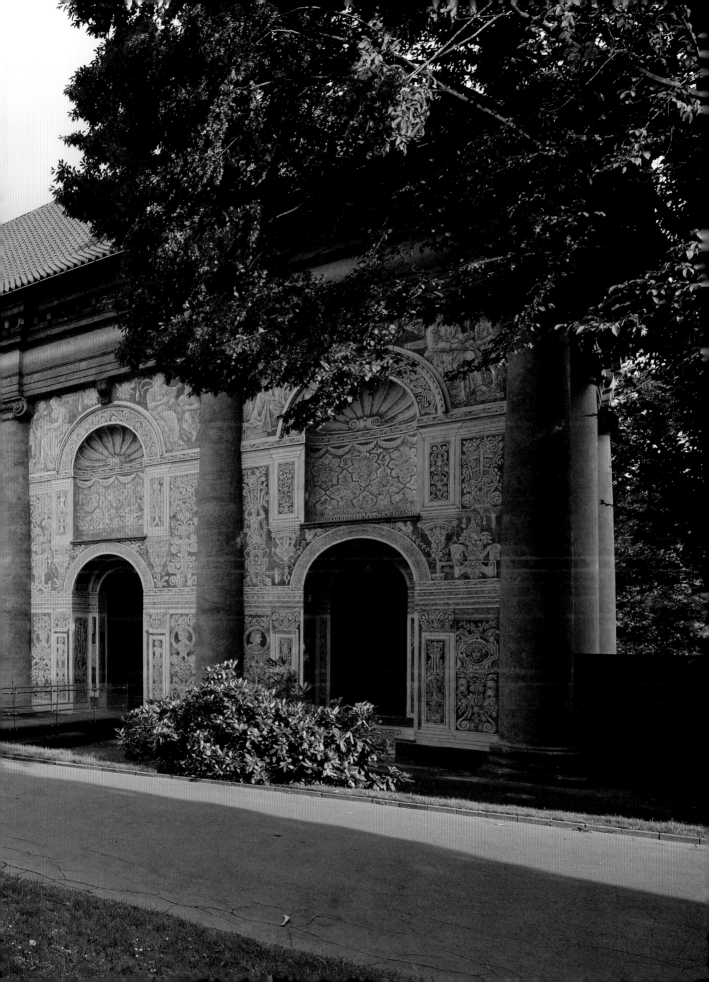

The Great Tennis Court was built in 1567–69 on plans by
Bonifaz Wohlmut in the Royal Garden. Tennis and other
similar ball games were among the popular amusements at
the courts of the nobility, consequently, in the precinct of
Prague Castle there were three or possibly even four tennis
courts, but this one was the largest and most impressive.
The massive semi-columns and the high arches of the
windows articulate the north façade, which is covered with
rich sgraffito decoration based on prints and representing
the Elements, the Christian virtues, the Seven Liberal Arts,
and a rich repertoire of ornaments. The Great Tennis Court
was accessible from the Castle through a wooden corridor
leading directly to it across the Powder Bridge (Prašný most).
Emperor Rudolph II could therefore play tennis and other
ball games unobserved: this is mentioned by François de
Bassompierre, later a French marshal, who visited Prague in
1604 and 'played ball there against the great Waldstein', and
the emperor came to watch 'our game through a louvre in
one of the windows leading to the tennis court, and he stayed
for a long time'. After a fire at the end of the Second World
War, the Great Tennis Court was thoroughly restored in 1952
by the architect Pavel Janák. During the restoration, two
socialist allegories were added to the spandrels in the central
bay: Industry, with the Five-Year Plan, and Agriculture with
stalks of grain and a sickle.

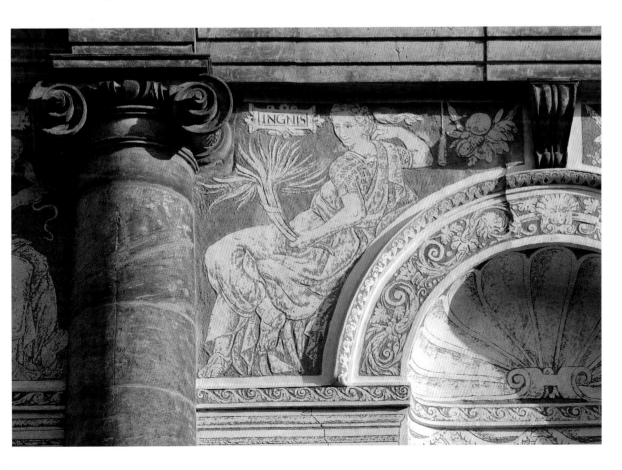

16A–F/ THE LORD BURGRAVE'S HOUSE (NEJVYŠŠÍ PURKRABSTVÍ)

The burgrave of Prague Castle was one of the most senior officials in the Bohemian Lands; appointed by the king, he presided over the Bohemian Diet and the Bohemian Law Court (*Landesgericht*). The seat of the burgrave had to correspond to his status in the country, and therefore already in 1335 the crown prince Charles of Luxembourg could be accommodated there when the royal palace was not yet completed. The great fire of 1541 also destroyed the house of the lord burgrave. The new, Renaissance-style house and its tower were erected from 1553 to 1555 by the master builder Giovanni Ventura. Other construction work was carried out from 1593 to 1596 under the direction of Ulrico Aostalli. His task here was to build accommodations for the emperor near the lord burgrave's house, to take the place of the converted prison in the White Tower, which the emperor had hitherto been using. The law court was also expanded, and decorated with scenes from the Judgement of Solomon, allegories of the Five Senses, and grotesques. The joists and beams of the ceiling are decorated with ornaments and charming imaginary landscapes with hunting scenes and allegories.

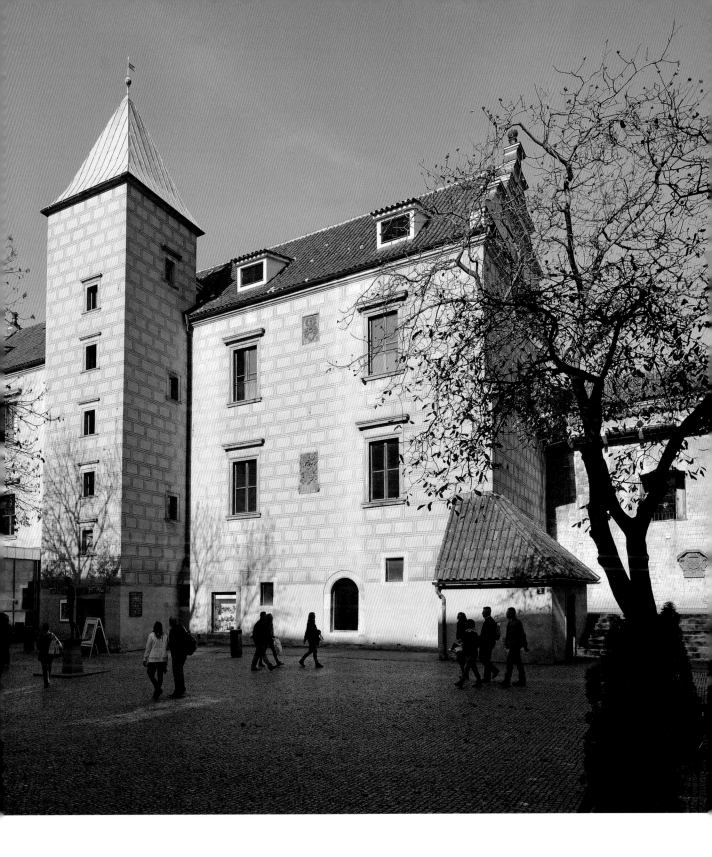

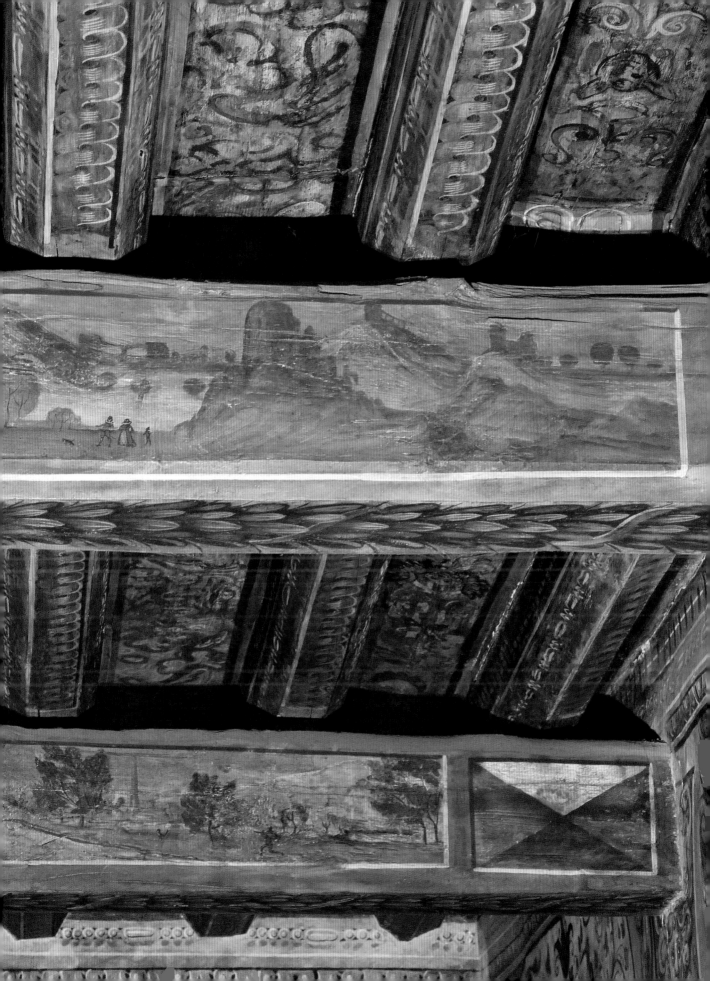

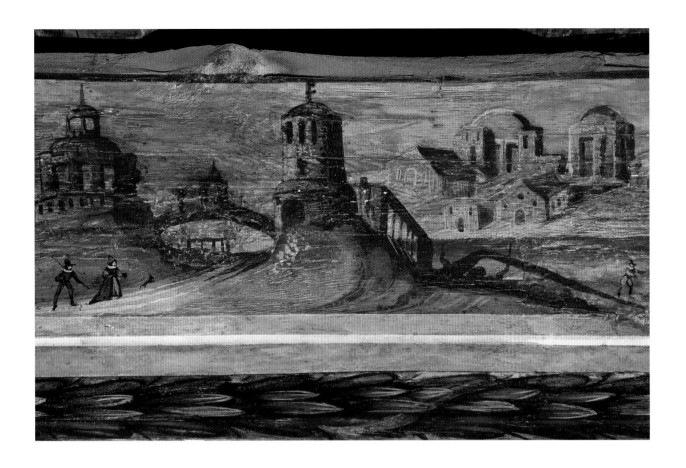

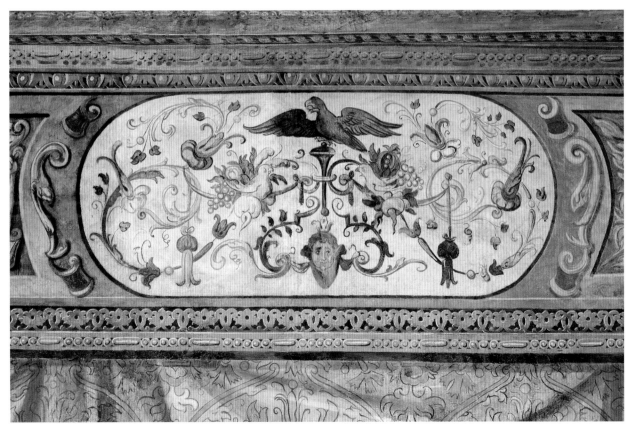

(111)

17A–B/ ROSENBERG HOUSE (ROŽMBERSKÝ PALÁC) – THE INSTITUTE FOR DISTRESSED NOBLEWOMEN (ÚSTAV ŠLECHTIČEN)

Peter the Elder of Rosenberg (z Rožmberka) had owned a house on this site since the 1520s. Peter the Younger, called the Lame (Kulhavý), made an agreement, in 1545, with Honz (or Hans) Vlach (whose real name was probably Giovanni Fontana of Brusata), for the building of a house, which was finished in 1556. While it was owned by William of Rosenberg (Vilém z Rožmberka) from 1573 to 1574, the Renaissance building was substantially enlarged by adding a new wing with a garden and colonnade. In the late sixteenth and the early seventeenth century, the house became part of the imperial residence in exchange for Lobkowicz House (today, Schwarzenberg House) on Hradčanské náměstí.

In the mid-eighteenth century, part of the Rosenberg House was converted into the Institute for Distressed Noblewomen (Ústav šlechtičen, Theresianische Adelige Damenstift). Its extraordinarily impressive appearance and its place in the panorama of the city is known only from *vedute* made in the seventeenth and eighteenth centuries. Although the recently renovated large hall on the ground floor gives us some idea of the size of this part of the seat of William of Rosenberg, Lord Burgrave of the Bohemian Kingdom, it says nothing about the exceptional overall grandness of this building. For a slightly better idea of that, we have at least the preserved drawings of the two façades and the courtyard, which were made before the total remodelling of the palace in the reign of Empress Maria Theresa.

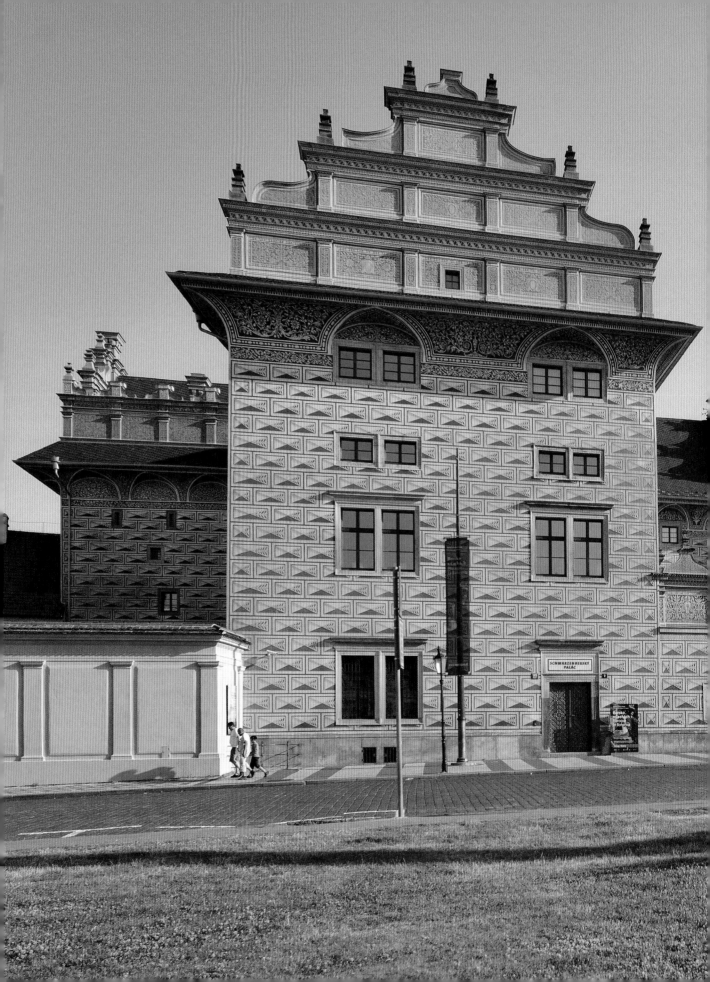

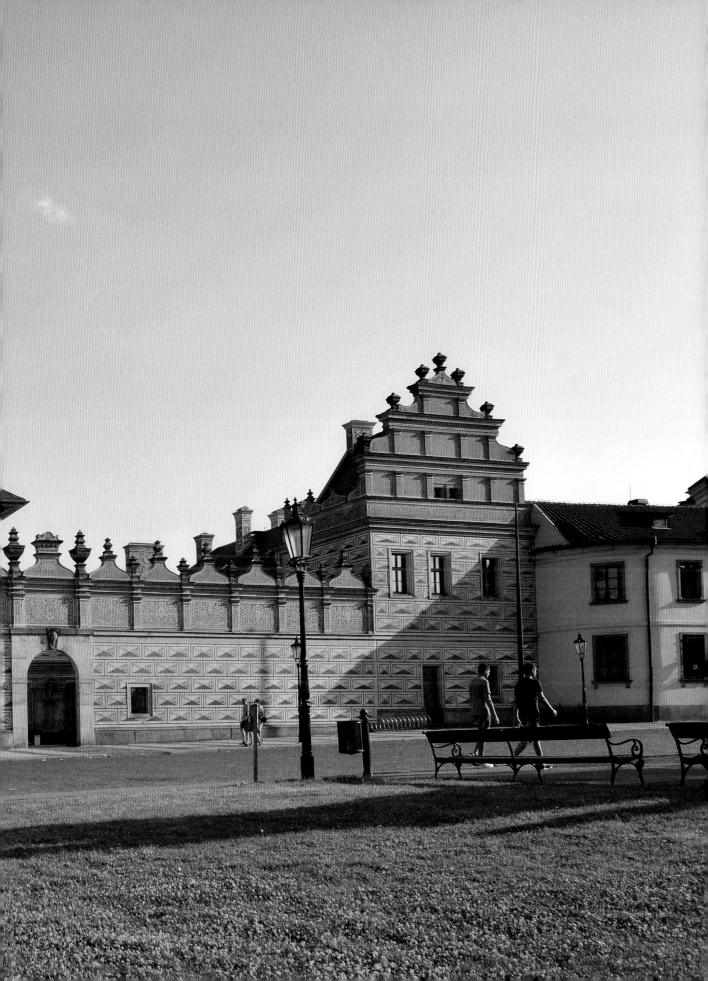

After the great fire of 1541, John the Younger of Lobkowicz gradually bought three buildings that had been damaged in the conflagration. The master builder Agostino Galli (whose name was czechified as Augustin Vlach) soon began to build a grand house for Lobkowicz on the edge of the slope above the town. This great edifice, completed by 1567 in a clearly visible place in the panorama of Prague, often changed owners. The heirs of John Lobkowicz the Younger sold the house in 1594 to George (Jiří) Lobkowicz, the Lord High Steward of the Kingdom of Bohemia. Four years later the house was confiscated from its new owner, who was sentenced to life imprisonment for treason, fraud, and lèse-majesté. Rudolph then advantageously exchanged it with Petr Vok z Rožmberka (Rosenberg) for his great house at Prague Castle. Vok's heirs were Švamberks (Schwanberg), and the house was confiscated from them too. And so in 1624 the Eggenbergs became the new owners. The house was not given its current name until 1719, when Prince Adam Francis Schwarzenberg became the heir general of Marie Ernestine von Eggenberg, née Schwarzenberg.

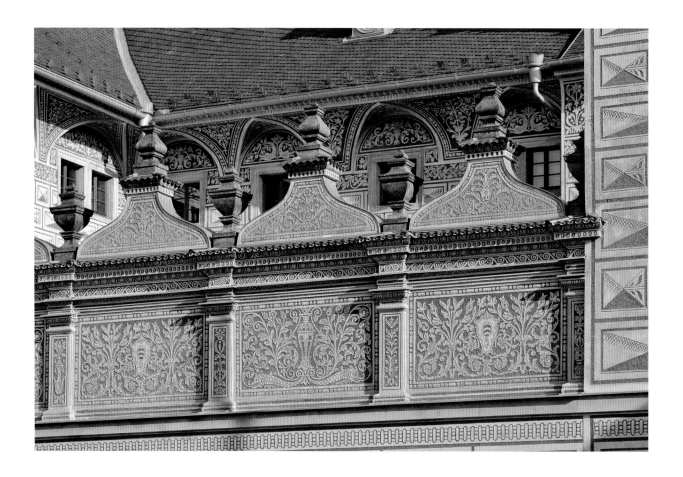

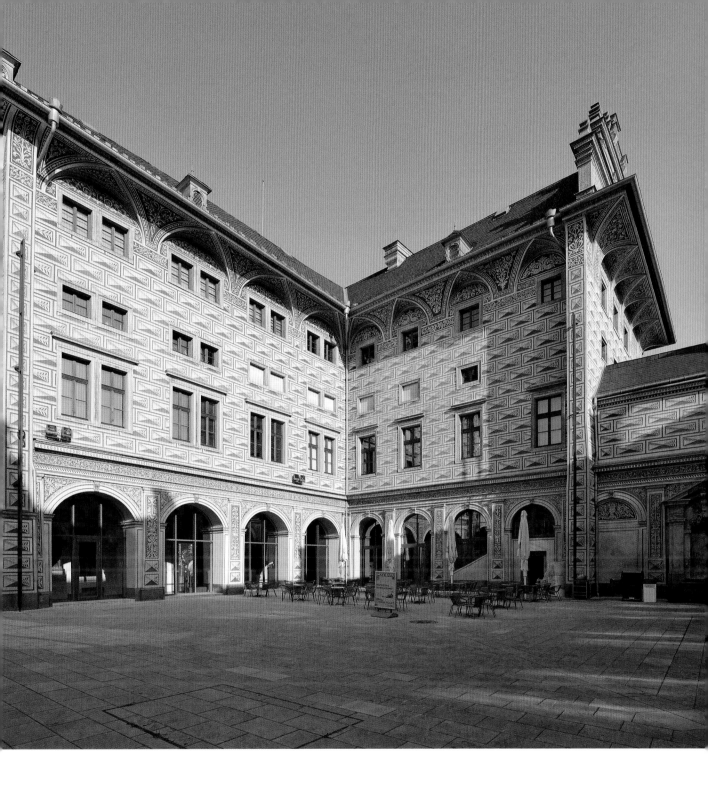

(117)

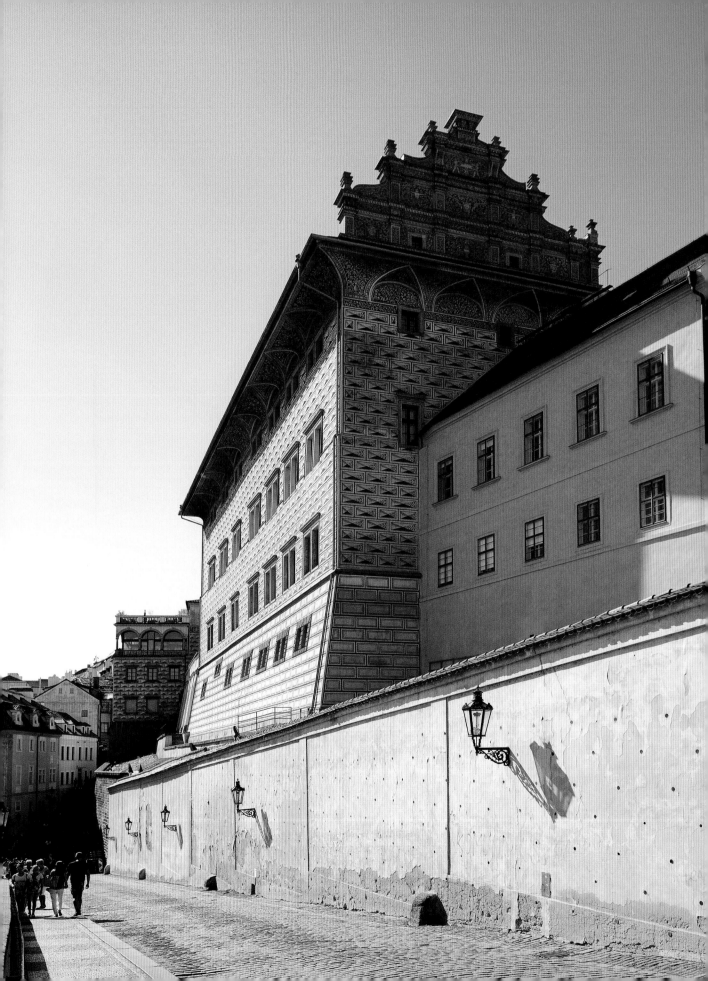

The external appearance of the house has almost not changed at all since the late sixteenth century. It was, however, given new sgraffito decoration from 1871 to 1890, on designs by the distinguished Prague architects Josef Schulz and Jan Koula. The interior underwent more substantial change, yet some elements, for example, some of the Renaissance vaults, portals, and paintings on the second floor of the north and the east wing from *c.*1580 have been preserved. Today, after recent thorough research, reconstruction, and restoration, the house is again open to the public, who come to see the National Gallery's collection of Bohemian Baroque art.

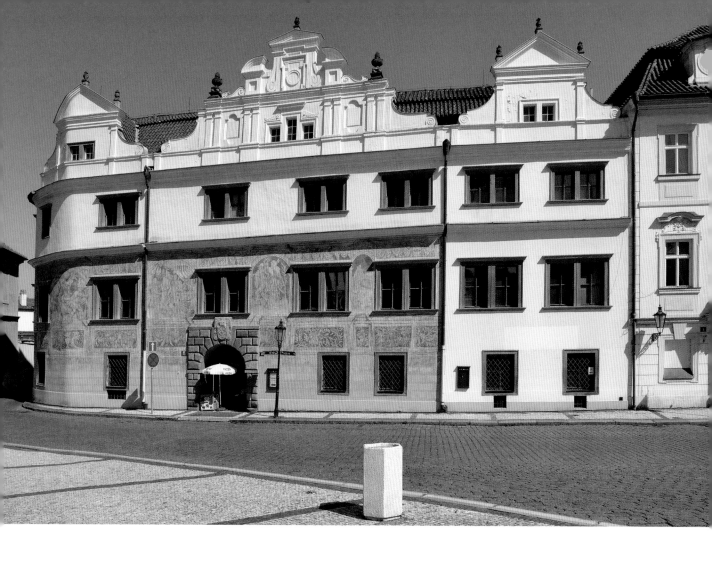

19A–B/ MARTINITZ HOUSE (MARTINICKÝ PALÁC)

In about 1580, Jiří Bořita z Martinic bought from Ondřej Teyffl (Andreas Teufel von Zeilberg) a two-storey house on the corner of Hradčanské náměstí (Hradčany Square). He had the house considerably enlarged and had the façades on the street and courtyard sides richly decorated with figurative sgraffito. The second large phase of building took place after the house was inherited by his nephew, Jaroslav Bořita z Martinic, a representative of the Emperor, now known mostly as a vicitm of the Second Defenestration of Prague (1618). He built a wing with a stately room on the first floor and a projection on the north side facing the Deer Park Moat (Jelení příkop). In more recent times, the house has been the Office of the Chief Architect of Prague, and was renovated at great expense from 1967 to 1973 and from 1996 to 1999. Its abundant sgraffito decoration draws its subject matter from the Old Testament, classical mythology, and prints by various sixteenth-century artists.

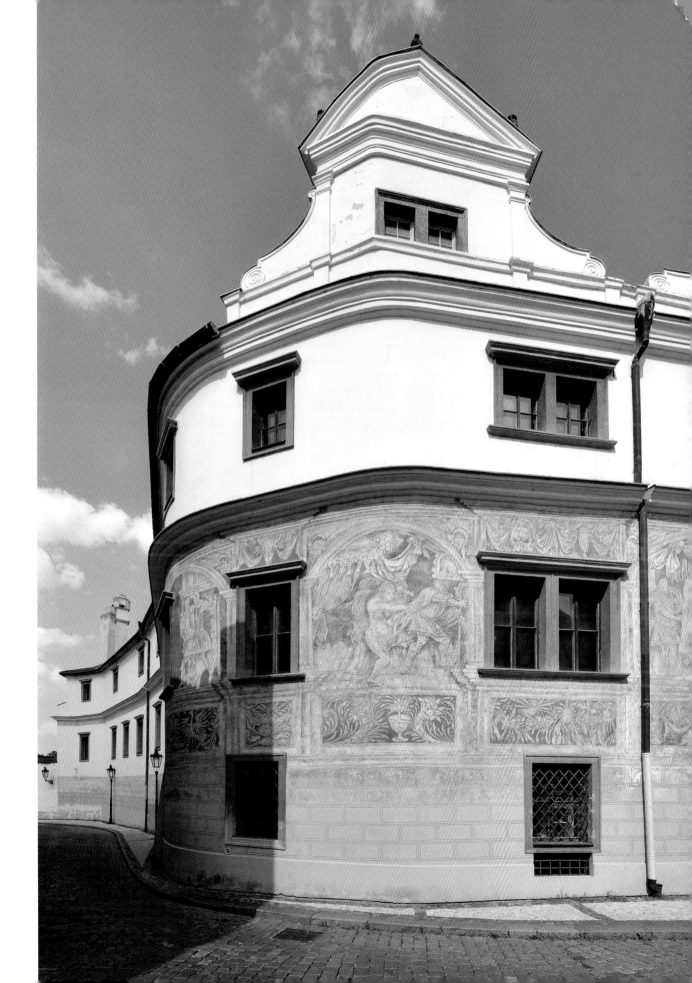

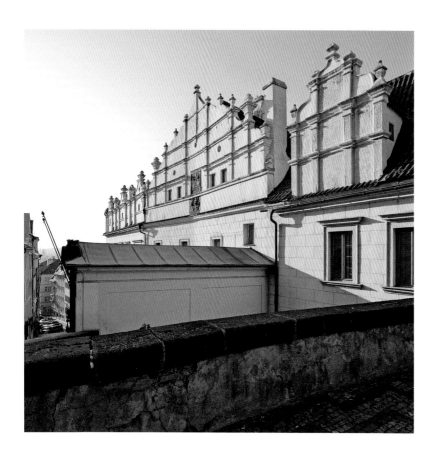

20A–B/ HRADEC HOUSE (PALÁC PÁNŮ Z HRADCE)
(THE FAÇADE OF WHAT IS TODAY THUN HOUSE,
FROM THE CASTLE STEPS)

Jáchym z Hradce bought the house 'below the Castle Steps' (Zámecké schody), from Burian Žabka, mainly because of its location just below Prague Castle. From 1561 to 1566, Jáchym had it substantially remodelled and enlarged, so that it reflected his standing as Lord High Chancellor of the Kingdom of Bohemia and a privy councillor to Emperor Ferdinand I and Maximilian II. The palatial building was completed at the Castle Steps with a tower surmounted with a cupola, from which one had a splendid view of the greenery of Petřín hill and the whole city. Jáchym z Hradce, however, did not live to see the building completed: he drowned shortly after having set out from Vienna on the journey home to Prague, when the bridge over which his carriage was travelling collapsed. His son Adam II was also an official at court (even becoming, in 1593, the Lord Burgrave, during the reign of Rudolph II), and a builder. Further remodelling of the house was probably carried out under a master builder at the court, Ulrico Aostalli, from 1580 to 1593, when a new storey and a new wing were added on. The façades were unified with simple sgraffito 'rustication', which we can admire to this day on its north side (facing the steps).

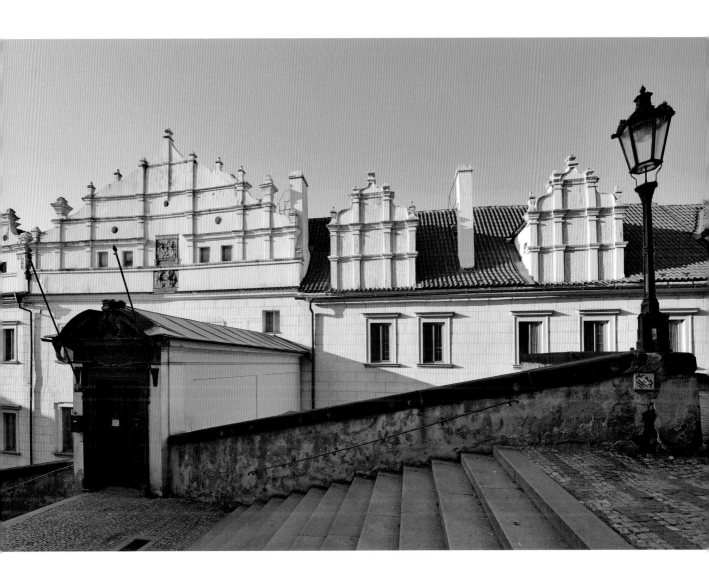

21/ HRADČANY TOWN HALL (HRADČANSKÁ RADNICE)

Until 1592, Hradčany, the Castle district, was under the jurisdiction of the lord burgrave of Prague Castle. When Rudolph II raised Hradčany to a royal borough, a suitable building had to be found for its town hall. An existing building was thoroughly remodelled from 1602 to 1605. On the property of the town hall there was a taproom and, in 1616–17, new butcher's shops were built here to replace old ones. In 1602, Mariano de Mariani was paid for his depictions of 'Justice and whatever else he painted' on the façade. The original façade decoration was over-painted in the reign of Emperor Joseph II (*reg.* 1765–90), when, with the merging of the Prague towns, this town hall was closed down and the building was sold to a private owner. In 1914, the sgraffito on the façade, including the coats of arms and the allegory of Justice, was restored.

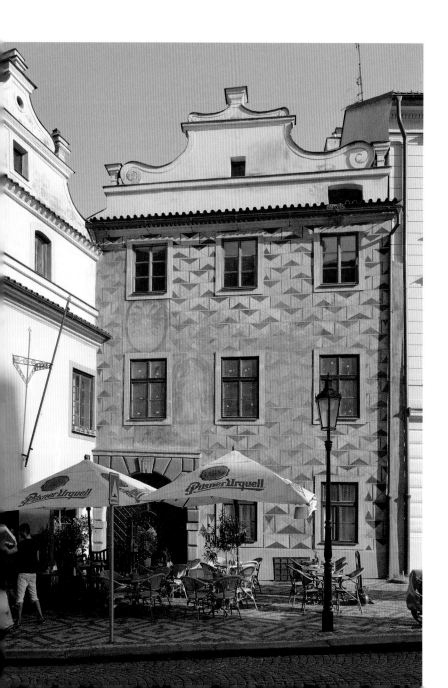

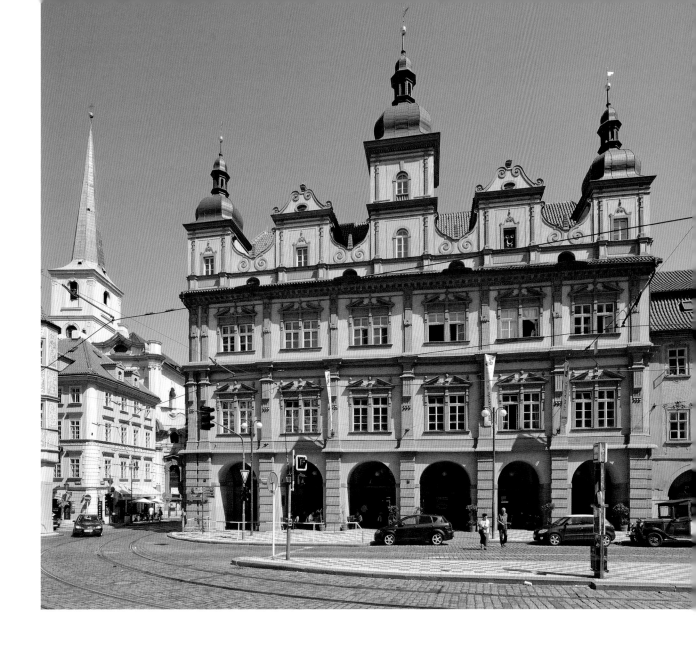

22/ THE TOWN HALL OF THE LESSER TOWN (MALOSTRANSKÁ RADNICE)

The seat of the town hall of the Lesser Town of Prague (Menší Město pražské) changed three times from the thirteenth century onward. It has been at the present location since the late 1470s or early 1480s. After two great fires, in 1503 and 1541, it was considerably enlarged in the 1580s, which is also when a brewery was built in the courtyard. The attack, in 1611, by the troops of Leopold V, Archduke of Austria and Bishop of Passau, was disastrous for the town hall: it was not only plundered but also seriously damaged. Consequently, the Lesser Town representatives requested Emperor Matthias, Rudolph's successor, to provide financial assistance to build an impressive and dignified new town hall.

The plans for its thorough rebuilding, from 1616 to 1619, could only have been drawn up by a master builder of extraordinary skill, perhaps from the court. In our day, from 2006 to 2009, the town hall was completely renovated, restoring its original appearance with the turrets and gables which had been removed in 1818.

23A–B/ SPA HOUSE (DŮM ZVANÝ LÁZEŇ, ALSO VELIKOVSKÝ HOUSE)

The first Renaissance remodelling of this originally late Gothic house was carried out in the 1540s. Further construction work in the late sixteenth and early seventeenth centuries greatly increased the quality of the building. According to a list of houses from 1608–12, it belonged to Georg Ghel, the chairman of the Lesser Town council. When he died, his widow, Anna, inherited the house. She then married Hans Jakob König, assistant to the Keeper of the Imperial Collections and son of a famous antiquary. The family was still in the emperor's service in the 1640s. In our day, after extensive renovation in the 1990s, fragments of sgraffito decoration were found on the façades, together with the oldest sundials in Prague, from 1608.

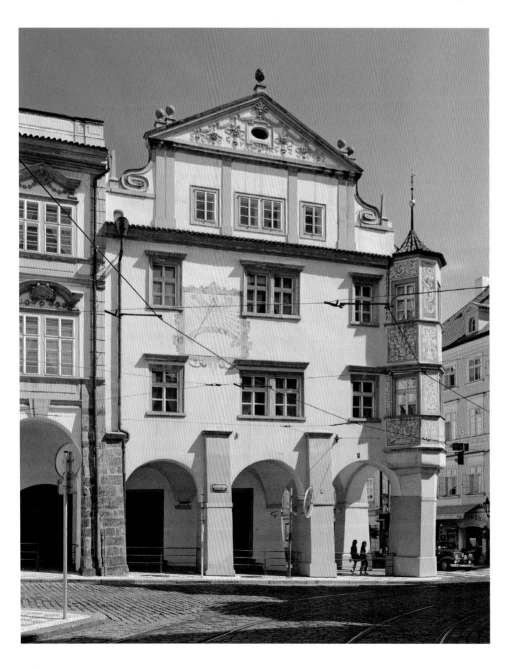

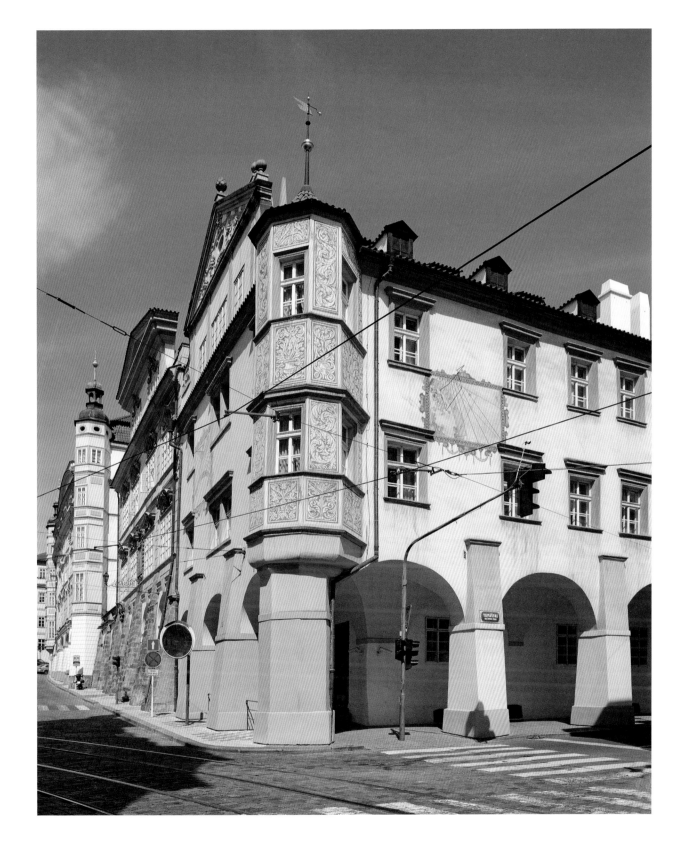

(127)

24A–B/ THE THREE OSTRICHES (DŮM U TŘÍ PŠTROSŮ)

The little Gothic houses at the end of Charles Bridge gradually gave way to new, Renaissance houses. One of the properties was bought, in 1597, by Jan Fuchs, a maker of ornate feather decorations for hats for the imperial court. He considerably enlarged the house, remodelled it, and had the façade decorated with wall paintings. This work was by the court painter Daniel Alexius z Květné, whose other work includes the decoration of the Wenceslas Chapel in St Vitus' Cathedral. Only fragments of his façade paintings are still preserved – the house sign between the windows and the helmet with an ostrich plume, which is painted on the corner. Ostrich feathers also appear on the decorative window surrounds, and the rooms on all three floors were also decorated with paintings. Everything was meant to suggest the craftsmanship and know-how of the artisan owner.

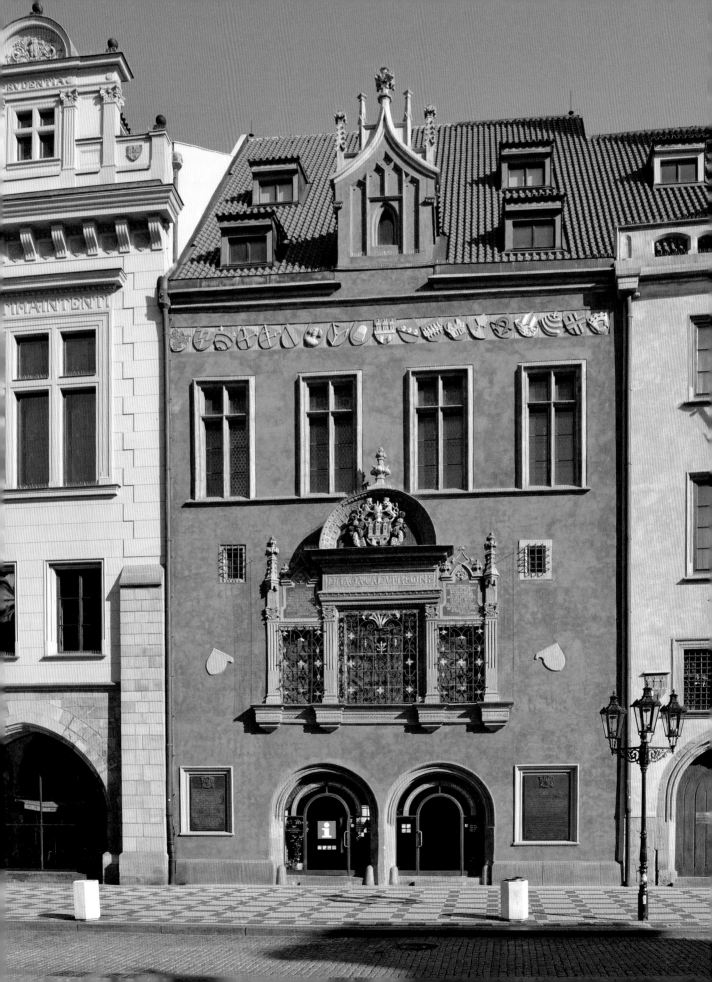

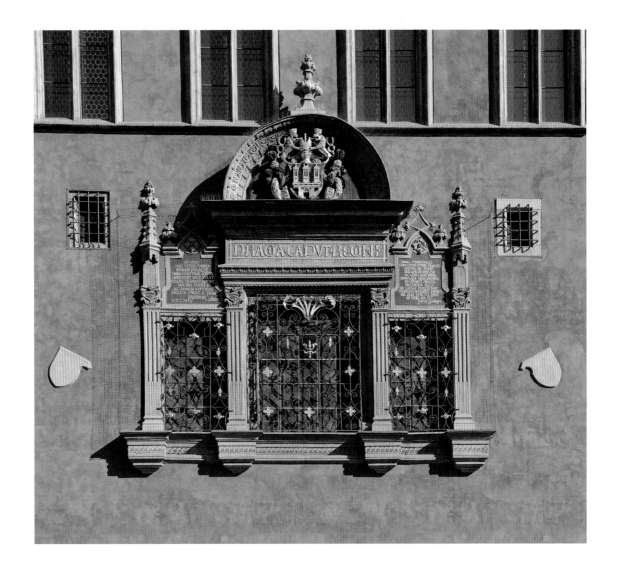

25A–B/ THE TOWN HALL OF THE OLD TOWN (STAROMĚSTSKÁ RADNICE)

The unification of the Old and the New Town of Prague
in 1518, approved by King Louis II five years later, led
to further construction work on the town hall of the Old
Town. At that time, its façade on the first floor below the
council hall was decorated with a huge Renaissance window
surmounted by a semicircular tympanum. It makes clear
reference to the source of its inspiration – the windows
and portals of the Old Royal Palace, at Prague Castle, by
Benedikt Ried. The town hall window was set into the façade
after 1519, during repairs after the collapse of the stone
staircase on the south side. The lower side windows were not
inserted until 1731. The window grilles are Baroque.

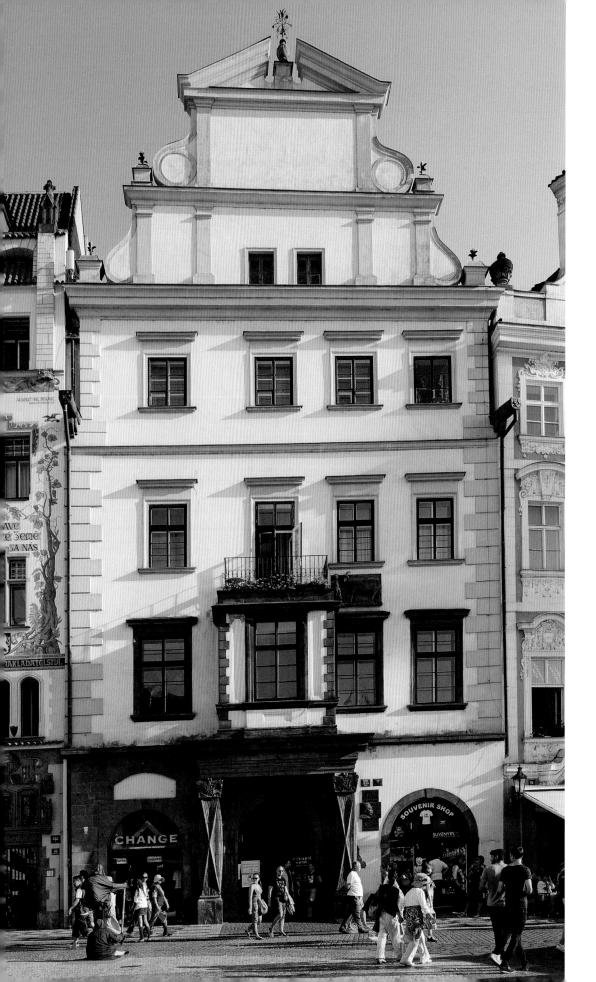

(132)

26A–C/ THE PORTAL OF THE STONE LAMB (DŮM U KAMENNÉHO BERÁNKA)

The Gothic house called U Kamenného beránka was in its day among the most impressive on Old Town Square (no. 551). Towards the end of the fourteenth century a wing was added onto the courtyard side, making this house, on one of the most expensive locations of the Old Town, even more valuable. Further modernization of the house was carried out in about 1531, when it was given a new entrance. The huge portal was designed in the new, Renaissance style, similar to Ried's portals in the Old Royal Palace.

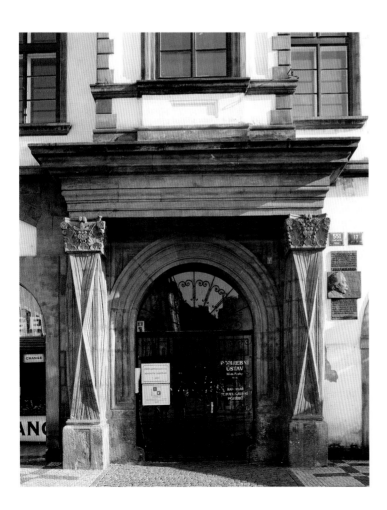

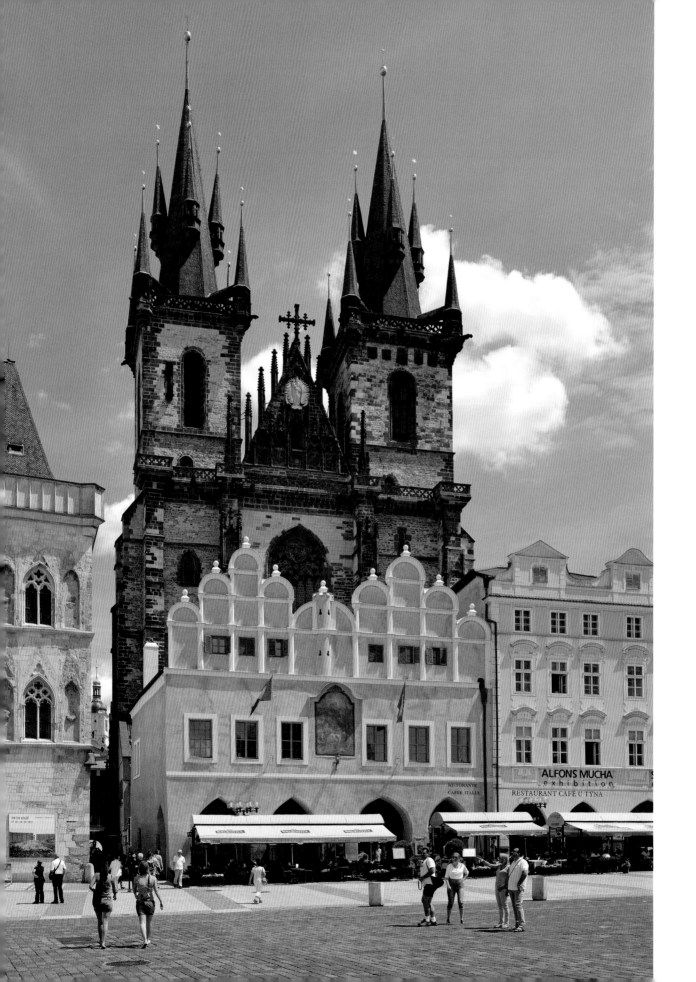

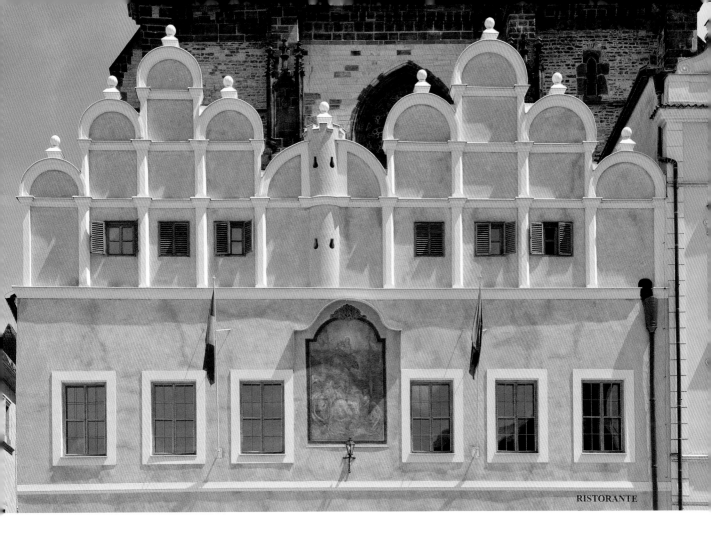

RISTORANTE

27A–B/ THE THEIN CHURCH COLLEGE (TÝNSKÁ ŠKOLA)

This Prague school of Latin, established by the Church of the Virgin Mary before the Thein (Panny Marie před Týnem) at the start of the fourteenth century, acquired a new building under King Wenceslas IV (*reg.* 1378–1419) in front of the Thein Church. Two townhouses were bought for the school before 1407 by master masons of the Thein Church. After the Hussite Wars, the school remained Utraquist, and the master mason Matěj Rejsek became its rector in about 1475. Before the mid-sixteenth century these houses of the Thein Church College were united and given new façades – three huge arched gables, of which the middle one is lower and has a turret with loopholes. The master builder found his inspiration for this design in the Venetian architecture of the period. Thus, in addition to the large window on the town hall and the portal of the Stone Lamb (U Kamenného beránka), another striking Renaissance building appeared on Old Town Square.

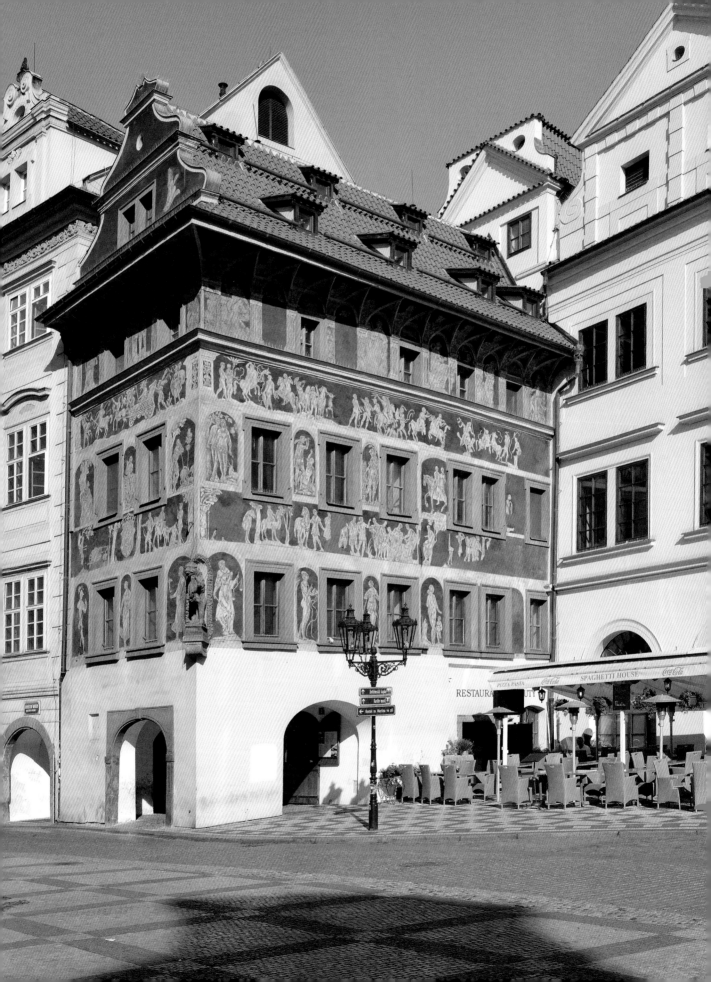

28A–B/ MINUTE HOUSE (DŮM U MINUTY)

Visitors to Old Town Square (Staroměstské náměstí) are always drawn to this house, whose façade is covered in rich sgraffito decoration. It used to be called the White Lion (U Bílého lva) and also the Chimney-sweeps (U Kominíků). Only much later was it renamed U Minuty, an appellation, however, that has nothing to do with time. Instead, it refers to the 'minutely' cut tobacco that used to be sold here. The small medieval house, enlarged by the purchase of part of the neighbouring house, was made even bigger when, before 1564, a third storey was added on. It was surmounted by a cornice with lunettes. In 1601, the house was bought by the Přehořovský z Kvasejovic family, who commissioned the sumptuous sgraffito of the façades. The work, depicting mythological, biblical, and historical scenes, was carried out in two stages. During various remodelling in the late Baroque period the sgraffito was whitewashed. It was not restored until the 1920s. The young Franz Kafka lived with his parents on the second floor of the house from 1889 to 1896.

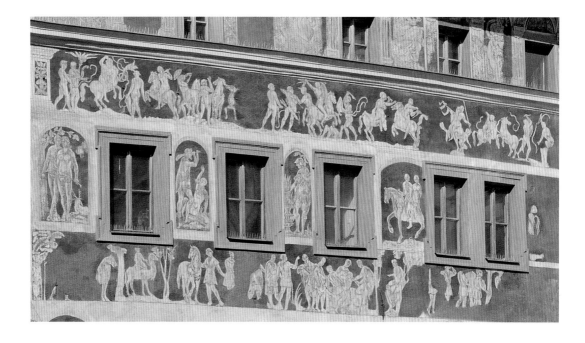

29A–B/ GRANOVSKÝ HOUSE IN THE UNGELT

Since the Middle Ages, the Thein (Týn) Courtyard, called the Ungelt (from the Middle High German word *Ungeld*, *Umgeld*, or *Ohmgeld* for a sales tax), was the central point of the international trade routes through Prague. Under the protection of the monarch, it was a place for merchants to stay, to store goods, weigh them, and pay the customs duties. In 1548 Jakub Granovský z Granova became the manager of the Ungelt. With the full authority of his office, he settled all outstanding debts on the Ungelt house, and requested Emperor Ferdinand I to give him this neglected building (nos. 639 and 640) in return for faithful service and the promise that he would repair it. The emperor granted his request in 1558, on the condition that Granovský would hire a gatekeeper for the Thein Courtyard.

While Granovský was in charge, the costly Renaissance building was erected in 1559–60. First, the existing parts of the house were remodelled, then a wing was added onto the courtyard with arcades on the ground floor and upstairs, and the façades were decorated with sgraffito. The Ungelt is a superb example of classic Renaissance architecture in the Bohemian Lands. The extraordinary impression it makes is intensified by the lavish chiaroscuro decoration of the courtyard façade with biblical scenes similar to the work of Francesco Terzio, a court painter to Archduke Ferdinand II.

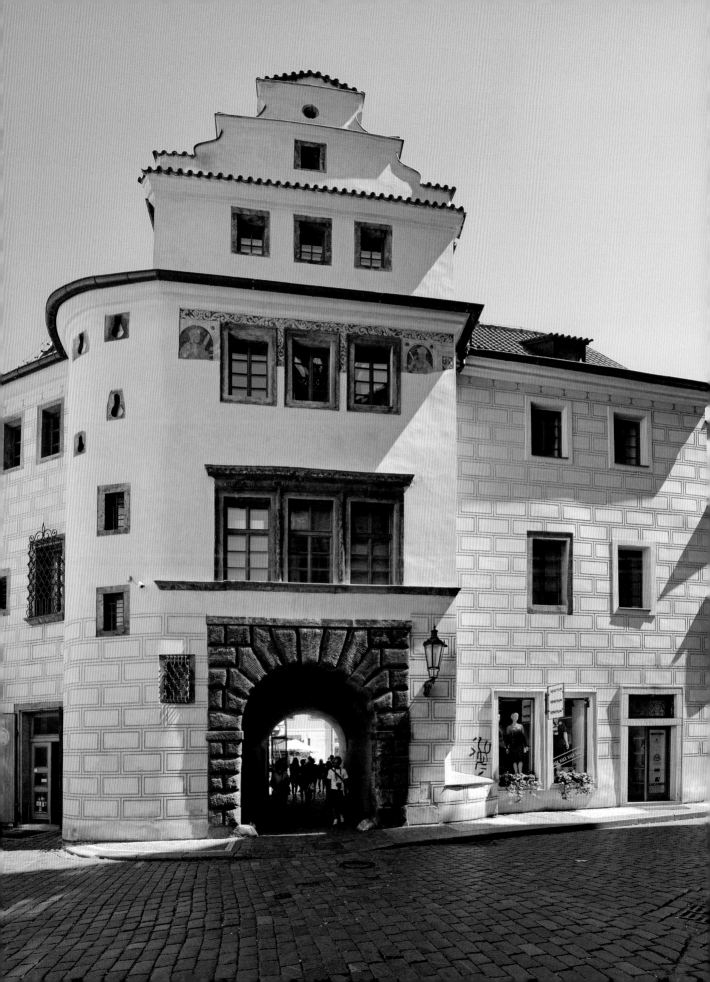

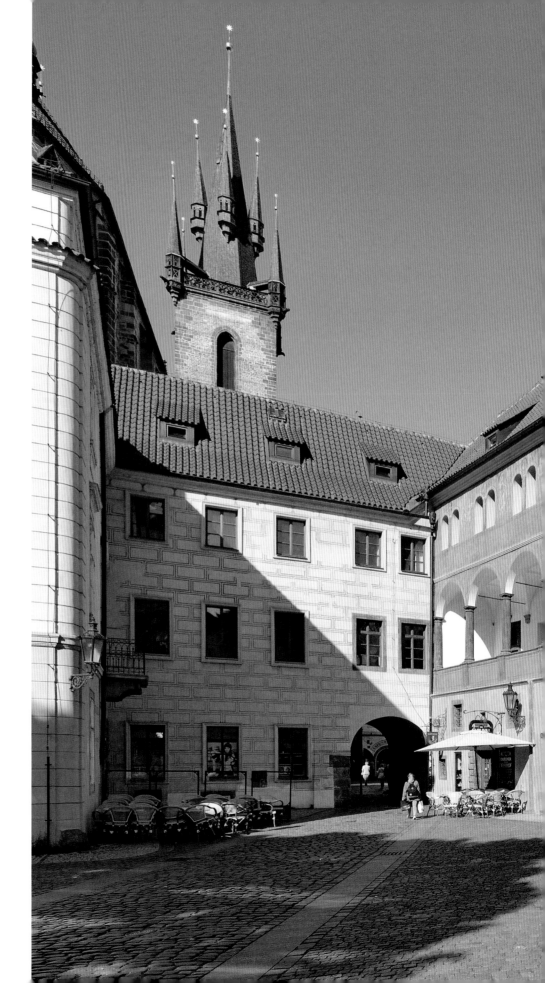

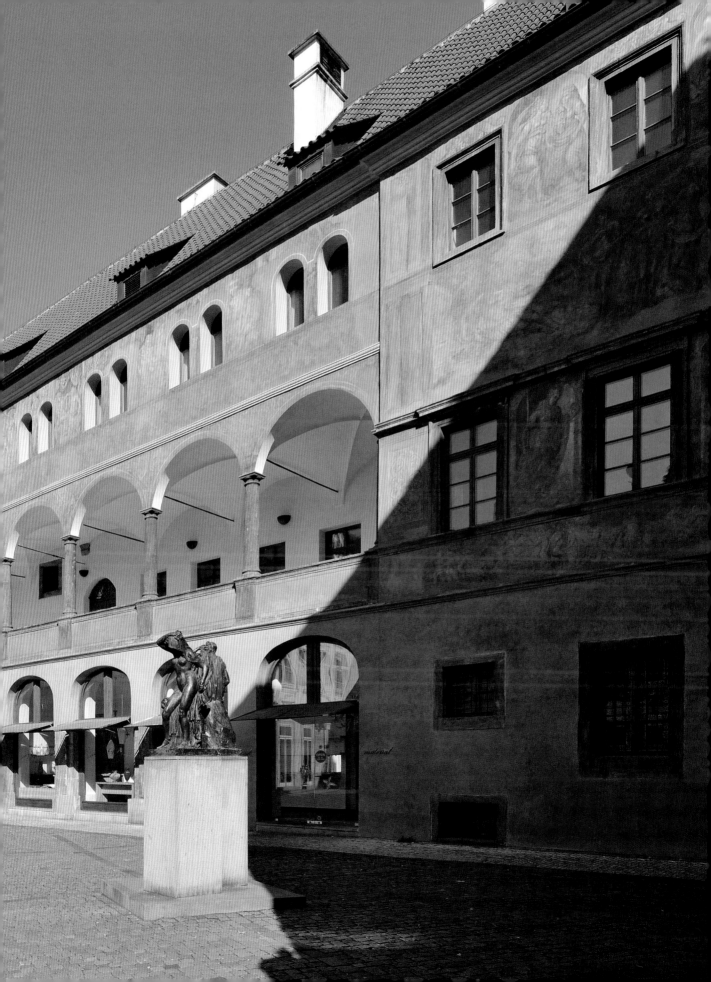

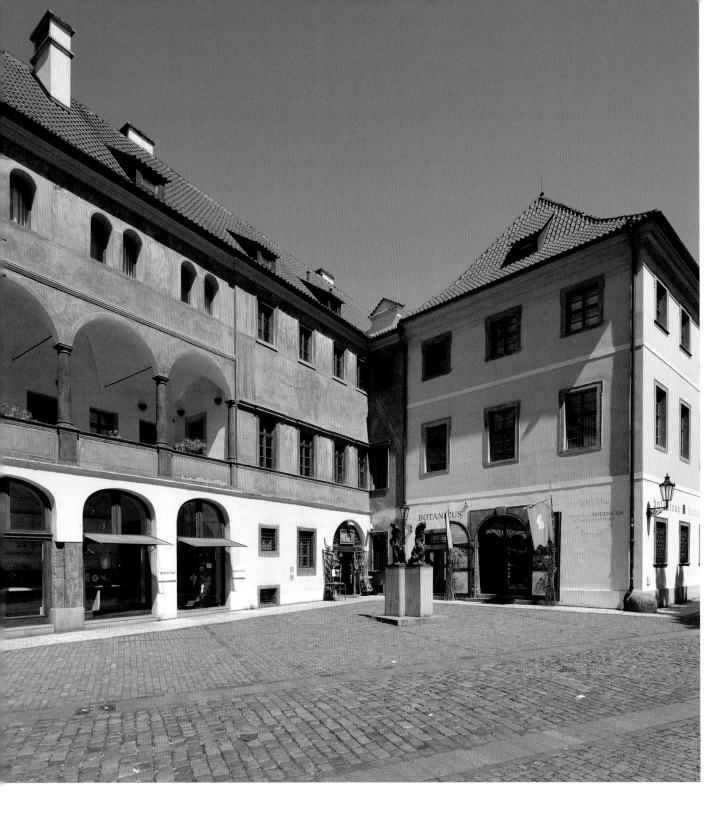

29C–E/ PETRÁČEK HOUSE IN THE UNGELT

After 1560, thanks to Jakub Granovský z Granova the Younger, the originally medieval Ungelt was transformed into a large Renaissance palazzo with façades richly decorated with sgraffito. Part of the complex, linked on the west with the main building, today house no. 640, was inherited in 1667 by Markéta Petráčková – hence the name Petráček House (Petráčkovský dům). Earlier, when it was owned by the Granovský family, this part of the Ungelt was like an independent building with a small courtyard with arcades on the first floor (visible from today's Štupartská ulice). Whereas the façade towards the street is covered with simple sgraffito decoration in the repeating geometric pattern reminiscent of the back of an envelope, the courtyard was given lavish decoration that we can admire today thanks to comprehensive reconstruction which returned the Renaissance character to this part of the house.

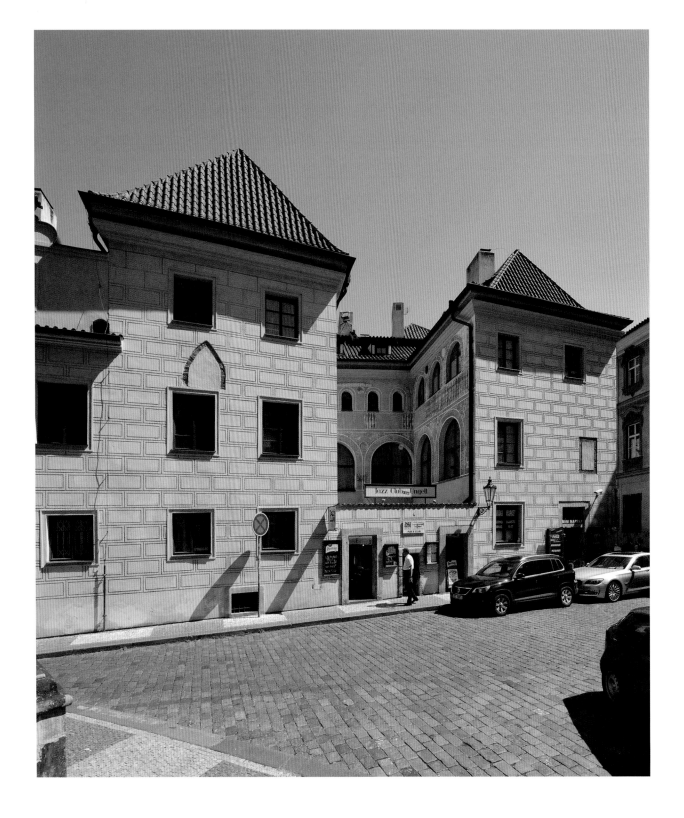

(144)

By 1609 the Gothic house by the entrance to the Ungelt, in which wine
tasters used to live in the fifteenth century, was thoroughly rebuilt
in the Renaissance style. In the sixteenth century, it was already a
patrician's house. Later it was bought by Franz Osterstock, a beer-tax
collector, whom, in 1604, Emperor Rudolph II granted a coat of arms
and the nobiliary particle 'von Astfeld'. At that time, the house was
given a third storey; the big Renaissance vaulted taproom (*mázhauz*
in Czech or *Maßhaus* in German) and the rooms on the first floor were
given painted open-beamed ceilings, which have been preserved to
this day. For his loyalty to Emperor Ferdinand II during the Estates'
Uprising, Osterstock was made the imperial steward (*vogt*) of the Old
Town. Consequently, the house was later called Osterstock House
(U Osterštoků). It is now occupied by Prague City Gallery.

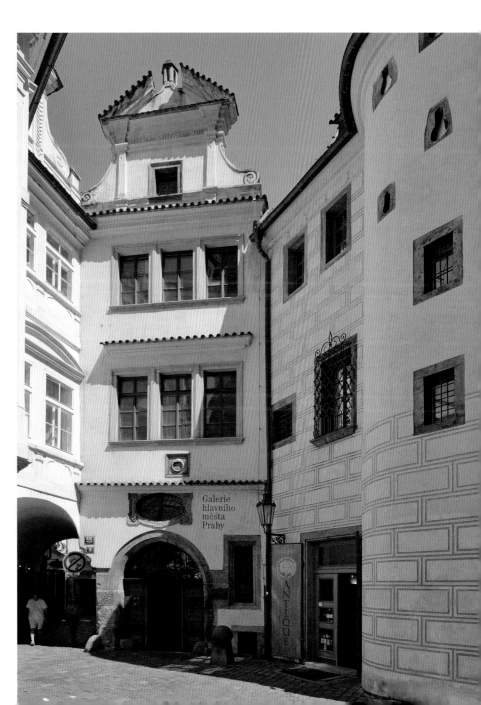

31A–B/ THE GOLDEN STRAW (DŮM U ZLATÉ SLÁMY) OR BLACK SERPENT (DŮM U ČERNÉHO HADA) (ALSO CALLED THE KEYS/U KLÍČŮ)

This originally medieval house was comprehensively remodelled from 1560 to 1574, when it was owned by the goldsmith Mates Švermon. At that time, it was given a second storey above the ground storey and adorned with two striking arched gables, attesting to the influence of Venetian architecture in Bohemia. Its being joined to the neighbouring house on the corner, whose Late Baroque appearance has been preserved to this day, has not concealed its original Renaissance appearance. During remodelling in recent times, the interiors of both the houses, which beginning in the late eighteenth century had a single owner, were considerably adapted to meet the needs of the Central Bohemian Gallery.

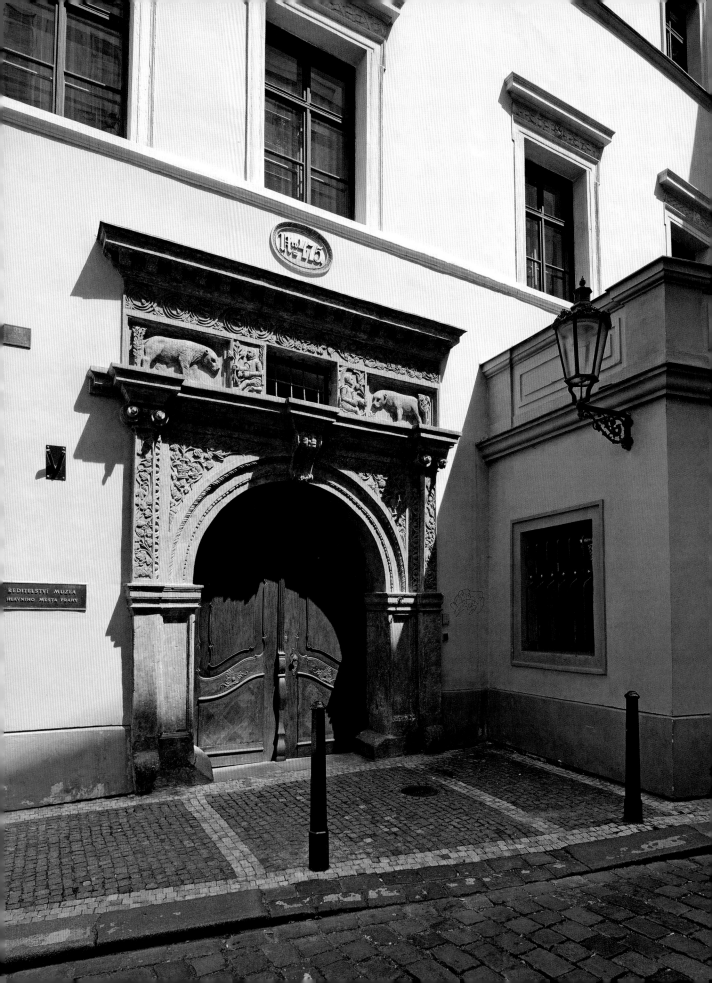

(DŮM U DVOU ZLATÝCH MEDVĚDŮ)

In the mid-sixteenth century the house was owned by Pavel
Severin z Kapí Hory, who was a rich shopkeeper, well-known
printer, and member of the town council of the Old Town of
Prague. Severin was bequeathed the house by his father-in-law,
Václav Sova z Liboslavi, a rich Prague miller, and probably
adapted it for his business needs. As well as several editions
of the Bible in Czech, he also published works by Luther,
Chelčický, and Kuthen (a Czech chronicle) and the second
oldest known Czech cookery book. The house must have been
considerably remodelled even when it was owned by Severin's
son-in-law, the printer Jan Kosořský, from 1564 to 1567.
It was probably at that time that the most remarkable part
of the house was built – the stone Renaissance portal with
outstanding sculptural decoration including little aedicules,
whose two bears form the house sign. From 1550 to 1554
Kosořský worked with, and officially took over the printing
business after Severin's death. After the failed uprising of
the Bohemian Estates against Habsburg rule, when Emperor
Ferdinand I lifted the ban on printing, Kosořský converted
to Roman Catholicism, and published the *Zřízení zemské*
(Constitution) in 1556 and also the romance *Život Adamův aneb
jinak od starodávna Solfernus* (The life of Adam, or, as it has long
been known, Solfernus, 1553) by Václav Hájek z Libočan. The
most important of the works he published was the humanist
scholar Sebastian Münster's Cosmography in Czech (*Kosmografie
česká*). Kosořský sold the house in 1567 to the merchant Jan
Netter. Netter's last will and testament contains not only a long
description of the house but also a record of the astonishingly
wide range of goods that this rich merchant offered for sale.

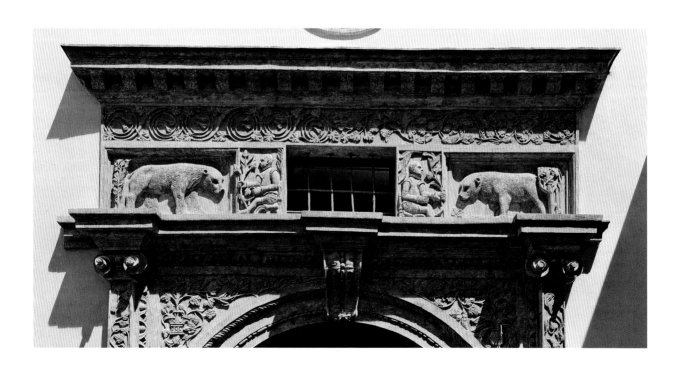

33/ THE GOLDEN TREE (DŮM U ZLATÉHO STROMU)

Dlouhá třída (Lange Gasse) was a carriageway between the city centre and the then Prague suburb of Poříčí. It once had thirteen breweries and also houses whose owners were permitted to brew beer for private gain. From 1586 to 1608, Václav Krocín z Drahobejle, the lord mayor of the Old Town of Prague, converted two Gothic houses into a single architecturally impressive Renaissance house. In Dlouhá třída a large brewery building thus came into being with a courtyard decorated with arcades. The entrance gate is still inscribed with the year 1608, suggesting that Krocín probably did not live to see his building completed. Even though the house did not avoid later remodelling, its original, charming arcaded courtyard testifies to the high quality of Late Renaissance burgher architecture.

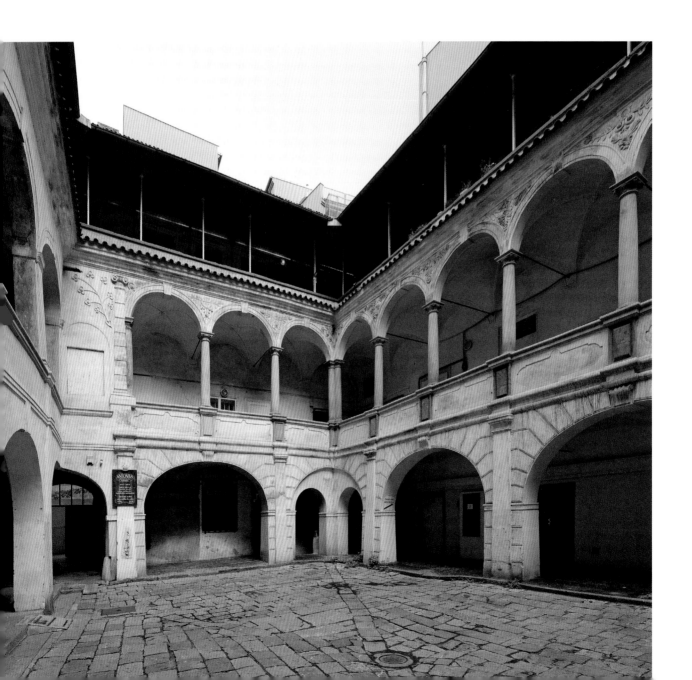

In 1610, Joachim Andreas von Schlick (Jáchym Ondřej Šlik),
Count of Passau and Weißkirchen, bought a garden near the
Old Town Square for the German Lutheran congregation. Work
on the building, whose master builder is generally believed to
have been Giovanni Domenico de Barifis (d. 1647), proceeded
quickly, and was completed in 1614. Consecrated that same
year, this typical Lutheran church with large galleries on the
first floor is one of the pure Late Renaissance buildings of
Prague. A contemporaneous report states that some art works
from St Vitus' Cathedral were hidden here from the ravages
of Hussite iconoclasm. The church has largely preserved its
original appearance even though it had been confiscated in 1624
and ownership was transferred to the Minim Friars. During
the reign of Emperor Joseph II, the building housed the mint.
When the mint was closed down, the Bohemian Lutherans, in
1861, demanded the return of the church, so that they could
hold services here. For the church land, however, they had
to pay 15,000 guilders. From that point until the 1940s, the
original appearance of the church was gradually restored.

35A–B/ THE FIVE CROWNS (DŮM U PĚTI KORUN)
Since 1402, the house on this piece of land has borne the
sign of the five large imperial crowns, and the walls of
the original medieval building have to some extent been
preserved in today's house. The building, however,
was substantially enlarged after 1600. The remodelling was
grandly conceived: by its height, width, and impressive
architecture, the house still stands out amongst the
surrounding burghers' houses. The massive gable with high
niches emphasizes the height of the house. The entrance is
emphasized by the superb stonework of the portal, which
is almost twice as high as those of the other houses. The
costly construction work probably caused its builder, the tax
collector and businessman Peter Nehrhof von Holtenberg,
considerable financial difficulties, and so he rented out
vacant rooms to foreigners.

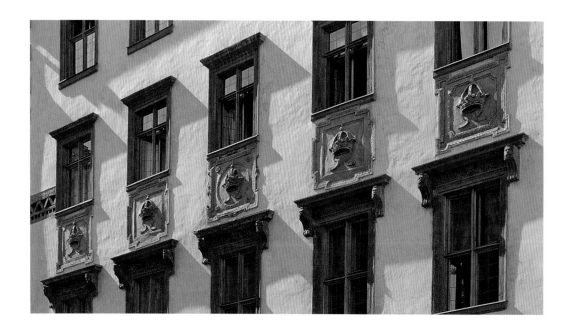

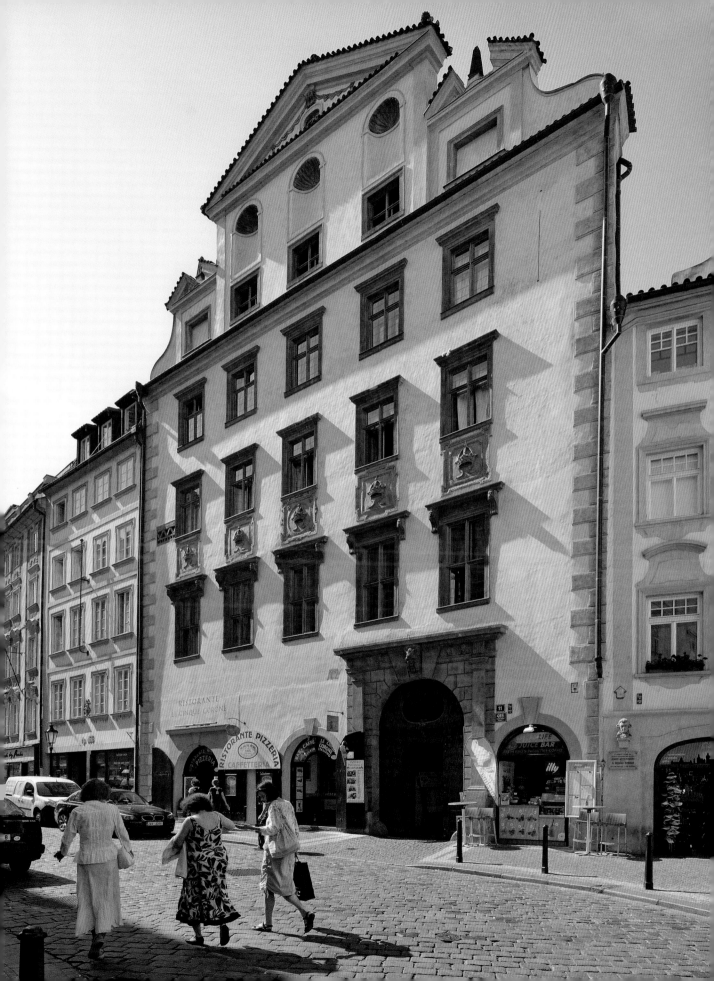

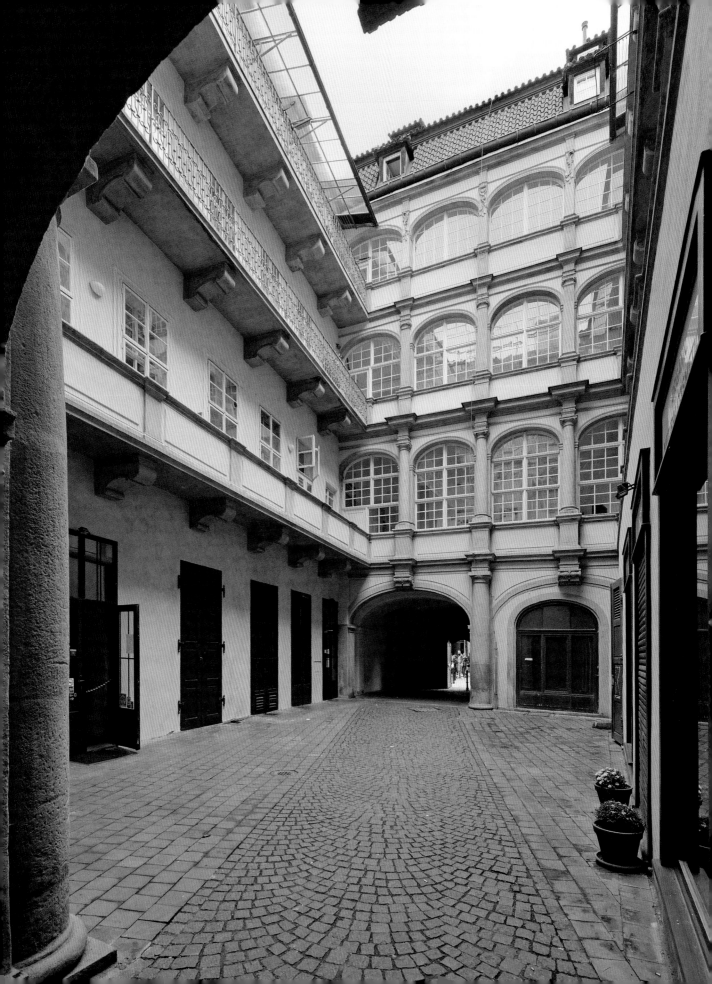

36/ THE MAGI HOUSE OR TEYFEL HOUSE
(DŮM U SVATÝCH TŘÍ KRÁLŮ OR TEYFLŮV DŮM)

In the early seventeenth century, Johann Teyfel, the son of
a Breslau merchant, Nicolaus Teyfel, who had settled in
Prague, had a palazzo-style house built for himself on the
foundations of an earlier Gothic building. His was among
the most architecturally impressive of any burgher's house
in Prague. He could afford such a costly building because,
apart from commerce, he was also involved in banking, for
example, providing loans to the court treasury (*Hofkammer*).
For his services, he was given an hereditary knighthood with
the nobiliary particle 'von Zeilberg'. He died in 1609, and
his wife Esther spent her widowhood leading an expensive
social life. In 1620, an occasional guest of hers was the
Elector Palatine Frederick during his fourteen-month reign
as King of Bohemia. The house, with a passageway between
Melantrichova and Michalská streets, is an outstanding
example of Late Renaissance architecture, as is evident
from its two portals – the entrances to the large building –
and the high arcades of the courtyard façades (see the facing
page), which have remained despite the Rococo remodelling
after 1768.

37/ A WELL WITH A RENAISSANCE WROUGHT-IRON SURROUND

In the sixteenth century, water was supplied to public wells in Prague by water towers. Though the large, architecturally impressive well on the Old Town Square was dismantled in 1862, a considerably smaller, simpler version remains preserved to this day on the nearby Lesser Square (Malé náměstí), providing a typical example of a sixteenth-century well. Much like the one on the Second Courtyard of Prague Castle, this well is protected by a decorative wrought-iron surround set on a circular marble basin. The year 1560, in gold-coloured metal numbers on the top rail of the iron frame, may refer to the earlier well, because the characteristic pattern of the twisted iron bars suggests that it more likely dates from *c.*1590. The well is today largely a reconstruction of the original.

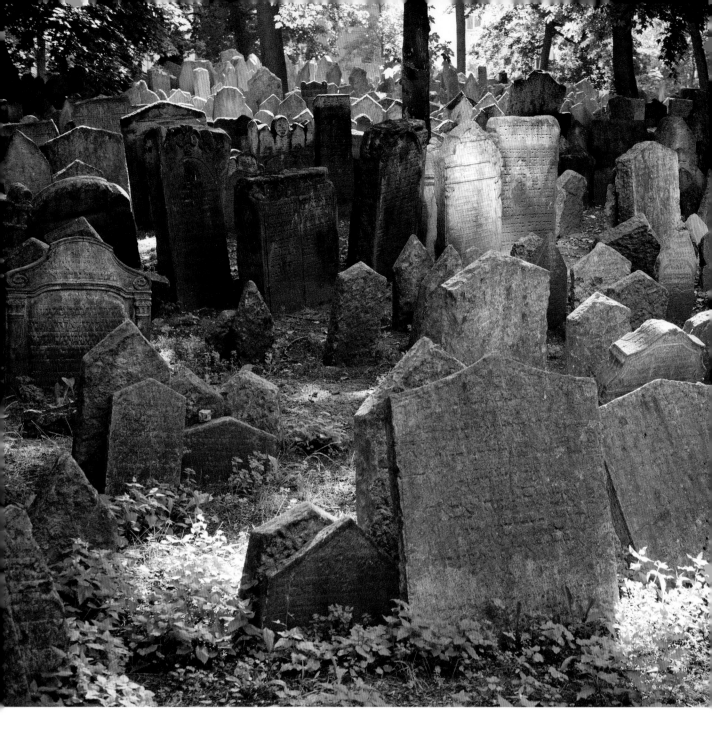

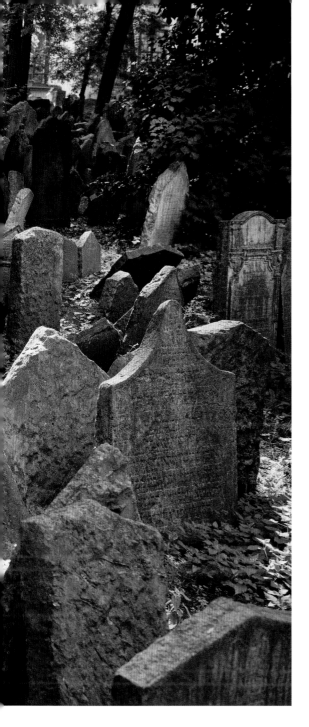

38/ THE OLD JEWISH CEMETERY

This was the third oldest Jewish cemetery in Prague, after the oldest in Újezd, in the Lesser Town, and the second oldest, in the New Town. It was established in the late fourteenth and the early fifteenth century in what is today the Josefov quarter (Josephstadt) of the Old Town, and was expanded several times with the purchase of neighbouring gardens and houses.

A house with the garden by the bank of the river Vltava was purchased for the cemetery by Mordechai Maisel, a merchant and banker, who was the head (*primas*) of the Jewish Town. It was also thanks to him that construction work in the ghetto was completed. He is buried in this cemetery. Burials continued here until 1787, when Emperor Joseph II issued a ban on burial in the city.

Under one of the best-known and most impressive tombstones in the cemetery lie the remains of Judah Loew ben Bezalel, known simply as Rabbi Löw or the Maharal. He came from a distinguished family of rabbis, and in 1553 became the Chief Rabbi of Moravia. Twenty years later he moved to Prague, where he was the head of a Talmudic school at the Klausen Synagogue. In 1597 he was made the Chief Rabbi of Bohemia and gained renown as a distinguished scholar of ethics and education. He is considered by some scholars to be a forerunner of Hasidic Judaism.

The Jewish quarter was gradually expanded by purchasing houses owned here by Christians. In 1492 Yeshei Horowitz bought the house called U Erbů (The Coats of Arms) and established a private prayerhouse there. His son, Aron Meshullam Zalman Horowitz, one of the richest and most influential members of the Jewish Community, had a new synagogue built between his family house and the Jewish cemetery. Finished in 1535, the building has a ceiling with a vault of intersecting ribs, in the spirit of the Late Gothic, but the richly decorated portal is Renaissance, as are details inside the building. Until 1607 the synagogue was part of the Horowitz house. It was then remodelled and expanded by additions, including a wing, a meeting hall, and a women's section. At that time, too, the façades of the building were unified with paired windows with semicircular arches. Judah Coref de Herz was the master builder not only of this Late Renaissance remodelling of the synagogue, but also of many other buildings in the ghetto.

40/ THE TOWN HALL OF THE NEW TOWN (NOVOMĚSTSKÁ RADNICE)

As in the Old Town, the town hall in the New Town also gradually grew in size. Its earliest part, to the east, was built from 1377 to 1398. The south part was built in the 1410s, and the massive, tall tower was built in the mid-fifteenth century. On its ground floor was a prison, and on the first floor was the chapel of the Assumption and St Wenceslas. When, in 1518, the Old and the New Towns were united, this town hall lost its original purpose, and became the offices of the municipal authorities. Paradoxically, it was in that same period, from 1520 to 1526, that it was remodelled in the Renaissance style. After a great fire in 1559 the north and the west wing were built and the east side was also remodelled in the Renaissance style. Today's appearance of the building, which was partly remodelled in the Empire style in the early nineteenth century, is the result of changes to its originally Renaissance appearance which were made by the architects Antonín Wiehl and Kamil Hilbert in 1905–06. On the righthand side, at the main entrance to the town hall, is a metal standard measure of a Prague cubit.

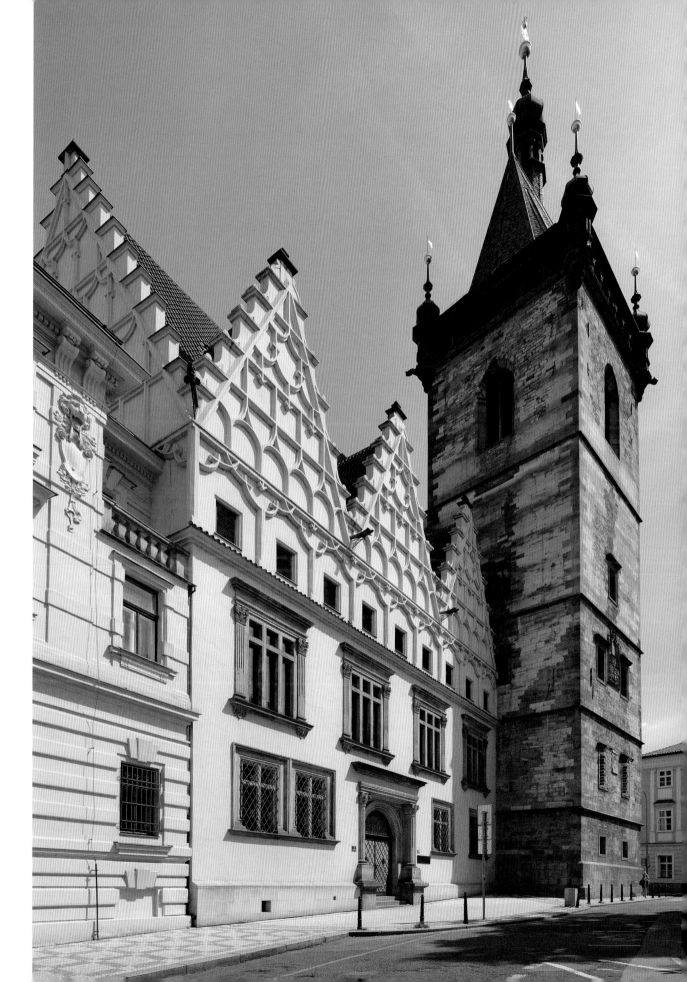

Archduke Ferdinand II, a highly knowledgeable amateur
builder, created one of the most beautiful and interesting
pieces of architecture of the Bohemian Renaissance. It
acquired its name because of its hexagram plan and its
external appearance, more like a fortress than a place of
recreation, a Lusthaus or summer palace. In the most recent
scholarly publication on the Star hunting lodge, the art
historian Ivan P. Muchka offers an explanation for this
design, which he found in the literature of the period, a 1554
treatise by Pietro Cataneo. According to Cataneo, architects
should know that if they are fully 'to satisfy their clients'
sense of whimsy, they have to abandon rectangular shapes,
and design great houses on circular, oval or other similar
plans'. The building was erected quickly in 1555–6. Its stucco
decoration was finished about four years later. Some of the
names connected with the building are Pietro Ferrabosco,
Juan Maria del Pambio (better known as Giovanni Maria
Aostalli), and Bonifaz Wohlmut. Together with the large
game reserve with its vast number of animals, it served a
single purpose for its then many visitors: it was a hunting
lodge on whose grounds high-born guests were permitted
to hunt. The disposition of the interior of the lodge –
including a central hall (with shallow niches) on each floor
and surrounded by rooms corresponding to the arms of
the star – seems rather like stately rooms intended, say, for
large collections. The large hall, designed for entertainments
and dancing, is on the second floor. The kitchen was in an
adjacent building. The lodge had no rooms for putting up
guests. The splendid stucco decoration on the ground floor
is by Antonio Brocco and his assistants, who had come to
Prague from Dresden. Owing not only to its high artistic
quality but also to its great number of scenes, this stucco
work must have dazzled visitors. In the same scholarly book
about the hunting lodge, Ivo Purš suggests that its plan and
name refer to the heavenly fortress of the planetary gods,
a place reserved for members of the ruling dynasty, who
descended from these divinities.

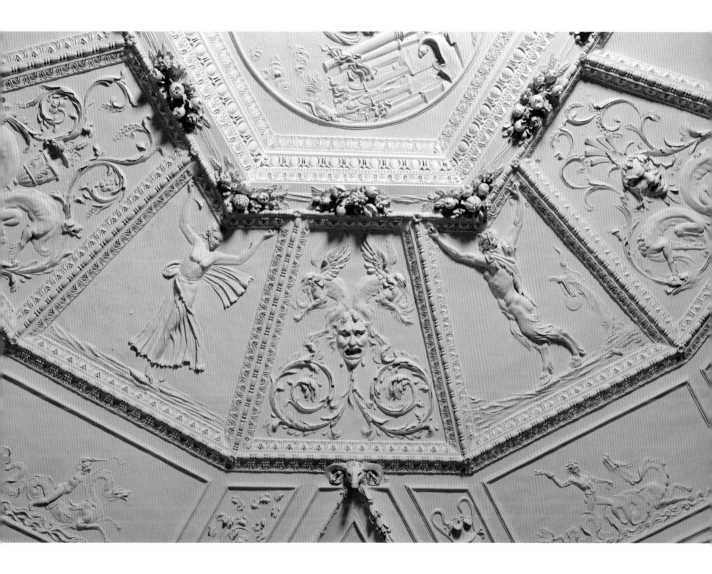

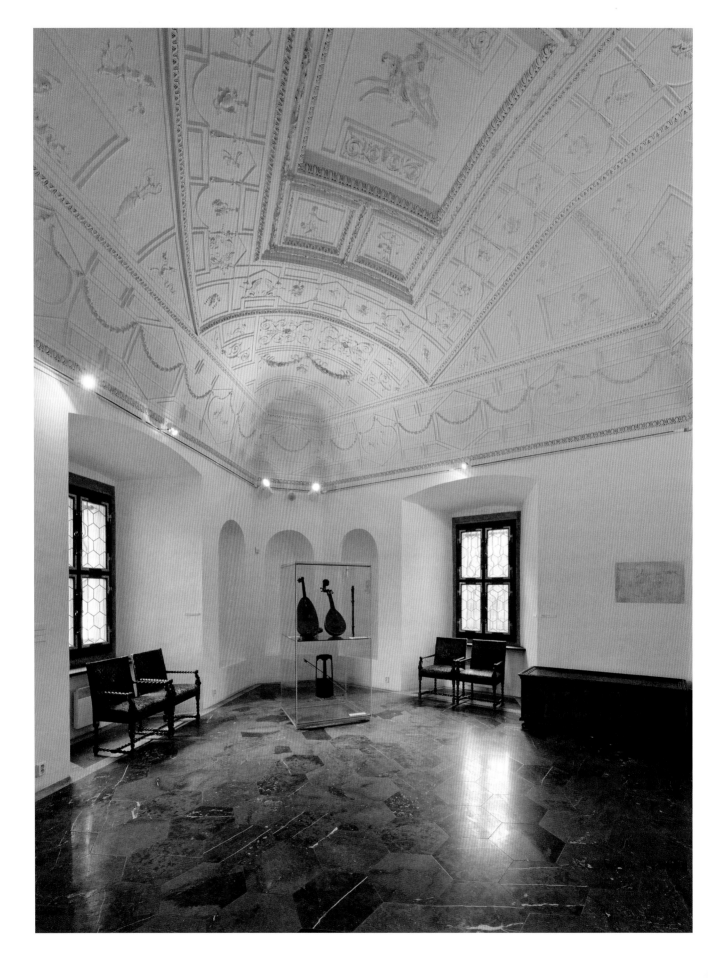

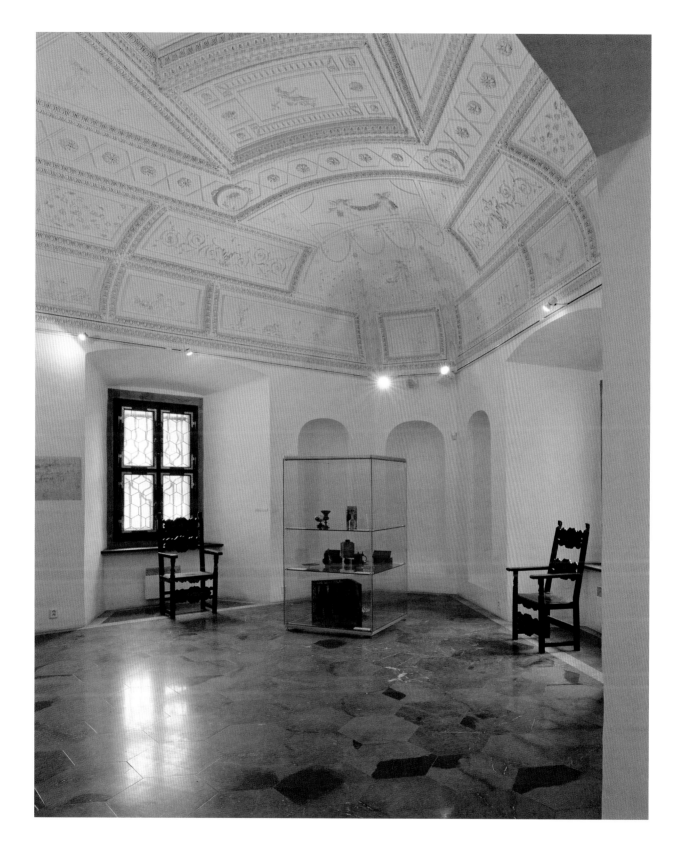

EMINENT PERSONAGES OF RENAISSANCE PRAGUE

Anne of Bohemia and Hungary (1503–1547), a Jagiellon, the daughter of Anne of Foix and Vladislav II, the wife of Emperor Ferdinand I, and Queen of Bohemia, Hungary, and the Romans.

Anne of Foix (1484–1506), the third wife of King Vladislav II.

Ferdinand I (1503–1564), a Habsburg, Holy Roman Emperor, King of Bohemia (*reg.* 1526–64), the Romans, and Hungary, Archduke of Austria, the father of Maximilian II and grandfather of Rudolph II.

Ferdinand II of Austria (1529–1595), a Habsburg, Archduke of Austria, the son of Ferdinand I, and the uncle of Rudolph II. He was the Count of Tyrol, the governor of the Bohemian Lands (1557–67), and ruler of Further Austria

Ferdinand II (1578–1637), a Habsburg, Duke of Styria, Archduke of Austria, Holy Roman Emperor, King of Bohemia (*reg.* 1617–37), of Hungary, and Croatia.

George of Poděbrady (Jiří z Poděbrad) (1420–1471), King of Bohemia, elected by the Bohemian nobility in 1458, the only king of Bohemia who was not of the ruling dynasty.

Leopold V (1586–1632), a Habsburg, Archduke of Austria, Bishop of Passau and Strasbourg, Count of the Tyrol, the brother of Ferdinand III, the Duke of Styria

Louis II (1506–1526), a Jagiellon, King of Bohemia and Hungary, Margrave of Moravia, the son of Vladislav II Jagiellon.

Mary of Austria (Spain) (1528–1603), the wife of Emperor Maximilian II, mother of Rudolph II, daughter of Emperor Charles V.

Matthias (1557–1619), a Habsburg, a brother of Rudolph II, whom he succeeded as Emperor and King of Bohemia (*reg.* 1611–19), Hungary, and Croatia, and Archduke of Austria.

Matthias Corvinus (1443–1490), a Hunyadi, King of Hungary, and, beginning in 1469, the anti-king of Bohemia, and, from 1485 onward, Archduke of Hungary.

Maximilian II Habsburg (1527–1576), son of Ferdinand I and Anna Jagiellon, the father of Rudolph II, Emperor and King of Bohemia (*reg.* 1564–75) and Hungary, and Archduke of Austria.

Philip II (1527–1598), King of Spain, England, Portugal, Naples, and Sicily.

Rudolph II (1552–1612), son of Maximilian II Habsburg and Mary of Spain, Emperor, King of Bohemia, Hungary, Croatia, ruled in Bohemia from 1576 to 1611.

Vladislav II (1456–1516), a Jagiellon, King of Bohemia and Hungary, and Margrave of Moravia.

Abondio, Antonio (1538–1591), an Italian sculptor, medallist, and sculptor in wax, a court artist of the emperors Maximilian II and Rudolph II.

Aostalli de Sala, Ulrico (1525–1597), an Italian master builder and master mason, began in about 1547 to work in Bohemia, including, in the late 1550s, at Prague Castle.

Arcimboldo, Guiseppe (1526–1593), an Italian painter, beginning in 1562 a court portrait

painter of the emperors Ferdinand I and Maximilian II, created 'composite heads' and 'reversible heads'.

Brocco da Campione, Antonio (Campione, ?–?), an Italian sculptor and artist in stucco, after 1557 in the service of Archduke Ferdinand II in Prague, with whom, after 1567, he went to the Tyrol.

Brus z Mohelnice, **Antonín** (1518–1580), a grand master of the order of the Knights of the Cross with the Red Star, the eighth archbishop of Prague (1561–80).

Busbecq, **Ogier Ghiselin de** (also Augerius Ghislain, 1522–1592), a diplomat, botanist, linguist, antiquarian, a tutor to Prince Rudolf.

Bydžovský, **Marek z Florentina** (1540–1612), a chronicler, a master of Prague University, Dean of the Faculty of Arts.

Cholossius, Adam (also Chocholouš, 1544–1591), a master of arts, teacher, poet.

Collin, Alexander (also Colin, 1527/29–1615), a Netherlandish sculptor, created the royal mausoleum in St Vitus' Cathedral and the tombstone of Emperor Maximilian I at Innsbruck.

Collinus z Chotěřiny, Matouš (also Kolín, 1516–1566), a humanist, professor at Prague University.

Cranach, Lucas, the Elder (1472–1553), a German Renaissance painter.

Crato, Johannes von Krafftheim (also Craftheim, Johann(es) Krafft, 1519–1585), a German humanist and physician.

Fonteo, Giovanni Battista (1546–1580), an Italian poet and humanist.

Granovský z Granova, Jakub (?–?), a Prague burgher, from 1558 in charge of the Ungelt.

Griespek von Griespach, Florian (also Gryspek z Gryspeku, 1504–1588), the founder of the House of Griespek von Griespach, a secretary and confidant of Emperor Ferdinand I, a king's counsellor, and a distinguished builder.

Hájek z Hájku, Tadeáš (1525–1600), a Czech scientist, mathematician, distinguished astronomer, personal physician to the emperors Ferdinand I, Maximilian II, and Rudolph II, and a friend of Tycho Brahe.

Hájek z Libočan, Václav (?–1553), a priest and chronicler, author of the *Kronika česká* (Bohemian chronicle), which covers the period from the arrival of the Czechs in Bohemia to the reign of Ferdinand I.

Hradce, Adam II z (1549–1596), in the reign of Rudolph II, was Lord Burgrave of Prague and Lord High Chancellor of the Kingdom of Bohemia.

Hradce, Jáchym z (1526–1565), during the reign of Maximilian II, was Lord Chancellor of the Kingdom of Bohemia, privy councillor, and a knight of the Order of the Golden Fleece.

Jaroš, Tomáš (1500–1571) a gunsmith, bell founder, and metal founder at the courts of the emperors Ferdinand I and Maximilian II.

Kozel, Jan (born Johann Bock, ?–1566), a Prague printer, worked with Michael Petrle.

Krocín z Drahobejle, Václav (*c*.1532–1605), a burgomaster of the Old Town of Prague from 1584 to 1605.

Lobkowicz, Jan z, the Younger (1510–1570), a member of an old Bohemian noble family, Lord Chamberlain of the Kingdom of Bohemia and Lord Burgrave of Prague.

Lucchese, Giovanni (?), an Italian master builder, active in Prague in 1539/40 and at manors owned by the Bohemian Treasury (*Kammerherrschaft*), employed by Archduke Ferdinand II.

Master of the Litoměřice Altarpiece (*c*.1470–?), came to Bohemia from either southern Germany or the Danubian Basin, the most important painter at the court of King Vladislav II.

Mattioli, Pietro Andrea (1501–1577), a physician and botanist of Italian origin, active in Prague from 1554 to 1564 as the personal physician to Archduke Ferdinand II.

Mehl ze Střelic, Jiří (1514–1589), a senior official at the monarch's court, a humanist, patron of the arts, and book collector.

Melantrich z Aventina, Jiří (born Jiří Černý Rožďalovický, *c*.1511–1580), a distinguished Czech printer and publisher.

Müller, Nikolaus (?–1586), a goldsmith and merchant of German origin, employed at the courts of Archduke Ferdinand II and the emperors Maximilian II and Rudolph II.

Netolický, Bartoloměj (?–*c*.1562), a printer in the Lesser Town of Prague.

Ottersdorf, Sixtus von (1500–1583), a lawyer, humanist, writer, translator, and chancellor of the Old Town of Prague.

Pernštejna, Vratislav z (1530–1582), a Bohemian nobleman and diplomat, Lord Chancellor of the Kingdom of Bohemia.

Petrle, Michael (also Peterle, Petterle, 1537–1588), from Annaberg, a wood engraver, painter, illustrator, printer, beginning in 1565 a member of the Prague painters' guild, made the Prague *veduta* of 1562.

Peysser, Hans (1505–1571), a woodcarver and cabinetmaker, involved in making the Singing Fountain for the Royal Garden at Prague Castle.

Reinhart, Nicolas and **Claudius** (also Reinhard, ?–?), gardeners from Lorraine, active at Prague Castle in 1540–41.

Ried, Benedikt (also Rejt, Rieth, Reyd, 1454–1536), an outstanding master builder of German origin, worked from 1489 until the end of his life at the Prague courts of Vladislav II Jagiellon, his son Louis II, and Ferdinand I, and elsewhere in Bohemia.

Rožmberka, Vilém z (1535–1592), the head of the House of Rožmberk (Rosenberg), a distinguished politician, Lord Burgrave of Prague, a knight Order of the Golden Fleece.

Sadeler, Aegidius (1570–1625), a Netherlandish painter, a master drawer, and, beginning in 1597, an engraver at the court of Emperor Rudolph II, one of the most important engravers of his time.

Seisenegger, Jakob (1505–1567), an Austrian painter, distinguished portraitist, at the court of Emperor Ferdinand I.

Spazio, Giovanni (?–?), an Italian master mason at the court of Emperor Ferdinand I.

Spiess, Hans (also Hanuš, 1440–1503), a German master mason, beginning in 1477 worked at Prague Castle and elsewhere in Bohemia during the reign of Vladislav II, a master of the Prague masons' guild.

Spranger, Bartholomeus (1546–1611), a court painter to the emperors Maximilian II and Rudolph II.

Steinmeissel, Hans (?–1572), a Prague clockmaker.

Stella, Paolo della (?–1552), an Italian master builder and mason employed, beginning in 1538, at Prague Castle in the reign of Ferdinand I.

Stevens, Pieter (*c*.1567– after 1624), a Netherlandish painter, particularly of landscapes, court painter to Rudolph II.

Strada, Jacopo (1507–1588), among other things, an Italian goldsmith, antiquarian, historian, numismatist, and also keeper of the art collections of the emperors Maximilian II and Rudolph II.

Terzio, Francesco (1523–1591), an Italian painter and engraver at the court of Archduke Ferdinand II.

Tomek, Václav Vladivoj (also Wácslav Wladiwoj, 1818–1905), a Czech historian, teacher, and, later, rector of Prague University; was also a politician.

Trautson, Paul Sixtus (1550–1621), Lord Marshal and Imperial Privy Councillor.

Uccello, Gaspare (also Uccelli, Oselli, Osello, and de/ab Avibus, *c*.1536–1590), an Italian engraver.

Veleslavína, Daniel Adam z (1546–1599), a humanist scholar, professor of history at Prague University, organizer of literary life, and a renowned printer.

Wohlmut, Bonifaz (also Wolmut and Wohlmuth, before 1501–1579), a German mason and master mason at Prague Castle during the reign of the emperors Ferdinand I and Maximilian II.

Zech, Jakub (also Jacob or Jakob, Czech or Čech or Zähen, ?–1540), a clockmaker in charge of the Old Town astronomical clock.

ACKNOWLEDGEMENTS

The Karolinum Press thanks the managers of various collections of art and other historical items, particularly the Prague Castle Administration, for having generously provided illustrations for this publication and for granting permission to publish them.

MAP OF PRAGUE

1 Prague Castle

2 Schwarzenberg House (or Lobkowicz House) (Schwarzenberský or Lobkovický palác), Hradčanské náměstí 2

3 Hradec House (Palác pánů z Hradce, also Slavata or Thun House), Zámecké schody 1

4 Martinitz House (Martinický palác), Hradčanské náměstí 8

5 Hradčany Town Hall (Hradčanská radnice), Loretánská 1

6 The Town Hall of the Lesser Town (Malostranská radnice), Malostranské náměstí 21

7 The Spa House (Dům zvaný Lázeň), Malostranské náměstí 20

8 The Three Ostriches (Dům U Tří pštrosů), Dražického náměstí 12

9 The Thein Church College (Týnská škola), Staroměstské náměstí 14

10 The Stone Lamb (Dům U Kamenného beránka), Staroměstské náměstí 17

11 The Town Hall of the Old Town (Staroměstská radnice), Staroměstské náměstí 1/3

12 Minute House (Dům U Minuty), Staroměstské náměstí 3

13 Granovský House in the Ungelt, Týn 639/1

14 Petráček House (Ungelt House) in the Ungelt, Týn 640/2

15 The Golden Ring (Dům U Zlatého prstenu), Týnská 6

16 The Golden Tree (Dům U Zlatého stromu), Dlouhá 37

17 The Church of the Holy Saviour (Kostel sv. Salvátora), Lutheran, Salvátorská 1

18 The Jewish Cemetery (Židovský hřbitov), Široká

19 The Pinkas Synagogue, Široká 3

20 The Two Golden Bears (Dům U Dvou zlatých medvědů), Kožná 1

21 The Golden Straw (Dům U Zlaté slámy, also U Klíčů [The Keys] and U Černého hada [The Black Serpent]), Karlova 34 / Husova 21

22 A well with a Renaissance wrought-iron surround, Malé náměstí

23 The Five Crowns (Dům U Pěti korun), Melantrichova 11

24 The Magi House (Dům U Svatých tří králů, or Teyfel House [Teyflův dům]), Melantrichova 15

25 The Town Hall of the New Town (Novoměstská radnice), Karlovo náměstí 23

26 The Star Hunting Lodge (Letohrádek Hvězda), in the game reserve at the White Mountain (Bílá hora).

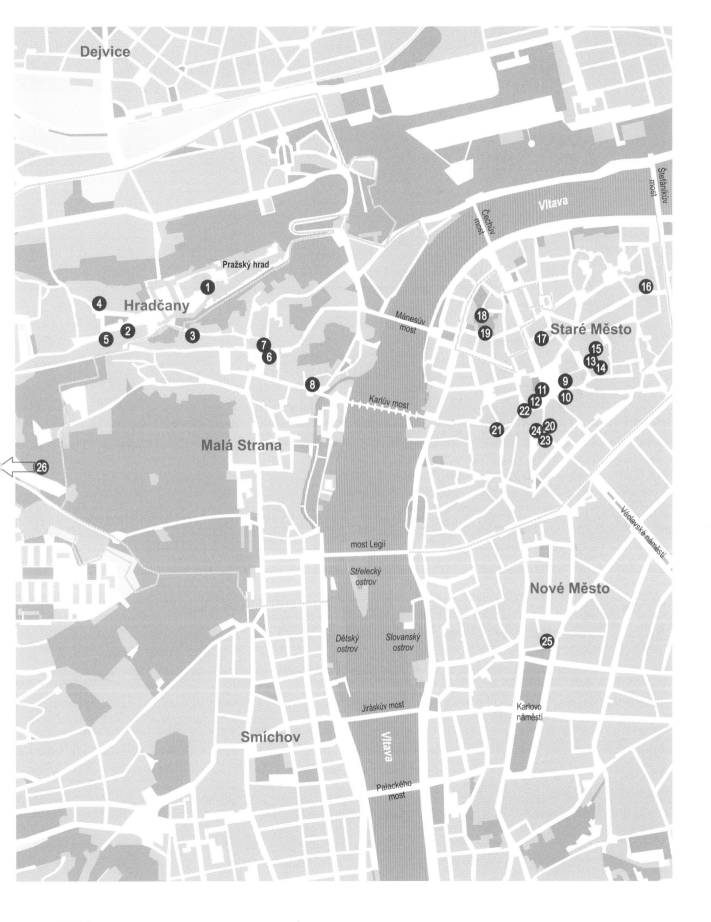

Dejvice

Pražský hrad

Hradčany

Staré Město

Malá Strana

Karlův most

Nové Město

Smíchov

Vltava

Čechův most

Mánesův most

Štefánikův most

Václavské náměstí

most Legií

Střelecký ostrov

Dětský ostrov

Slovanský ostrov

Jiráskův most

Karlovo náměstí

Palackého most

(175)

MAP OF PRAGUE CASTLE

1 The Vladislav Hall (Vladislavský sál)
2 Vladislav's Bedchamber (Vladislavova ložnice)
3 The Old Diet (Stará sněmovna)
4 The Equestrian Stairs (Jezdecké schody)
5 Rooms of the New Land Rolls (Nové zemské desky)
6 The Louis Wing (Ludvíkovo křídlo)
7 The choir loft, St Vitus' Cathedral
8 Wall paintings by the Master of the Litoměřice Altarpiece, in the Wenceslas Chapel, St Vitus' Cathedral
9 Renaissance Portal of the Convent of St George (kláštera sv. Jiří), U Sv. Jiří 33/5
10 The Lord Burgrave's House (Nejvyšší purkrabství), Jiřská 6
11 Rosenberg House (Rožmberský palác, Ústav šlechtičen), Jiřská 2/3
12 Lobkowicz House (Lobkovický palác), formerly Pernstein House (Pernštejnský palác), Jiřská 3
13 The Powder Tower (Mihulka Tower)
14 The Great Tennis Court (Míčovna)
15 The Fig House (Fíkovna)
16 The Singing Fountain (Zpívající fontána)
17 The Royal Summer Palace (Královský letohrádek), also called Queen Anne's Summer Palace (Letohrádek královny Anny) or Belvedere

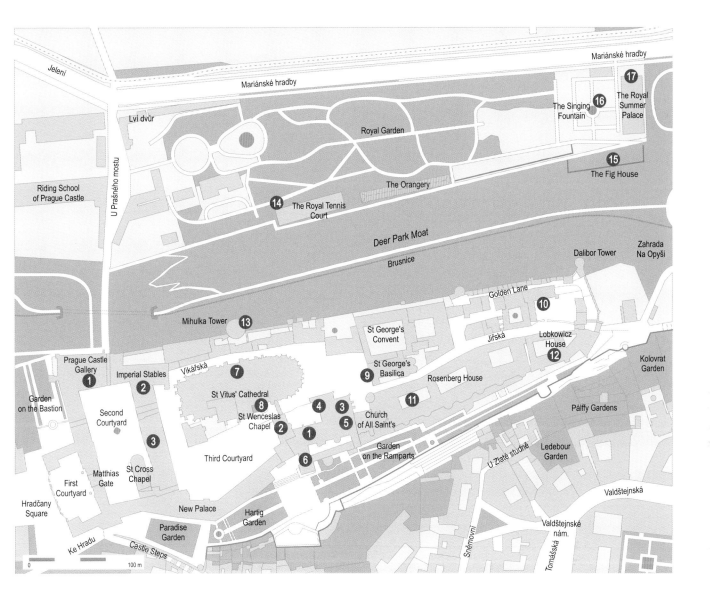

Jelení

Mariánské hradby

Mariánské hradby

Lví dvůr

Royal Garden

The Singing Fountain **16**

17 The Royal Summer Palace

Riding School of Prague Castle

U Prašného mostu

The Orangery

15

The Fig House

14 The Royal Tennis Court

Deer Park Moat

Brusnice

Dalibor Tower

Zahrada Na Opyši

Golden Lane

10

Mihulka Tower **13**

Vikářská

St George's Convent

Jiřská

Lobkowicz House

12

Kolovrat Garden

Prague Castle Gallery

1

Imperial Stables

2

7

St George's Basilica

9

Rosenberg House

Pálffy Gardens

Garden on the Bastion

Second Courtyard

3

St Vitus' Cathedral

8

2

St Wenceslas Chapel

4

1

3

5

11

Church of All Saint's

U Zlaté studně

Ledebour Garden

Matthias Gate

St Cross Chapel

Third Courtyard

6

Garden on the Ramparts

Valdštejnská

First Courtyard

Hradčany Square

New Palace

Hartig Garden

Paradise Garden

Sněmovní

Valdštejnské nám.

Tomášská

Ke Hradu

Castle Steps

0 100 m

(177)

LIST OF ILLUSTRATIONS

Dust jacket, front: window of the Town Hall of the Old Town; **back:** the Royal Summer Palace

Front flap: The Town Hall of the Old Town

Double-page before title page: stucco ceiling of the Star Hunting Lodge; **opposite copy-right page:** the Vladislav Hall; opposite **contents page:** A master mason (probably Benedikt Ried) – detail from a wall painting by the Master of the Litoměřice Altar, in the Wenceslas Chapel, St Vitus' Cathedral; **overleaf:** the Star Hunting Lodge; **after overleaf:** coat of arms of the Kingdom of Bohemia, on a wall of the rooms of the New Land Rolls, Prague Castle

Documentary illustrations

The Klaudyán (Claudianus) Map of Bohemia, 1518, woodcut, 1260 × 640 mm, the initials N.C.V.K (Nicolaus Claudianus and the engraver Andreas Kaschauer), Prague, archiv Univerzity Karlovy v Praze, archiv Nakladatelství Karolinum, p. 14.

View of Prague, 1536–38 – whole and detail, the Queen's Palace, coloured drawing, Würzburg, Universitätsbibliothek, Handschriften, sig. Delin. IV, p. 17.

Aegidius Sadeler, *Vladislav Hall* – whole and detail, 1606, copper engraving, 570 × 615 mm, private collection, pp. 18–19.

The Royal Garden with the Summer Palace in the Seventeenth Century, from Lucius Barrettus [Albert Curtz] (ed.), *Historia Coelestis*, 1666, copper engraving, private collection, photo Oto Palán, p. 21.

Pietro Andrea Mattioli, *Herbář* (A herbal) – title page and further example, Czech edition, 1562, Prague, Památník národního písemnictví, photo Oto Palán, pp. 22–23.

Václav Hájek z Libočan, *Kronika česká* (Bohemian chronicle) – title page. published by Jan Severin, 1541, Prague, Památník národního písemnictví, photo Oto Palán, p. 25.

After a drawing by Francesco Terzio, engraved by Gaspare Uccello, *A Portrait Emperor Ferdinand I*, 1558–71, copper engraving, Prague, Národní galerie v Praze, p. 26.

After a drawing by Francesco Terzio, engraved by Gaspare Uccello, *A Portrait of Archduke Ferdinand II*, between 1558 and 1571, copper engraving, Prague, Národní galerie v Praze, p. 27.

Fragment of terracotta decoration of Pernštejn House (today, Lobkowicz House) at Prague Castle, Prague, Sbírky Pražského hradu, photo Jan Gloc, p. 30.

Jiří Melantrich z Aventina (title page of the Melantrich Bible), 1570, Prague, Památník národního písemnictví, photo Oto Palán, p. 33.

Matouš Collinus z Chotěřiny, commemorative plaque, the Aula magna (Great Hall) of the Carolinum, 1566, Prague, archiv Nakladatelství Karolinum, p. 34.

Jakob Seisenegger, *Portrait of Maximilian II as a Young Man*, before 1544, oil on canvas, 188 × 84.5 cm, Prague, Obrazárna Pražského hradu, photo Jan Gloc, p. 36.

Francesco Terzio, *Emperor Maximilian II in Armour*, *c.*1564, wash drawing, 210 × 120 mm, private collection, p. 37.

6B/ Detail of a wall with the coat of arms of the Kingdom of Bohemia, Prague, Správa Pražského hradu, photo Jan Gloc

6C/ A cabinet in the rooms of the New Land Rolls, Prague, Správa Pražského hradu, photo Jan Gloc

6D/ The rooms of the New Land Rolls, Prague, Správa Pražského hradu, photo Jan Gloc

7A–C/ The Louis Wing

7A/ South façade, Prague, Správa Pražského hradu, photo Jan Gloc

7B/ Vault, Prague, Správa Pražského hradu, photo Jan Gloc

7C/ Royal cipher of an L with a griffin and a lion, Prague, Správa Pražského hradu, photo Jan Gloc

8A–B/ Choir loft in St Vitus' Cathedral – whole and detail, Prague, Správa Pražského hradu, photo Jan Gloc

9A–F/ Master of the Litoměřice Altarpiece, wall painting in the Wenceslas Chapel of St Vitus' Cathedral

9A/ A master builder (probably Benedikt Ried), wall painting on the south wall, Prague, Správa Pražského hradu, photo Jan Gloc

9B/ Vladislav II and Anne of Bohemia and Hungary (née de Foix), wall painting on the east wall, Prague, Správa Pražského hradu, photo Jan Gloc

9C/ Arrival of an embassy– detail, wall painting on the west wall, Prague, Správa Pražského hradu, photo Jan Gloc

9D/ Arrival of an embassy– whole, wall painting on the west wall, Prague, Správa Pražského hradu, photo Jan Gloc

9E/ St Wenceslas working in a vineyard, wall painting on the north wall, Prague, Správa Pražského hradu, photo Jan Gloc

9F/ Vladislav Hall – detail of a wall painting on the west wall, Prague, Správa Pražského hradu, photo Jan Gloc

10/ Lucas Cranach the Elder, St Catherine and St Barbara with fragments of the figures of St Dorothy and St Margaret, *c.*1520, mixed media on a lime panel, 105 × 173.5 cm, Sbírky Pražského hradu, Správa Pražského hradu, photo Jan Gloc

11A/ South portal of the Basilica of St George – relief sculpture, photo Oto Palán

11B/ Detail of the relief sculpture – a portrait of Louis II Jagiellon as St George, Prague, Správa Pražského hradu, photo Jan Gloc

12A–H/ Royal Summer Palace

12A/ Full view, photo Oto Palán

12B/ Detail of arcade, photo Oto Palán

12C/ Vault, ground floor, Prague, Správa Pražského hradu, photo Jan Gloc

12D/ Hall, first floor, Prague, Správa Pražského hradu, photo Jan Gloc

12E–F/ Relief with Ferdinand and Anne of Bohemia and Hungary, photo Oto Palán

12G/ Relief of a hunt, photo Oto Palán

12H/ Relief from the ornamentation, photo Oto Palán

13A–B/ The Singing Fountain – full view and detail of the column with figures, including a satyr, photo Oto Palán

14/ Fig House, photo Oto Palán

15A–D/ Great Tennis Court (Míčovna)

15A/ Façade, photo Oto Palán

15B–C/ Details of the sgraffito, photo Oto Palán

15D/ Detail with column, photo Oto Palán

16A–F/ The Lord Burgrave's House (Nejvyšší purkrabství)

16A/ Façades, photo Oto Palán

16B/ Ceiling painting, Prague, Správa Pražského hradu, photo Jan Gloc

ELIŠKA FUČÍKOVÁ, PhDr. CSc.

Eliška Fučíková was born in 1940. The period linked with the first Habsburgs on the Bohemian throne and particularly the reign of Emperor Rudolph II became her main area of academic interest while a student of art history at Charles University in Prague. She was later employed by the Institute of Art History of the Czechoslovak Academy of Sciences. In the 1990s, she was made Director of the Department of Historical Preservation at the Office of the President of the Republic. It is thanks to her that the Prague Castle Gallery was renovated and began a new acquisitions programme. For her profound knowledge of the art of Rudolph's times and of early drawings she is highly sought after by many institutions at home and abroad as a partner in organizing exhibitions and conferences, and for expert consultations and lectures. For her work, she has received a number of awards from all over the world.

Exhibitions and their catalogues (a selection)

Rudolfínská kresba, Prague: Národní galerie v Praze, 1978.
Effetto Arcimboldo, Venice: Palazzo Grassi, 1987.
Prag um 1600, Essen: Villa Hügel, and Vienna: Kunsthistorisches Museum, 1988.
The Stylish Image: Printmakers to the Court of Rudolf II, Edinburgh: National Gallery, 1991.
Capolavori della pittura veneta dal Castello di Praga, Belluno: Palazzo Crepadona, 1994.
Meisterwerke der Prager Burggalerie, Vienna: Kunsthistorisches Museum, 1996.
Rudolf II and Prague, Prague: Prague Castle, 1997.
Prague Castle Gallery, Prague: Pražský hrad, 1998.
Imperial Paintings from Prague, Maastricht: Bonnefantenmuseum, 2000.
Praga magica 1600, Dijon: Musée Magnin, 2002.
The Story of Prague Castle, Prague: Pražský hrad, 2003.
Valdštejn: Inter alma silent musae? Prague: Valdštejnská jízdárna, 2007.
Hans von Aachen (1552–1615), a European Court Painter, Aachen, Prague, Vienna: Suermondt-Ludwig-Museum, Císařská konírna, Kunsthistorisches Museum, 2010.
The Rožmberks: A Short Exhibition Guide, České Budějovice: National Heritage Institute, to accompany the exhibition 'The Rožmberks: A Czech Dynasty and Its Path Through History', Waldstein Riding School, Prague, 20 May to 20 August 2011.
Rudolfínští mistři: Díla dvorních umělců Rudolfa II. z českých soukromých sbírek/The Masters of Rudolf II's Era: Works of Art by Court Artists in Private Czech Collections, Prague: Muzeum hlavního města Prahy, 2014–15.

Publications (a selection)

Rudolfínská kresba, Prague: Odeon, 1986.
Eliška Fučíková, Beket Bukovinská, and Ivan Muchka, *Die Kunst am Hofe Rudolfs II.*, Hanau: Werner Dausien, 1988.

'Die Malerei am Hofe Rudolfs II.', pp. 177–92, as well as 70 catalogue entries, in *Prag um 1600: Kunst und Kultur am Hofe Kaiser Rudolfs II.*, catalogue to an exhibition in Villa Hügel, Kulturstiftung Ruhr, Essen, 1988.

'Malířství a sochařství na dvoře Rudolfa II.', in Jiří Dvorský and Eliška Fučíková (eds), *Dějiny českého výtvarného umění* vol. II, Pts 1 and 2, Prague: Academia, 1989, pp. 182–22.

Tři francouzští kavalíři v rudolfínské Praze: Jacques Esprinchard, Pierre Bergeron, François de Bassompierr, Prague: Panorama, 1989.

Eliška Fučíková, Beket Bukovinská, and Ivan Muchka, *Umění na dvoře Rudolfa II.*, Prague: Aventinum, 1991, published in German as *Die Kunst am Hof Rudolfs II*, Prague: Aventinum, 1991.

'Prague Castle under Rudolf II, His Predecessors and Successors', *Rudolf II and Prague: The Court and the City*, vol. I, Prague and London: Thames and Hudson, 1997, pp. 2–71; vol. II: catalogue entries.

Eliška Fučíková, Petr Chotěbor, and Zdeněk Lukeš, *Prague Castle Gallery: A Guide to the Collections*, Prague: Správa Pražského hradu, 1998.

Eliška Fučíková and Ladislav Čepička (eds), *Albrecht von Waldstein: Inter arma silent musae?* Prague: Academia, 2007.

Rudolfínští mistři: Díla dvorních umělců Rudolfa II. z českých soukromých sbírek/The Masters of Rudolf II's Era: Works of Art by Court Artists in Private Czech Collections, Prague: Muzeum hlavního města Prahy, 2014–15.

Prague in the Reign of Rudolph II, Prague: Karolinum Press, 2015.

Awards

Minda de Gunzburg Award for the best scholarly catalogue of 1988, Paris, 1988.

Herder Prize Vienna and Hamburg, 1998.

Prize of the Engineering Academy of the Czech Republic for the restoration of the mosaic at St Vitus' Cathedral, Prague, 2000.

Chevalier de l'Ordre des Arts et des Lettres, Paris, 2003.

Lifetime Achievement Award of the Czech Association of Art Historians, Prague, 2013.

This series is devoted to the history of Prague, with a focus on
the arts and intellectual life of the city. In a factual yet lively
way it seeks to give an informed account of the thousand-year
development of the city with its changes, both intellectual and
material, and its legendary *genius loci*, thus contributing to general
knowledge about Czech culture. A typical volume in the series
comprises a comprehensive account of its topic, accompanied by
illustrations and 'walks through Prague', by means of photographs
of the preserved historic architecture and other works of art
together with commentary. The publication includes a list of
important historical figures, an index with corresponding maps
of the location of the art and architecture, and a bibliography.
The contributors to this series are respected Prague art historians,
photographers, and translators.